remixthe book

remix the book

Mark Amerika

University of Minnesota Press

Minneapolis

London

See the companion website for this book at www.remixthebook.com.

"Source Material Everywhere" was previously published as "Source Material Everywhere: The Alfred North Whitehead Remix," *Culture Machine* 10 (2009). An earlier version of "Artist, Medium, Instrument" was published as "Artist, Medium, Instrument: The Nam June Paik Remix," *Journal of Korean Buddhist Research Institute* 50 (2008): 133–49. Portions of "The Renewable Tradition" were previously published as "The Renewable Tradition (Extended Play Remix)," *Fibreculture* 15 (February 2010); and as "Professor VJ's Big Blog Mashup," in *Voice: Vocal Aesthetics in Digital Art and Media,* ed. Norie Neumark, Ross Gibson, and Theo Van Leeuwen, 191–206 (Cambridge, Mass.: MIT Press, 2010).

Published by the University of Minnesota Press
111 Third Avenue South, Suite 290
Minneapolis, MN 55401-2520
http://www.upress.umn.edu

Library of Congress Cataloging-in-Publication Data

Amerika, Mark.
 Remixthebook / Mark Amerika.
 p. cm.
 Includes bibliographical references and index.
 ISBN 978-0-8166-7614-9 (acid-free paper)
 ISBN 978-0-8166-7615-6 (pbk. : acid-free paper)
 I. Title.
 PS3551.M37R46 2011
 811'.54—dc22
 2011016767

Printed in the United States of America on acid-free paper

The University of Minnesota is an equal-opportunity educator and employer.

18 17 16 15 14 13 12 11 10 9 8 7 6 5 4 3 2 1

For Ron and Kathy

Contents

Acknowledgments

Given the innovative list of titles focused on new media culture that have already been published by the University of Minnesota Press—books I personally take pleasure in reading and am constantly challenged by—I am sincerely grateful to everyone at the Press who has made this book a reality, particularly Doug Armato, for his generous support of the project through all phases of its development, and Danielle Kasprzak, for assistance with all of the details one must attend to when producing an experimental book project such as this one.

I extend my deep gratitude to the international network of students who have participated in the Remix Culture seminars and workshops I have conducted at the University of Colorado and other venues around the world. Many of the ideas used as source material for this book were originally presented in these intersubjective jam sessions, and I for one loved every minute of it.

Play All the Remixes

(An Introduction)

This is not a book per se. Think of it as more of a hybridized publication and performance art project that appears in both print and digital forms. The work started out as a series of theoretical performances that took place in my Professor VJ blog (http://professorvj.blogspot.com) but that have since been remixed into this multitrack composition featuring selectively sampled phrases and ideas from visual artists, poets, novelists, musicians, theorists, comedians, and process philosophers who have influenced my own creative practice throughout my life.

One of the main reasons *remixthebook* is more than a print book published by a prestigious university press is that the work expands the concept of writing to include multimedia forms composed for networked and mobile media environments. For example, there is an accompanying website at http://remixthebook.com. This website is the online hub for the digital remixes of many of the theories generated in the print book. Since one of the primary aims of the project is to create a cross-disciplinary approach to the way contemporary theory is performed and to anticipate future forms of writing that challenge traditional modes of scholarly production while still taking on the philosophical issues of our time, *remixthebook* could be considered an experiment in creative risk management where the artist, also a professor, is willing to drop all academic pretense and turn his theoretical agenda into (a) speculative play. This speculative play is collaborative and, as such, is best articulated in the creative space often referred to as the commons. Given the social networking protocols of our age, it only makes sense to make the various iterations of the work available as source material for others to use for their own remixological performances.

How does an artist-generated theory, one that encourages others to remix its source material, challenge traditional forms of scholarly discourse? Maybe it has something to do with innovating new modes of theoretical performance that intentionally mash up the jargon of academic writing with the avant-pop forms of digital rhetoric generally found in new media culture. In *remixthebook*, the tone of the remixes is a cross between an improvised keynote address delivered at a conference on disrupting narratives, a stand-up comedy routine, and the kind of live, pedagogical performance found in experimental seminars and lectures conducted in a practice-based research lab focused on inventing the future forms of avant-garde art and writing. These self-consciously performed theoretical routines reveal a metafictional style that infects all of my creative work no matter what media or mediums I may be investigating. In fact, the notion of a *routine,* one that could easily apply to both the dark language digressions of William Burroughs and the social commentary of comics like Lenny Bruce and George Carlin—but in two totally different contexts—is something I am aware of when role-playing whatever persona I am in the process of becoming at any given moment in the work.

The notion of performing theory as a part of a creative process in which artists intuitively construct various conceptual personae *to see exactly what it is they are becoming* relates to one of the quotations in *remixthebook* attributed to the writer E. L. Doctorow: "You write to find out what you're writing." That quotation is referred to in the book as part of a conversation I recall Doctorow once having with television host Charlie Rose and is cited at the very end of *remixthebook,* where there is a list of much but not all of the source material accessed during various phases of the work's performance and post-production. Sampling a line from my last book, *META/DATA,* these remixes are composed as "on-the-fly digressions-within-digressions and avoid conventional footnoting and referencing since the books, websites, and conversations I am using as

source material were integrated into the work while nomadically traveling hundreds of thousands of miles, and were often resourced from memory alone, which, in the book, I suggest is fictional and, as such, meant for spontaneous, unconscious remixing at the artist's will."

Given the rapidly changing digital culture most of us are immersed in these days, and especially the way networked and mobile media communication systems are influencing the development of hybridized, post–studio arts practices, my hope is that the remixthebook project will indicate to emerging artists and scholars, particularly those engaged in advanced forms of digitally processed, practice-based research, an alternative model of multimedia writing they can invest themselves in as part of a professional course of action. The time for repositioning the contemporary artist's relationship to theory per se has already come and gone. For example, it is no longer a matter of requiring that MFA or practice-based PhD students write thirty- to forty-page papers responding to the canonical texts of poststructuralism and whatever trendy academic theories follow. Emerging artists may *elect* that path as a way to experiment with the less spontaneous forms of academic discourse associated with late twentieth-century humanities research, but the protocols of theoretical performance, and the fields of distribution they manifest themselves in, are changing so fast that theory itself can no longer properly become canonized, and for most artists and theoretically inclined creative writers, that's a good thing.

What is happening to theory, and what I project will continue to happen to theory, can be found in the efflorescence of innovative, practice-based research projects conducted in what we now think of as the digital arts and humanities. Even though the entrenched forces of the status quo may choose to ignore the revolutionary, paradigmatic shifts that have already taken place in and around academia, there can be no question that the advent of new media forms of art, theory, and creative

writing has begun to disrupt the university apparatus and its ability to maintain strict protocols related to pedagogy, what counts as a publication or exhibition, and the way university personnel committees respond to evaluating digital forms of scholarship and creative work. For these reasons and others, *remixthebook* is especially targeted at those who find it necessary to continually invent the avant-garde strategies of the future and who do not see a disconnect between the various role-playing figures they may find themselves becoming, including but not limited to some rare combination of artist, theorist, digital humanities scholar, DIY expert, and/or new media entrepreneur. To assume that the creative research of a vanguard intelligentsia shape-shifting in the networked space of flows will predictably produce traditional scholarly outcomes that report on the new media trends of the day, or that contemporary artists must nail themselves to the confines of a traditional studio environment while feigning disengagement from the all-consuming forces of the online social networking culture, is a disservice to those empowered by the innovative and critical uses of the emerging technologies we all turn to for our daily communications.

In this regard, it could be said that *remixthebook* attempts to fill in the widening audience gap that exists between the professional experts generally associated with academic book culture and the DIY experts–cum–digital flux personae we see performing in network culture. My hope is that the remixthebook project will provide one possible platform on which these two worlds can converge and that the extemporaneous flow that can be sensed in the print and digital remixes that this introduction links to will appeal to a growing and diverse network of collaborators who are interested in the interdisciplinary and innovative arts of our time, particularly those professional or amateur experts who make, write about, theorize, or otherwise interact with net art, electronic literature, digital cinema/video, sound art, mobile media art, game culture, live

AV (audiovisual) performance, online social networking, and media hactivism.

My own experience as an interdisciplinary artist and educator who travels internationally to conduct remix, postproduction art, and digital theory workshops tells me that many contemporary art practitioners, theorists, and advanced students who naturally find themselves attracted to interdisciplinary research are looking for expanded models of writing that complement their investigations into the way new media technologies and the daily rituals we all perform with them are transforming both art practice and the theoretical discourses that run parallel to and occasionally infect the work. In fact, over the past decade, I have observed how advanced contemporary art and creative writing students are interested in seamlessly integrating their own artist theories into the core artistic practices they are in the process of developing *while immersing themselves in the network culture*. For many contemporary artists and writers, this means setting their mind on autopilot and *letting the language speak itself*. Sometimes the language wants to speak fiction, sometimes poetry, and at still other times it prefers to come out like a warped remix of pseudoautobiography, creative nonfiction, and theory. *remixthebook* plays with all of these genres and more. The playful use of genre as remixological filter is employed to spontaneously tweak each occasion of writing, and the entire enterprise is designed to expand the concept of what it means to perform one's artwork as *a spontaneous and continuous theory-to-be*. My hope is that other interdisciplinary artists, digital humanities scholars, and innovative arts educators will use this hybridized publication and performance project to experiment with their own practice-based research into remix art and culture. This is why I put the source material out there, so by all means *remix the book!*

<div align="right">

Boulder, Colorado / Kailua, Hawaii
January 2011

</div>

remixthebook

If we give the attributes of a medium to the artist, we must then deny him the state of consciousness on the esthetic plane about what he is doing or why he is doing it. All his decisions in the artistic execution of the work rest with pure intuition and cannot be translated into a self-analysis, spoken or written, or even thought out.

—Marcel Duchamp, *The Creative Act*

If we are all artist-mediums, we must then accept the fact that we are all in perpetual postproduction and that our aesthetic fitness relies on our ability to trigger novelty out of our unconscious creative potential. All of the decisions we make while performing our ongoing work of postproduction art rest with pure intuition and are envisioned as part of the creative act.

—from *Professor VJ's Big Blog Mashup*

Source Material Everywhere

(The Alfred North Whitehead Remix)

There's something about sitting in your studio
in the middle of the Pacific Ocean
geographically speaking farther away
from any other significant land mass
than any other location on Planet Earth
drinking 100 percent organic Kona coffee
picked just last week by your almost friend
but most certainly acquaintance Isaac
and roasted only last week

that makes you feel like you can do
whatever you want with your life
that the choices are yours to make and
the object of your study—
if you think of this creative space you play *in*
as an object—

can be the philosophical rendering of a theoretical premise
on duration (the timelessness of moving–remixing)

Drinking 100 percent just roasted Kona coffee
while the rain is pouring out of the mountain and
smashing into my picture window
suggests Nature's own avant-garde movement is
trying to bust in and destroy everything that came before it

Meanwhile musing on the writings of
Alfred North Whitehead
somehow led me to the performance art of David Antin
whom I have also been reading lately

You would think Antin and Whitehead would have very little
or nothing to do with each other but then why not
especially given contemporary remixologists' tendency
to find social connectedness in *everything* they encounter
so with the 100 percent Kona buzzing my brain
I turn my head slightly toward the left and read Antin
talking about the specific object of his study
which in this instance was how all art schools are alike
or are more like each other than anything else in the world

The more I read Antin the more I see him
discussing / talking about / *ruminating on*
art objects in general
which he says he is surely not interested in making himself

This not wanting to make objects is something
I can of course agree with 100 percent
(thank you Kona for the certainty)
but Antin says he can see why other artists *would* want
to make art objects because making art objects
fulfills the desire of those who not only want
to make things but make things
that are meaningful and whose meaning will be
solidly carried forward for *the duration*

He says that this feeling of making art objects
that branch out into the field of social relatedness
is part of a desire to create something unique in the world
something that actually *means* something
and is part of the creative process we align ourselves *with*
because if the art objects don't mean anything
then there is the risk that the artist
and those who encounter the thing they made
will not see these objects as art
whereas on the other hand

if they are beautiful enough or at least
play with the idea of *art*
and *beauty* and even *irony* (these are my words)
and are very much crafted into a well-made thing
(one that has a certain aesthetic sexiness about it)
then it will just *reek* of meaning
and—as the saying goes—*mission accomplished*

Not that we all want to make meaning out of objects
but for those who do want to make meaning out of objects
they definitely want that meaning *to stick around*
i.e. want it to endure
which brings me back to duration
but in a funny misdirected kind of way
because Whitehead's version of duration
(which is different than Bergson's
yet heavily influenced by him)
if I understand him even a little
is something that occurs as a contemporaneous experience
one that is part of a community of concrescent occasions
forming an immediate present while establishing
the principle of common relatedness
(a principle—Whitehead tells us—
that can be realized as an element of one's *datum*)

With my head tilted slightly toward the right I find myself
reading this heavy-duty process philosophy of Whitehead
while a totally unexpected hard rain slams into
the big picture window separating my studio
from the pristine aloha scenery I look out at every morning
while *at the same time* knowing that today's beach walk
will have to wait until early afternoon at the soonest
and that what I am now experiencing in my immediate present
is another kind of durational achievement
that I had not anticipated

but was *remixologically inhabiting* nonetheless
as part of my early morning ritual

something inside me stirs
so that I am now turning my head back toward the left
to read although *read* is the wrong word
maybe I mean *processually experience*
(i.e. further investigate via my ongoing
hyperimprovisational/intuitive/embodied praxis)
Antin's own take on duration in relation to
the art object and meaning

Antin and Whitehead as actual entities
were opened as books on my desk
books that were in themselves some kind of
made thing or object
that were outliving their predestined durations
and as I was turning away from Whitehead for a moment
literally turning my head toward the Antin book
and eagerly reading him say that
"now i know that it is also this potential of
objects for duration that is part of their attraction
both for the people who want to make them
and the people who want to perceive them
this tenacious physical hold
on existence
which gives an artist a kind of claim on human attention
over a period of time that is a promise
both for its makers and receivers of
a type of survival
in this duration
and this is something we all experience as artists
because even as a poet and a performer
which for me is nearly the same thing

i want to do something that will have
all the immediacy and impact of
a wisecrack and yet will offer itself up to the mind
again and again like a koan
and stay long enough for that
which is a kind of duration"

it clarified something that had been nagging at me
all week as I began to envision this next phase of
philosophical monkey see monkey do
I was about to take on all in the name of *Remixology*
namely that it is easy for an artist to commiserate with
the aforementioned desire to create something
that can be experienced multiple times
or something that can be *reexperienced over time*
not just by rereading a book or revisiting a painting
or watching the same movie or video installation
over and over and over again and again

because many artists want their work to have some kind of
staying power that veers toward cultural immortality
while at the same time imagining that their work indicates
the creative immediacy of the contemporary moment
syncing itself with the "nexus of occasions"
that according to Whitehead inform one's duration

one's accumulation of precious life datum

as part of their autogenerated personal history
itself a kind of *fiction in the making*

This is to say that artists want to be *of* their time
but to also move beyond the mere contemporary
so that we may enter another world within our world

(the slippery and always slipping-away world of timelessness)

Something I have noticed over the years
is that these artists who also want to create work
as an object that can be envisioned as
"a whole set of related experiences
maybe rich and mysterious and new"
(to sample from Antin again)

often want these objects
to circulate in the emerging markets of
aesthetically produced commodity exchange
where what is still labeled "art"
can counterfeit the revaluation of all value

(excuse the touch of Nietzsche)

We are talking about the art world (after all)
and this other world within our own world
is an always already globally inflected emerging market
subsumed in the reigning age of aesthetics

an age where I like to set my own preferences
(thank you very much)
so that I may customize my experience of life
if only to temporarily fashion myself into being

which gets me to thinking that the idea of
a rich and mysterious and new set of related experiences
(as Antin calls them)
triggered by the making of *things*
or as I would prefer *the remixing of data*
may be a fallacy
not in a negative way

but in a fallacious way
let's call it the Novelty Fallacy

a fallacy built on the shores of creative destruction
where members of the creative class who fuel
this forever emerging market in the age of aesthetics
turn to innovation as the every only sign of the times

one they are cleverly positioning themselves to sign on to
as part of a larger strategy to underwrite their ongoing
durational achievement

but then that so-called fallacy of the New
would contradict everything this book is about

(or would it?)

**duration slippage — / — micro comeback — / — are we
there yet? — / — the promise of money**

Oh right
now I remember
the promise of money
that's somehow connected to the primacy of meaning
or the desire to create a heretofore unrealized (novel form of)
meaning in objects that outlive us and that somehow
increase in value with each successive spurt in volume
contained within the durational achievement of
capitalism itself

(Let's forget the current Deep Recession
we are all going through

this horrific mini-Depression of a Lifetime

Let's just pretend it doesn't exist—
are you buying this so far?)

These are the things we have to contend with
if we are to build a legacy
or not a legacy per se
but more like a duration that outlives us even as we
in our state of creative immediacy
only know duration as a contemporary feeling
immersed in its own novelty

Think of it as the mysterious resonance of being
here in the now—the uncertain now

while generating an on-the-fly remix of who we are
in the creative immediacy of
our selectively manipulated data *experience*
because (and I really have to slip this in)
money talks and bullshit walks

Not that walking is bad for you
actually it's very good for you
if you really want to get into it then
I suggest you buy a pedometer and wear it all day and
if you go over 10,000 steps you're staying in good shape
literally you are sculpting
your cardiovascular skeletal musculature
into much better shape
10,000 smackers
is how I look at it
(think of it as money in the bank)
which happens to be close to the same number
one of my works at Art Miami Basel is selling for

meaning that someone now has to take this *pseudothing*
I've made out of the manipulated data of my experience
(i.e. compressed data burned on a plastic disk)
and place a value on it in relation to its *potential*
its potential to maintain a duration beyond
a contemporary feeling for what is novelty now
within the context of an always emerging market
which though it may have its ebbs and flows
still pulls the promise of progressive movement
into the cosmic future as if there were no end in sight

(Did I already suggest that we pretend
the mini-Depression we are living through
does not really exist?)

How does one develop a contemporary feel for
placing value on the manipulated data of
someone else's aesthetic experience?

Given the fact that each artwork
object-based or not
is an excerpt from each artist's
custom-built durational achievement
how do we determine the value of
each cut from the body of the beast?

Perhaps we can begin via structurally integrated
modes of intuition that feed off
the lunacy of art market psychology
which is not to say that the art world is very touchy-feely
no far from it

The totally glam art/fashion parties are the opposite of *that*

They are more like what Whitehead gloms on to
when he writes about "The Theory of Feelings"

In fact he opens his section on "The Theory of Feelings"
discussing the philosophy of organisms
referring to it as "a cell-theory of actuality"
that is to say
"each ultimate unit of fact is a cell-complex
not analyzable into components with
equivalent completeness of actuality"

which in art world terms I translate as
"there is not one sure thing that drives the art market"
(not even money although money is the currency
that charges the social relatedness of the various role-players)

Imagine a complexity of things being made or made up
by those who in the creative immediacy of
their selectively manipulated data *experience*
aesthetically remix their creative presence
into what we might call *novelty*
novelty as the always already remixed present
revealing the mysterious resonance of
social relatedness *as* currency in an emerging market of ideas
fueled by this same sense of novelty
(and it really is a *sense* of novelty
just think of the hungry collectors hounding the scene
sniffing out the next new phase of novelty)

Yes novelty fuels novelty ad infinitum
and this is process theory *branded*

(of course this is also liable to make artists—
society's ultimate novelty generators—
sick to their stomachs except for the fact

that they too now have been trained
to sniff out what those who buy art
may be anticipating as the next new thing to sniff
so that together they can sniff each other
the ways dogs do when first getting acquainted)

Embodying Whitehead's "Theory of Feelings"
via an ability to generate value out of novelty
especially the contemporary art objects whose duration
history will soon determine for the always-emerging art market
moves well beyond the mercenary trends of the day

It is also related to that species of improvised creativity
Whitehead refers to as an "actual entity"
one that he describes as "spatialized"
and actuated by its own "substantial form"

This actual entity he describes sounds to me like
a remixological hacker–cum–artist-medium

as when he says:

"The 'effects' of an actual entity
are its interventions in concrescent processes
other than its own"

and that by hacking into and/or remixologically inhabiting
and/or intervening in the datum of our shared
(collective collaborative) presentational immediacy
this actual entity that I refer to as
the artist-medium
becomes a transformational *object*
who unconsciously triggers their readymade potential
to stimulate "the production of novel togetherness"
(as Whitehead refers to it)

(despite everything I have written above
it should be noted that I usually shy away from the term *object*
focusing instead on the term *bodyimage*
to suggest the qualitative *sense data* that one accumulates
over the history of one's personal experiences
[their ongoing durational achievement]
via an embodied praxis that processes reality
by remixologically inhabiting the flow of source material
one circulates in *as* an artist-medium rendering
their *bodyimage* into the social network

but then I wonder: what is the personal
experience of the one who circulates?
is it really one? or is it a plural plus [p+]?

Whenever I write or speak off-the-cuff
it never really feels as if it's my own words
discharging into the environment

rather it feels like a compilation of
sampled artifacts gleaned from
the artificial intelligentsia I circulate in
and that becomes my networked milieu)

Whitehead also goes on to state that
the actual entity as "object"
has a *formal* aspect to it
and that this formalism comes to be
via a creative process that is immanent to it
something any contemporary remixologist can relate to
because the embodied praxis of the artist-medium
is predicated on their ability to formally innovate
new iterations of contemporaneity
by sampling from the flux of data

at their immediate disposal
(Source Material Everywhere)

As we have already acknowledged
the remixologist *is* a novelty generator
one who performs in the immediate present
as a way of establishing the mysterious resonance of
social relatedness within the context of
a fluctuating currency in the always-emergent market

a market that is fueled by this same sense of novelty

With this in mind we could ask:

"Is it possible for the remixologist to become
a rich and famous artist without selling out?"

**embodied praxis — / — theory of feelings — /
— selling out — / — autohallucination**

In addition to his "Theory of Feelings"
Whitehead uses the occasion of processing
his version of mixed reality
to investigate what he matter-of-factly terms
Higher Phases of Experience
and is it only me
or does reading Whitehead sometimes feel like
a kind of non-drug-induced autohallucination?

He quotes himself in *Process and Reality*
by sampling a few lines from the first of his books
I actually ever read back when I was nineteen

a book titled *Religion in the Making*
a title that when I first saw it on the reading list
immediately turned me off
since I was now becoming an adult
and wanted to be independent of whatever it was
that my parents may have tried to imbue
culturally politically prehistorically and religiously

At the time I was not interested in *making* anything
but my own experimentally processed artwork
(*religion* was simply out of the question)
and in those days "artwork" for me translated as
"creative writing" and drawing and something like music
but what I would now generically refer to as "sound art"

But then something strange happened and I realized
at age nineteen that I was now being *pulled in*
by Whitehead's *Religion in the Making*
a book that caught me totally by surprise
mostly due to its holistic use of language
which at the time felt like it was simultaneously
so abstract in a metaphysically incoherent way
as well as rhetorically concrete in its execution
focusing my attention on the experiential qualities of
my life story as an enduring aesthetic *fact*

An enduring aesthetic fact?

At age nineteen and with still no formal education
unless you call going to public high school full-time
in Miami in the seventies a kind of formal education
how could I (someone who between the ages of
fourteen and seventeen had also been working
full-time at the greyhound racetracks—
two full-times = no time to think about it)

come to conclude that my life story
was an enduring aesthetic *fact*
i.e. how could I be swayed via the confidence of
Whitehead's self-assured writing style
that my own life was associated with the rhythms
and physical vibrations that arise out of
the conditions for intensity and stability—
a tough balancing act if ever there was one?

Reading Whitehead's book at nineteen
began stimulating that part of my brain
that was ready to play with the philosophical-poetic
source material at my disposal
so that soon I was *using* the book's writing
as source material to dream up new versions of self
(quickly disposing of both self and religion per se
that is to say diminishing their influence on my then
wildly flirtatious relationship with an experimental lifestyle
that would rid myself of the need to encounter God *as* a self—
for what was God to a secular nineteen-year-old
former racetrack employee transforming
the disjointed multiplicity of his flux identity
into fictional decharacterizations of "self" *in* novel form?)

novel form — / — seventies norm — / — mixed reality
— / — "in the making"

The quote in his *Process and Reality*
that Whitehead samples from *Religion in the Making*
follows a comment on what he terms
"an intense experience"
one that he assigns to an enduring object

that gains the enhanced intensity of feeling
arising from the contrast between inheritance
and novel effect (i.e. what's already there
and what we do with it—remixologically)
all the while tapping into its free-flow sensation
as an embodied praxis syncing *bodyimage* rhythms
with the flux of data waiting to be "naturally selected"
so that it can then be simultaneously mutated
while performing the ultimate balancing act
between intensity and stability

(*Remixology* meet *Evolutionary Biology*
i.e. the art of syncing the pulse of blood music
with the affective filtering of bodyimages
fusing in spontaneous bursts of variation
speeding into heretofore unimagined forms of
qualitative life experience resonating
in the distributed memory banks of
the artificial intelligentsia postproducing presence

—or so I thought)

"An intense experience is an aesthetic fact"
writes Whitehead and then he begins to lay down
some "categoreal conditions" (as he calls them)
that are to be generalized "from aesthetic laws
in particular arts"

He then samples from *Religion in the Making*
two of these conditions / aesthetic laws
and remixes them into *Process and Reality:*

> 1. The novel consequent must be graded in relevance so as to
> preserve some identity of the character with the ground.

2. The novel consequent must be graded in relevance so as to preserve some contrast with the ground in respect to that same ground of character.

These two principles (he goes on to say)
are derived from the doctrine (what doctrine?) that
"an actual fact is a fact of aesthetic experience.
All aesthetic experience is feeling arising
out of the realization of contrast under identity."

Looking back at my possible readings of this excerpt
during the late seventies and into the early eighties
I can see where I would have been attracted
to Whitehead's focus on intense aesthetic experiences
and his high valuation of novelty as a way to generate
fluctuating forms of identity/characterization
that would then morph the "actual entity" into pools of
differential feelings sinking and swimming
with the ebb and flow of whatever life rhythm
may have been evolving as part of its
ongoing aesthetic practice (he would call this practice
a "religion in the making" but I would not buy into it
and thought of it as something more akin to
the freedom to compose an artistic lifestyle practice
even as I started using myself / my body
as an "it-thing" to be guinea-pigged
for an ongoing research project lending itself
to all manner of future observation and data collection)

Remixologically speaking
"Religion in the Making"
circa 1979–80
became for me a nuanced version of
"Art in the Making"

How was I to become an artist
acting on whatever ground was available
unless I made it up from scratch?

Vito Acconci once wrote:

> If I specialize in a medium, then I would be fixing a ground
> for myself, a ground I would have to be digging myself out of,
> constantly, as one medium was substituted for another—so,
> then, instead of turning toward "ground" I would shift my
> attention and turn to "instrument," I would focus on myself as the
> instrument that acted on whatever ground was, from time to
> time, available.

Is this what we mean by "grounding out"?

Even today this "Art in the Making"
becomes something different yet again
let's call it (for lack of better)
"Life in the Making"
(a total cliché for sure—one I adore
especially after having pursued an artistic lifestyle practice
for almost three decades across ten planets
and forty galaxies and seventy blood transfusions)

Given all of the above
would it not make utter sense that the biosphere
would be the next best place for me to unravel
my free-flow sensations of intense aesthetic experience
especially since the actual entity of the it-thing body
moonlighting as a "novelty generator" hacking the Real
is always operating in *asynchronous realtime*?

(From *META/DATA:*

Two examples of experiencing life in asynchronous realtime
where one's sense data becomes stretched or shortened into
durational shapes and smears that are at once dislocated
and spatialized are (1) playing in a live computer mediated
performance art event and (2) teleporting one's mind to
a faraway place in a totally different time zone. In the first
instance, the VJ improvises a new set of image experiences by
collaborating (or jamming) with a laptop as the other player in
the jam. It's a space of live composition where the computer
processor meets the artist processor. Both of these players
process at different speeds and with a different set of goals
and, dare I say, intentions. One is machinic; the other is all-too-
humanly intuitive. I'll let you decide which is which.

The point is that the speed with which the computer changes its
digital imaging output as a response to the artist's transaesthetic
input is relative. Sometimes the VJ may push the laptop appa-
ratus to a point in its programmed intelligence where it has
no idea what to do with all of the mixed signal, transaesthetic
inputs it is getting and so performs some random function as
a way of arbitrarily keeping up with the VJ's constant demands.
These random functions become immediately visualized as an
ongoing sequence of unexpected imagistic events that the
VJ then responds to in what feels like realtime but (because
of immeasurable instances of readiness potential verging on
unconscious thought processes) is really more like make-or-
fake time. This make-or-fake time is *totally unreal* and emerges
in live performance as part of the artist's ongoing, creative
intuition—an indeterminate sense data space that actually
occurs in the imperceptible margins of whatever action takes
place during the event, creating an hallucinatory Doppler effect
that makes performers feel as though they are asynchronously

communicating with both their jamming laptop partner and the audience too. This is when digital art personas are operating in the ZONE of unrealtime, and the groove where they are metaphorically becoming a wave of rhythmic asynchronicity, defamiliarizing all of their poetic phrasing as a way to extend the possibilities of breath and parting lines, can feel like the ultimate high an artist is capable of experiencing.)

True to form

 always in search of

 the Ultimate High

 while lost in the postproduction of presence

The Postproduction Artist in me now feels inclined
to abandon straight improvisation as a method of
poetic composition and would like to strategically remix
Whitehead's "categoreal conditions"
for "New Media Artists in the Making":

 1. The novelty generator must be valued in relation to their ability to position the energy [source material] they create with the ground they act on while performing their latest remix.

 2. The novelty generator must be valued in relation to their ability to position some contrasting energy [source material] with the ground in respect to the already existing energy [source material] they are sampling from while performing their latest remix.

existing source material — / — categoreal imperatives — / — experiential sediment — / — universe of technical images

The experiential sediment accumulating inside
with its fluctuating data rates informing
every instance of novelty generation
moves the "remixologist in the making"
into spaces beyond self—identity—character
and transforms one's unconscious projections
into the physical experience of image rendering
pulling them into a compositional force field of
seductive knowledge and immanent satisfaction
via the lure of potentially positive feelings

(something artist-mediums
can never fully sever themselves from
as they continually pursue the Ultimate High

a hedonistic pleasure that often comes for some
from a simple return to writing)

And yet as Antin writes or transcribes
via his talk story *The Price*
"what is locus of the source or ground
of the self . . . what i had in mind
was to look for the place where the self
or what i take to be the self
has its ground"

(resonating as it were with Acconci's
instrument "that acted on whatever ground
was available" at any given moment

as well as Whitehead's "ground of character"
a phrase I catch a glimpse of as
I turn my head to the right and see
the opened page of *Process and Reality*)

Now I have never been one who invests much
in concepts of self or character per se
opting for flux persona or even
the idea of an erotically charged
fictional decharacterization of said self
(said who?)

As I look back to 1986 a mere eight years
after having left the greyhound racetrack in Miami
and absorbed all of the Whitehead I could at the time
I wrote my first published novel excerpt
"Alkaloid Boy" as part of *The Kafka Chronicles*
where I went off on this improvisatory riff:

Decharacterization:

first and foremost / high on the list of things

To Do

1) evil-eyed optimist
2) puritanical pessimist
3) retrograde renegade
4) easygoing numskull
5) taxing interest
6) megalomaniacal monsterman
7) persevering wanderer
8) sunshiny souvenir

9) sovereign veneer

10) venereal vegetarian

11) pornosophic filmmaker

12) college student

13) bank president

14) beatnik historian

15) girl watcher

16) punky playboy

17) diseased dyslexic

18) monkey grammarian

19) existentialist outlaw

20) linguistic statesman

21) novelty generator

22) effervescent eunuch

23) egghead eavesdropper

24) neoconservative butcher

25) egotistical holyman

26) harmonic hegelian

27) continue the discontinue

28) still crazy after all these years

29) butcher the butcher

30) wearisome whacker

31) where art thou waterfall?

32) butcher the butcher

333) dead meat dead meat dead meat dead meat

421) off to the boonies

5X1r#217) name address social security perforation

dis

int

egr

ati

on!

final mishapover

BLOWN

pro ./ por ./ tions

eros intensification

"self need not be so unitary as all that"
(Antin continues in *The Price*)
"it depends on what kind of ground it emerges from
how it emerges from it
how continuously it emerges and how uniformly
it presents itself on emerging
and maybe it doesn't really emerge
maybe it only hovers about a certain place
this hovering a kind of complex act performed
by a number of actors whose interaction
we could call the self"

Here is where we enter the realm of
what I have been calling intersubjective jamming
which is different than the idea of a Networked Author
or Collaborative Groupthink Mentality that preys
on the lifestyles of the Source Material Rich
and seemingly forever Almost Famous

For this "hovering" is a "complex act"
that is "performed" by "actors"
who interact in the gestural manipulation of
a "narrative in the making" that just may be
the story of our lives (sounds like a soap opera)
but is more likely something along the lines of
a complexity of events being made by those who
in the creative immediacy of

their selectively manipulated data
form an aesthetic experience that we might call *novelty*

novelty as the immediate present *felt*
as an ongoing creative act of moving-remixing

one that is capable of establishing
a mysterious resonance of
social relatedness *as* currency
in a networked narrative environment
that (quoting Ron Sukenick)
"like a cloud . . . changes as it goes"

(we are still talking about
the always-emerging art market too)

This interactive form of intersubjective jamming
that takes place via the gestural manipulation of
a narrative in the making points back to Vilém Flusser
who in his *Into the Universe of Technical Images*
writes about all kinds of gestures that inform novelty
(writing gestures visualizing gestures codifying gestures
photographic gestures publicizing gestures):

> The question of what technical images mean is first and
> foremost a question of how the visualizing gesture is directed.
> Which way do the fingertips responsible for the images point?

And then:

> What is the maker's attitude?

> Where does he stand?

Although I am not in a position to answer
these questions posed by the gestural Flusser
I would remix Whitehead with Acconci
and say remixologists in the making
stand with their hyperimprovisational instruments
on whatever ground of the moment
they happen to be playing on as they
port their narrative/network potential
and its manifest aesthetic facts
into the compositional playing field
their novelty generation operates *in*

Flusser continues:

> To look at this position, this visualizing gesture with this question
> in mind is to realize that in it a revolutionary new form of
> existence is finding expression, a powerful and violent reversal
> of human beings' attitude toward the world. This reversal is
> so powerful and violent that it is difficult for us to see. For
> envisioners, those who produce technical images, stand against
> the world, pointing toward it in order to make sense of it. Their
> gesture is a commanding, imperative gesture of codifying.
> Envisioners are people who raise themselves up against the
> world and point at it with their fingertips to inform it.

And not just envisioners but as
the cyberpunk novelist Pat Cadigan imagines
we have also now become *synners*
human synthesizers who sinfully
feel hedonistic pleasure from dreamwriting
our futures as image-rendering protagonists
fighting the artificial eyes of the machine

In her novel *Synners*
one of her characters is Visual Mark
a professional visualizer
someone who has the power
to construct on-the-fly dreamlike music videos
out of his creative unconscious

These dream-vids are simulcast
across the virtually distributed network
that happens to be tapping into
his creative mindshare
in *asynchronous realtime*

At one point in the novel, Visual Mark is simply there:

> The sense of having so much space to spread out in—a baby
> emerging from the womb after nine months must have felt the
> same thing, he thought.

Oozing images in a vast playing field
where everything is disintermediated
could turn intersubjective dreamtime jam sessions
into endless remixological performance potential

But the sinister (syn-ister) side effect of
these virtually distributed autohallucinations
is that they are always already bought and controlled by
the Megacorporate Entities whose primary goal
is to diversify and vertically integrate all aspects of
the creative process in the field of distribution

The soundtrack to this dialectial narrative
could come from the French Europop band Air

who wrote and recorded a song titled
"Electronic Performers"
that I often listen to when in postproduction
(when in autovisualization mode)

The opening lyrics tell it all:

> We are the synchronizers
> Send messages through time code
> Midi clock rings in my mind
> Machines gave me some freedom
> Synthesizers gave me some wings
> They drop me through twelve-bit samplers
> We are electronic performers
> We are electronics

Even as I lose track of my drift
so that I may wander away from
what must have been a train of thought
(Whitehead? Antin? evolutionary biology?)
I can feel my body turning on

and in turning on

turning remixological

and in turning remixological

becoming a kind of synchronized synner/sinner

an electronic performer

an alchemist in search of his next crude discovery

by way of electronics

(identity soldered into signal belching noise)

codifying gestures — / — Revolutionary Visualizers — / — remixing as "grounding out" — / — warped time code

Perhaps now would be the perfect time
to make a very straightforward confession
one that is neither here nor there
but somehow still relevant given where we are
in this ongoing *talk story* about
actual entities laying down commanding gestures of
all types so as to intensify their experience
as an enduring aesthetic *fact*—

and that is that I have never learned how to type
I mean literally finesse the QWERTY system
and that as a hunt-and-peck two-bit operator
I feel as though I have developed a more sensual relationship
to the keyboard than I have with any other *thing*
(except for the obvious *others* I share my life with)
and that in truth when it comes to performing
I actually never see the keyboard as I type
the keys are just simulated microzones of tender
push-button potential for me to seduce
whatever knowledge may be residing in the network
generating a mashup of feelings I have accumulated over time
(maybe I'm just wired for this kind of actualization?)

This may seem a trivial footnote
but I have to wonder

if the remixologist as novelty generator
is to be valued in relation to
their ability to position some contrasting energy

(source material)

with the ground in respect
to the already existing energy

(source material)

they are sampling from

then what happens when they use their ground wire
to activate a series of operations where
they simply lose themselves in the ether
(maybe I'm not wired for this at all
that is to say—maybe I'm wireless
an enduring aesthetic fact
flying high on Tesla-like electrical conduction
and whose remixological potential
is the ultimate source for a renewable
"Energy in the Making")

In describing feeling Whitehead
ends his riff way above with a final remark writing
"A feeling is a component
in the concrescence of
a novel actual entity"
and then tells us that the feeling
is always novel in reference to its data:

The process of the concrescence is a progressive integration of
feelings controlled by their subjective forms . . . feelings of an

earlier phase sink into the components of some more complex
feeling of a later phase ... each phase adds its element of novelty.

The contemporary remixologist can relate
to all of this and remixes Whitehead to
expand on his philosophy:

An image rendering is a component feeling
in the concrete manifestation of
a remixological performance
one where artist-mediums
selectively filter the data
by tapping into their unconscious neural mechanism
layering the component feelings in varying
degrees of opacity and balance
conjuring more complex imagery
that generates yet more novelty
transmuting the remixologist's life
into the free-flow sensation of
an intense aesthetic experience
filtering an ongoing social relatedness
that opens up more creative potential

that is to say

more potential to produce novel togetherness

Whitehead refers to this transmutation
as a "becoming" in the actual world

"In the becoming, it [the subjective form]
meets the 'data' which are selected
from the actual world. In other words,
the data are already 'in being.' There

the term 'in being' is for the moment
used as equivalent to the term
'in realization.'"

Translation: **Source Material Everywhere**

That's the Reality

What we do with it as remixologists
emerges as a *process* of the concrescence:

Creative Processing of

Selectively Manipulated Source Material

(DATA)

manifests as the becoming

of

(Re)

Mixed Reality

Embodied in a Complex of Actual Feelings

**creative process — / — (re)mixed reality — / — economy
of motion — / — entrepreneurial spirit**

What does it mean to be creative?

Is it a posthuman condition?

Or is it aborigine with cyborgian implications?

Remixology samples from Whitehead when he says
"Creativity is the principle of *novelty*"
a *conditioned* indetermination
that morphs into a *real* potentiality
spurring on the further advance of
our ongoing creative momentum
via an applied aesthetics that both manipulates
and is unquestionably manipulated *by*
the environment that each novel situation
presents to us in its state of immediacy

This advance-garde of Creativity itself
forever in pursuit of transmuting aesthetic moments
creates a physical momentum
formally felt as an ongoing satisfaction
within an optimum *economy of motion*
one triggered by the intensity of experience
which in itself becomes an aesthetic fact
and informs "the production of novel togetherness"

The "production of novel togetherness"
is the ultimate notion embodied in
the term *concrescence* (where the many
become one and are increased by one)

An artist role-playing an amateur mathematician
who aligns his avant-garde practice
with the entrepreneurial spirit of an academic
looking to hurdle impenetrable institutions
in a series of single bounds (still binding)
might formulate it as such:

M = Many
One = Fluid Singularity
1 = Remix-in-process

and conclude

M = One + 1 ("always becoming")

The casual dropping of the parenthetical
"always becoming" signals a break away
from what others might call "total togetherness"
and instead highlights how Whitehead's
"production of novel togetherness"
advancing into intuitive states of creativity
is really what it means for artist-mediums
to live in perpetual postproduction
(a nontotalizing experience)

Always becoming a postproduction medium
is what it means to be aesthetically networked
(to tweak synaptic knobs while spinning)
(to customize artist-apparatus filters
as part of a collective hallucinatory achievement)
(to embody creative synthesis in praxis
while intersubjectively jamming with
the copoietic environment
I call the *artificial intelligentsia*)

Visionary experience (it ends up)
is internetworked persona as shareware
(a consensual hallucination always seeking
the Ultimate High—"novel togetherness"?)

Is this what it means to be part of the networked avant-garde?

In *META/DATA* I suggest that we are all *born*
avant-garde (that it is our natural birthright)
but that one of the cruel ironies of being
a living breathing postproduction medium
in an age of superlate turbocharged capitalism
is that the environment that produces innovation
is now also the environment that kills creativity

This sets up an epic struggle for artist-mediums
whose ongoing satisfaction of formally felt experience
is codependent on their being able to intuitively
generate emergent forms of novelty ("Creativity itself")

**artificial intelligentsia — / — epic struggle — / —
"always becoming" — / — vibratory events**

In his *Process Metaphysics and Hua-yen Buddhism*
Steve Odin writes "Creativity is tenable only in
an asymmetrical framework of causal relatedness"
and highlights Whitehead's use of the term *vector*
as a way to signify a magnitude with *direction*

In this scenario vectors gather strength
via an accumulation of causal feelings
+1 +1 +1 +1 +1 +1 +1 +1 +1 +1 +1
feelings relayed into ongoing throbbing intensities
compiled as occasions of aesthetic experience
forming a pattern of energetic transmissions
between vibratory events

For the contemporary remixologist
this relaying or *relayering* of experience

translates as an intensive "always becoming"
or *always live* postproduction performance
that turns the trajectory of the artist-medium
into a simultaneous and continuous
fusion of light motion energy sensation
effect affect emotion ("an enduring aesthetic fact")

Remixologically inhabiting the datum
that pings your unconscious neural mechanism
and spurs you on to create your own version of
this enduring "narrative in the making"
points to each "actual entity's" *aesthetic fitness*
i.e. each applied remixologist's potential
to render into vision (to literally *envision)*
a nuanced mix of what it means to circulate
within the networked space of flows

The Many that is "always becoming"
+1 +1 +1 +1 +1 +1 +1 +1 +1 +1
and that advances toward the ultimate
dream of picture-perfect aesthetic fitness
is forever charging and recharging
"language to the utmost possible degree"
(as Ezra Pound once put it)
and actively intervening in concrescent processes
other than its own

that is to say

the Many Remixologists / Synners
collectively generating their complex visualizing gestures
are intuitively "becoming electronics" in parallel to
the Aesthetic Turn that is more than upon us

that has in fact *become* us

(and we it)

The pragmatist in me
the one who simultaneously ridicules
these progressive advances toward novelty
and the always-emerging art market that attempts
to capitalize on this Aesthetic Turn
while negotiating its excess on the periphery
wants to ask "How much will it cost us?"
i.e. "How invested must we really become?"
and as a follow-up "Given our attachments
to the pseudoutopian dream of
the Ultimate in Aesthetic Lifestyle Practice
how can we translate our creativity
into 'digicash' paracurrencies that will
enable us to afford being
the postproduction mediums
we long to become?"

(Musing over those questions is
at the heart of creative class struggle
in way-too-late technocapitalist lunacy)

Perhaps Remixology can help guide us
in that it shows contemporary artist-mediums
where to focus their attention while
performing these *always live* postproduction acts
that render them into simultaneous and continuous fusions of
light motion energy sensation effect affect emotion

Think of yourself as taking on the lead role
in an ongoing performance of postproduction art

where the title of your self-directed play is
The Life and Times of an Enduring Aesthetic Fact

For if Remixology is anything at all
it is an ongoing valuation of one's
Lifestyle Practice *as* an aesthetic fact

one that integrates selectively manipulated data
into its pattern of intensiveness
a pattern that is aesthetically perceived as
the novel production of togetherness
in its phase of (nonstop) origination

(imagine it as an eternally remixable "originary"
that *comes with* endless feeds of
streaming **Source Material Everywhere**)

The question remixologists constantly face
while performing their live postproduction sets
as a pattern of intense aesthetic experiences
is "How then to keep the Big Creative Mo alive
within an optimum economy of motion?"

Because when you think about it
in these times of global climate change
who really has energy to waste?

Or to put it another way:

How can the contemporary remixologist
build sustainable but also aesthetically complex
lifestyle practices that sample from their own
pseudoautobiographical data as a renewable energy source?

And how can this be performed in
one's "always becoming" live postproduction sets?

Can this be achieved via *improvisation*?

Illumination?

Intuition?

Questions like the ones above have a way of
keeping one focused and as always
may lead to unexpected outcomes
as you begin to start seeing things
you never knew were there but were
somehow always right in front of you

(*not* seeing what is right in front of you
has been thought of as a negative hallucination)

But can one really listen to the voice of intuition?

Yes I have seen and heard it *everywhere*
even though it's not necessarily something
that you can literally see or hear
maybe it would be better to say
I have felt it form inside of me
and have become intimate with the rhythm of
its spontaneous projections as I act on
whatever ground is available
to me at any given time

I have watched it (intuition) change shape
a kind of embodied yet amorphous shape-shifting
vector (magnitude with *direction*)
that has metamediumystically stimulated me

to tap into my own creative process theory
triggered by throbbing intensities as they shift
between occasions of aesthetic experience
forming a pattern of energetic transmissions
between all of the vibratory events
I have mutated myself through as
a *just-in-time* postproduction medium
(the creative advance of novelty *embodied*)
and so it seems only right that
as this riff inevitably draws to a close
that I would advance this movement
into novel forms of creative Remixology
by turning to Whitehead again
feeding off of his word flesh
stealing his voice
sampling his energy
as would any hungry parasite so ravenous
they can no longer speak for themselves
and are hoping to locate renewable energy sources
in the production of novel togetherness:

> Thus the "production of novel togetherness" is the ultimate
> notion embodied in the term concrescence. These ultimate
> notions of "production of novelty" and "concrete togetherness"
> are inexplicable either in terms of higher universals or in terms of
> the components participating in the concrescence. The analysis
> of the components abstracts from the concrescence. The sole
> appeal is to intuition.

Mind Bank Network

(The Allen Ginsberg Remix)

The first time Allen Ginsberg
tried to pick me up
he invited me over to his apartment
in Boulder Colorado for some pizza
(he even suggested that he would pay for it)
but I politely declined since I was not into it
and he seemed very nonplussed by it all

(I remember thinking afterward about
something my father once told me
it was the night of my first big high school dance
and I was driving my new [used] 1968 Chevy Nova
and was totally psyched to go out and meet girls

My Dad said that I should find the nerve
to pick the ten girls I liked
and most wanted to dance with
and one by one ask them to dance with me

He speculated that one would eventually say yes
and that by taking his crazy advice
I would soon be dancing with someone I liked

He was right)

Ginsberg and I met a few weeks later
at an informal press conference
where I was representing my online network Alt-X
(this was way before blogging or net journalism
i.e. 1994 at http://www.altx.com/amerika.online)

During the Q&A I asked him what
he thought about virtual reality

He looked at me dead in the eye and said
"Yes, but can it make you come?"

virtual reality — / — multimedia measure — / — language convergence —/ — processual relayerings

"My basic measure is a unit of thought"
Ginsberg writes in *Composed on the Tongue*
an idea he gets from fellow Beat poet Gregory Corso:
"And the reason it's a unit of thought is
that's what you wrote down on that line"
which is what happens in Remixology too
except instead of being squeezed by the line
while trying to catch the unintended effects of
breaking line where one breaks thought
what happens is you flip the switch
and use basic psychosomatic flow techniques
and the electrical currency of network conduction
to autohallucinate your multimedia measure
into the copoietic *mix*

Multimedia measure is different than verse
and cannot be translated into old-timey genres
like literature or visual art or happenings
although everybody myself included
has tried to supply the network discourses
with some measure of intermedia language convergence
since things are moving so fast and furious
and we want to make sense of it all!

But to "make sense" one must first "take measure"
and taking measure requires making *things*

intuitively

literally *drawing* from
the open source lifestyle practice
the remixologist happens to be projecting from
their Deep Interior
where incoming data feeds
mix with embedded memory and performance filters
enabling the postproduction medium
to generate on-the-fly versions of networked persona
via source material both structurally integrated
from the inside
and formally (some would say randomly) inherited
from the outside

These versions of networked persona are posited
as an accumulation of social pulsations
informing compositional acts of fictional performance
that are organized into processual relayerings of
complex feelings becoming aesthetic events
sometimes generating a fluid narrative substance
that may appear as a well-orchestrated connective glue
that continually gets employed in the remixologist's
cut-and-paste as-you-go open source lifestyle practice
whose story is written in the immediate emergence of
an asynchronous realtime (an "unrealtime")
triggered by "the language of the body"
unconsciously projecting its creative visualizations

narrative substance — / — connective glue — / — rhetorical brainwash syndrome — / — transmuting alchemy

"no ideas but in things"
writes William Carlos Williams

Williams the pediatrician-poet
who like Ginsberg was Paterson New Jersey
through and through and who in his
epic narrative poem *Paterson* wrote:

> The measure intervenes, to measure is all we know

was immersed in the local idiom he encountered
in his daily life while suffused with the images
that became his poetic occasion of the moment

Nowadays our poetic occasion of the moment
might come in the form of a tweet
or a texting idiom reserved for some
advanced form of prolonged adolescence

Imagine receiving a text message
or twitterized electronic shock that
out of nowhere concluded
in all of its concrescence

> so much depends
> upon

a red wheel
barrow

glazed with rain
water

beside the white
chickens

In the original
I see what Williams
wants me to see
poetically

the concrescence
could not be more
clear

but in the text message version
automatically updated in my pants pocket
which seemingly comes out of nowhere
causing my Pavlovian response to fish out
my iAppendage so that I can see who or what
in the World Wide Wank feels so welcome to penetrate
deep into the nomadic nothingness of my innermost regions

the poetry becomes more matter-of-fact

an "advertisement for myself"
(the "myself" who sent it)

essentially remixing the substance of
Williams's breakaway agenda so that it says

"Nobody here but us chickens!"

As if walking around with our heads cut off
were some kind of excuse to intentionally
lose touch with the prowling pervasiveness
of our sensuous *prima materia*

Sometimes you have to wonder if all
the Mobile Time Killers
shifting their accelerated bodies
through wafts of immersive traffic
signal an emergent organic structure
evolutionarily consistent with what one feels
when strolling on the sea shore
breathing in the wind spirit
being played by the trades
as they swim off the waves

or if they are rather banal representations of
what they *actually appear to be*
i.e. information junkies glued to the tube of
chemically processed corporate propaganda
coming straight into their mindscreens
as if being fed from "the end of that long newspaper spoon"
(to borrow a phrase from William S. Burroughs)

With or without the latest media gadgets
attached to our bodies as some kind of
necessary prosthetic aesthetics
there is forever embodied in the act of living
a fortitude for risking our total disconnection
from whatever it is that succumbs to our
ongoing sense of the Real

Really!

What are we supposed (not) to do?

Do we (not) turn toward Intuitive Technologies
to render our creative visualizations?

(Imagine a start-up company of new media art stars
who specialize in the emerging market of novelty generation

Their firm is called Intuitive Technologies and
their mission is to design a networked gift economy
fueled by peer-to-peer renewable energies
charging the exponential rise of user-generated content
thus facilitating the quick demise of
creative class struggle by quickly turning it into
crowdsourced mashups of spirit and pride

Is there anything ambivalent about this?)

In *Paterson*, Williams writes:

> Jostled as are the waters approaching
> the brink, his thoughts
> interlace, repel and cut under,
> rise rock-thwarted and turn aside
> but forever strain forward—or strike
> an eddy and whirl, marked by a
> leaf or curdy spume, seeming
> to forget .

(always those extra blank spaces for
the late period that punctuates
while straying into next concrescence)

Williams is magnifying his own thoughts
by syncing with the waterfall that pours
his imaginative source material back toward
everything inherited from variable nature's
pool of idiosyncratic potential

Remixing Williams for my own uses
I might say that we use measure
as an interventionist strategy
by hacking the code that informs
preprogrammatic impulse
i.e. suturing codework bits into
parsed language tributes to the dead
(that space of collective refuse
where the landfill comes alive
as when what is scripted to decay
suddenly is reconfigured into miracle glue
or the radiating truth serum of the moment)

While some might insist on eradicating
consumer culture's counterflow of
excess mind pollution and image junk's
cancerous outgrowth of shopping spectacle
by chemically burning through a media potpourri of
rhetorical brainwash syndrome

let us not forget that there are still
emergent forms of novel advance
circulating inside the copoietic network of
artist-mediums "being creative" in asynchronous realtime

This collaboratively generated playing field
where the measure itself intervenes
in the distributed space of flows

where collective field compositions
climax in an accumulation of causal feelings

+1 +1 +1 +1 +1 +1 +1 +1 +1 +1 +1 +1 +1 +1

can be felt as an ongoing satisfaction of experience
that is also enlivened as a continuous string of
spontaneous discoveries resonating
with all of the preceding manifestations of
just-in-time Creativity itself

The general idea behind this version
of applied aesthetics/remix(grammat)ology is
don't do as I say or do as I do
but remix your own creative potential
as a singular fringe-flow sensation
"always becoming" Itself
precisely because the one is never the One
and the Many is never the many
Itself being nothing more than the Many
as One +1 +1 +1 . . .

"always becoming"

In *META/DATA* I refer to these just-in-time
and often surprising manifestations of Creativity
as eureka moments (a transmuting alchemy
that deeply embeds itself in muscle memory
experienced as throbbing aesthetic intensities
yet formally felt as reverberating vibratory events
where the whole body is distorted into
what Ginsberg calls a "physiological spasm")

These eureka moments are infused
with the necessary dosage of what Gregory Ulmer
refers to as "artificial stupidity"

In his lecture on "Emergent Ontologies"
Ulmer plays against the computer and writes:
"If the computer has been associated with
artificial intelligence in terms of expert systems
and all that, the internet is the prosthesis
not of the conscious, expert mind,
but of the unconscious mind.

'Artificial stupidity'"

providing Remixology with yet another
layer of resonance *to spur the creature on*

Something Ulmer's theory-driven
practice-based research has always
prodded me into thinking is

"What drives the politics of performance
pedagogy in network cultures?"

Answer?

"It's the Creativity, stupid"

(Don't ask, don't tell)

**artificial stupidity — / — thinking machines — / —
quantum undecidability — / — *performances-to-be***

Subsidizing the advance of Creativity itself
is like performing a Robert Creeley
that is to say you go out of your way

to fuse your ongoing poetic strategy
with an artist theory that acknowledges
the space of conduction where Creativity rules
on its own terms using the artist-medium
as the conduit for experiential thought
expressed in units that bypass intellect
and find themselves climaxing
in ongoing acts of spontaneous fusion

and that makes it clear from the start that
to *become the creative apparatus*
in a hacker-driven age of aesthetics defined
by the design culture that fashions us into being

is to "give witness not to the thought of myself,
that specious concept of identity
but, rather, to what I am as simple agency,
a thing evidently alive by virtue
of such activity."

(*Evidently* performing a Creeley
is no mean trick)

"What uses me is what I use and in that complex
measure is the issue," writes the Creel
laying down a bottom-line principle
for our nascent remixological poetics

"I feel that poetry, in the very subtlety
of its relation to image and rhythm,
offers an intensely various record
of such facts. It is equally one of them."

"An intense experience *is* an aesthetic fact,"
Whitehead reverbs and then anticipating

the somatosensorial plasticity of causal feelings
"each ultimate unit of fact is a cell-complex
not analyzable into components with equivalent
completeness of actuality."

Remixologically speaking
I would say my basic sense of measure is
experienced as an *image-thing*
or *an intense aesthetic fact*
in perpetual postproduction with *just-in-time*
source material as part of an open source lifestyle
that in the very subtlety of its relation
to image and rhythm and *embodied praxis*
offers an intensely various record
of such facts (and is equally one of them)

This does not mean we are all destined
to resemble the modern poetic machine
whose agency is programmed to occasionally
make their scheduled ghost appearance

nor are we to conclude that the creative process
we align our interventionist measure *with* is
an algorithmically engendered thinking machine
we consciously jam with when engaged in always live
remixological sessions / postproduction sets

Becoming a postproduction medium
is like wrestling in the blood and guts of
a disenfranchised agency that turns to
its creative activity as evidence of its existence
while struggling to perform its mission

The processual relayerings of our sense data
remixed as intense aesthetic experiences

lead us to develop a sense of measure
vibrating with the morphic resonance of
a stimulated economy of motion that readies
our unconscious creative potential to intuitively
design our always live postproduction sets

In a perfect world the economy of motion
would guarantee no wasted energy in pursuit of
optimum electrochemically charged momentum
which is itself formally felt as an ongoing satisfaction
triggered by the intensities of our experience

For the contemporary remixologist
these processural *relayerings* of experience
translate into an always live postproduction performance
that turns the trajectory of the artist-medium
into a simultaneous and continuous fusion of
bodyimage to bodyimage events
i.e. an enduring aesthetic fact

Remixologically inhabiting the datum
that pings your unconscious neural mechanism
and spurs you on to create your own version of
this ongoing narrative in the making
is the only way to embody praxis
as you play yourself in the unfolding story

Think of your unfolding story as a generative fiction
one that operates on the uncertainty principle
while surfing that wave of quantum undecidability
we always seem to find ourselves riding on
as we mobilize our experiential thought processes
into whatever compositional field we happen
to be playing in ("whatever ground was available"
to sample from Vito Acconci again)

In its many iterations of *becoming philosophy*
Remixology envisions the artist as a postproduction medium
who *becomes instrument* while conducting
radical experiments in unconsciously projected creativity
(a double agent of distributed aesthetics whose work
quite literally *draws* on/with/from
an open source lifestyle practice
always *on the morph*)

Many artist-mediums working with new media technologies
are developing (multiple/hybridized/integrated)
daily practices as an alternative approach
to the regimentation of consumer bureaucracies

(perhaps we could call it an epic struggle
one the creative or hacker classes
continually commiserate over as a kind of
informal unionization that collectively
accumulates into some kind of bargaining power—

the radical spirit of always becoming
a postproduction medium?

How do artists leverage this instinctive creative process?)

Artist-as-Instruments play out their *performances-to-be*
on whatever compositional playing fields
they happen to be (re)cycling through when
caught in the heat of postproduction
(think of it as developing an economy of motion
targeted at turning the body into a renewable energy source)

That playing field would be
the *ground* of the moment
not one they would have to dig themselves

out of continuously but one that they would
act on as part of their constructed persona(e)
moving through the networked space of flows

("Yes, but can it make you come?")

distributed aesthetics — / — heat of postproduction — / — state of immediacy — / — mirroring neurons

Ginsberg gloms on to Pound's phrase of
direct presentation and applies it
to his vision of originating spontaneous imagery
as part of a larger strategy to "get the mind high"
(echoing Whitehead's call for Higher Phases of Experience
and the remixologist's quest for the Ultimate High)
and if all the synaptic firings and unconscious
deep interior projections are operating on
perfect pitch autopilot and you're ready for takeoff
the measure then turns into something unique like
"a collage of the simultaneous data of
the actual sensory situation."

For those of us using deep interior projections
to turn intense experience into aesthetic fact
the trick is to *become* Creativity itself
i.e. the actual sensory situation of Remixology
as it once again enacts the principle of novelty
(a principle of spurring on the further advance of
our ongoing creative momentum via
an applied aesthetics that both manipulates
and is unquestionably manipulated *by*

the environment that each novel situation
presents to us in its state of immediacy)

Keywords that keep generating connective tissues
and morphic resonance within the thought clusters
inhabiting these language excursions into the Deep
include *artist-medium / postproduction art /
enhanced intensity / novel effect /
sense of measure / embodied praxis /
mirroring neurons / aesthetic fact*
not to mention the endless *flux of data*
waiting to be selected and further manipulated
while performing the ultimate balancing act between
intensity and stability
in the live postproduction environment
the contemporary remixologist risks
their entire livelihood in

all of it picture-perfect source material
ideally situated for an always in-the-making
lifestyle practice researching an applied aesthetics
that grounds itself in creative achievement

How does one successfully bioengineer
the pure mobility of *bodyimage* rhythms
so that the affective remixing of all
the selected source material that is postproduced
transforms one's ongoing life experience
into an intense aesthetic fact?

The State of Immediacy is not very different
from an endless State of Creative Emergency
(Emergency being a heightened state of emerging-agency
where the always live artist-medium gives itself
extensive powers to develop an integrated

open source lifestyle practice that customizes responses to
these hyperimprovisational projections
from the creative unconscious
and that seemingly come out of nowhere and require
one's immediate remixological attention)

Remixology uses the continual emergence of agency
as a way to spontaneously discover
a sense of measure that will enable the artist-medium
to invent an alternative ontological drift
for Creativity to get lost in

and assumes that if the computer has been
associated with artificial intelligence in terms of
expert systems then the Internet
is the prosthesis not of the expert mind
but of the creative unconscious
(to resample Ulmer who also it should be noted
feeds me the source surrounding "emerging-agency")

Pre-Internet remixologists like Ginsberg
play with intense visionary experiences
as *enduring aesthetic facts*
and develop their spontaneous poetics
as a strategic philosophical device
to better apprehend the nature of
"synchronicity, because it was darkly inevitable"

Ginsberg said that at age twenty-six
he heard a voice that was
his own mature voice
his mature voice being the voice of
William Blake

He describes the voice of Blake as
"completely tender and beautifully . . .
ancient."

> I saw into the depths of the universe, by looking simply into the
> ancient sky. The sky suddenly seemed very ancient. And this was
> the very ancient place I was talking about, the sweet golden
> clime, I suddenly realized that this existence was it! . . . in other
> words that this was the moment I was born for.
>
> Anyway, my first thought was this was what I was born for, and
> the second thought, never forget—never forget, never renege,
> never deny. Never deny the voice—no, never forget it, don't get
> lost mentally wandering in other spirit worlds or American or job
> worlds or advertising worlds or war worlds or earth worlds. But
> the spirit of the Universe was what I was born to realize.

Religion in the Making?

But he later remixes this version of
the mystical experience into
a more digitally inclined poetics
that grows out of the thinking of his
Paterson patron W. C. Williams:

> Since a physiologic ecstatic experience had been catalyzed in my
> body by the physical arrangement of words . . . I determined long
> ago to think of poetry as a kind of machine that had a specific
> effect when planted inside the human body, an arrangement of
> picture and mental associations that vibrated on the mind bank
> network: and an arrangement of related sounds & physical mouth
> movements that altered the habit functions of the neural network.

Now he sounds more like
an autohallucinating new media artist
experiencing a kind of metempsychotic flashback
thanks to the nano-neuro-narcotic effects of
the Networked Buddha in ecstatic form

(a surprisingly pre-Internet form that
plays with its impermanence and flux
while tallying the marks that come with flow)

Perhaps unintentionally we see Ginsberg's visionary experience
resonate with Duchamp's notion of "the creative act":

> To all appearances, the artist acts like a mediumistic being who,
> from the labyrinth beyond time and space, seeks his way out to
> a clearing.

**mind bank network — / — instantaneous remixing — /
— "ghost tendencies" — / — prophetic illuminations**

The hyperimprovisational remixologist
flipping the switch and turning the power ON
uses basic psychosomatic flow techniques
and the electrical currency of network conduction
to autohallucinate his multimedia measure
into the copoietic *mix*
thus conjuring up images ready
for instantaneous remixing
while the self per se
disappears in a sea of source material

What emerges in this state of
direct presentation(al) immediacy

(interiorly projected "emerging-agency")
are the "ghost tendencies"
that Heisenberg called *potentia*
data-things to be experienced via
unlimited mediation and manipulation
(the art of generative Remixology, philo-style)

In pre-Internet writerly terms
Ginsberg taps into his sense data and writes
"The ambition is to write during a prophetic
illuminative seizure" where artist-mediums
find themselves "in such a state of blissful
consciousness that any language emanating
from that state will strike a responsive chord of
blissful consciousness from any other body
into which the words enter and vibrate."

Versioning Ginsberg for an emerging
state of networked agency ("always becoming")
I would say that the ambition is to remix
illuminative sense data **(Source Material Everywhere)**
during motor-prophetic eureka moments
where the artist-medium performs
the Next Version of Creativity
the mind bank network is coproducing
with the social environment it thrives in

It's the beyond-beta version of Meta's coproduction
where the Many intersubjectively jams with the One +1
and where "always becoming" a spontaneous discovery
means tapping into the remixological potential of
socially networked vibratory events on the verge of
initiating more body-brain-apparatus achievements
(for a contemporary remixologist this translates
as a tour de force of unconscious projections

or *always live* AV [audiovisual] performances
that fuse the artist into a moving field of
durational achievements that arise out of
the conditions of formative causality)

Playfully inserting one's latest sense of measure
into the always live postproduction set
the Next Version of Creativity
will use anything at any given time

Sex lust money drugs cars war

Coffee keys colors spiral jetties

Computers disease family music hype love

All in love is fair game

for

love is the every only god
writes e. e. cummings:

"who spoke this earth so glad and big
even a thing all small and sad
man, may his mighty briefness dig"

Dig for what?

A creative ore that resides
deep within the psyche?

The eureka moments of prophetic illumination
that lead to enduring feelings of satisfaction
resonate with the intense aesthetic experiences

projected from our Deep Interior
(that unconscious neural network of action
where the novel principle of Creativity
thrives in its postproduction *chaosmosis*)

Hitting it just right so that
the gushing creativity is channeled
and flows like never before
is not a second-rate inspirational metaphor
especially in the context of remixologically inhabiting
the profuse source material that morphs at will
within the copoietic mix of the artificial intelligentsia

Playing or intersubjectively jamming with
the abundant source material that leads you on
requires a complexity of mature feelings
that can be shaped into customized artist-apparatus filters

But how does one stylize or aesthetically tweak
the unconscious neural mechanism's flow?

Becoming a postproduction artist-medium
requires a revaluation of all values—
an activist engagement with the abundant source material
where the intensity of your enduring aesthetic experiences
take place as if you were creating them in realtime
but feel as though they are being created in unrealtime

The Unreality of Now is not some new age pseudoscience-speak

Check the freaky observers of contemporary cosmology
who would have us believe in a kind of reverse reincarnation
that is to say instead of having lived our experiences
in some other form in the past we may just as well

be living out these prophetic illuminations of the present
as a reincarnation of what will happen deep into the future

In this New Version of Creativity illuminating the psychosphere
we are all part of a cosmic inflation with its unbound potential
set free to fluctuate upward as it expands the universe
and as a consequence increase the abundance of possibility
for artist-mediums to essentially channel
what has yet to emerge
but what will eventually (thanks to quantum uncertainty)
pull us back into the direct presentation of the immediate Now
that we experience as if it were happening *right at this moment*

(think of it as the Rubber Band Theory of
the Will to Aestheticize
except now it's more like a Will to Elasticize
or even Plasticize Life in Unrealtime
i.e. imagine an emergent form of novel togetherness
where the collectively generated unconscious projections
taking place in the distant future of the universe
are manifested as Creativity's momentary outcome
in the fog of our uncertain Now—
everything is "snap to grid" as we maintain focus
while blurring the difference between art and life)

This state of direct presentation(al) immediacy
when experienced as prophetic illumination
coming from somewhere deep in the future
but also channeled from our own Deep Interiors
can be spontaneously shaped into what Ginsberg refers to as
"speech-rhythm prosody to *build up* large organic structures"
and enables artist-mediums "to mouth more madly"
whatever it is they are "summing up" while illumined

As Ginsberg says when writing
about his own technique with *Howl:*
"Meaning mind practiced in spontaneity
invents forms in its own image
and gets to last thoughts.

Loose ghosts wailing for body
try to invade the bodies of living men."

These loose ghosts are evolution's best-dressed
actual entities seducing all remixologists
so that they too will become inhabited and
ideally postproduced into spontaneous images

The fog of our uncertain Now
goes down *bodyimage* to *bodyimage*
although detailing the creative process as such
causes one to hear "ghostly academics
in limbo screeching about form."

(Sonic hauntologies of the wicked dead?
At what point does a medium truly expire?
"Sniff before tasting and proceed with care")

Does remixologically inhabiting the loose ghosts of
the distant future signal a deep affection
for everything that might have been?

Spontaneously inventing language form
cummings continues coming clean
with his energy love poem:

"for love beginning means return
seas who could sing so deep and strong

one queerying wave will whitely yearn
from each last shore and come home young

so truly perfectly the skies
by merciful love whispered were,
completes its brightness with your eyes

any illimitable star"

**sonic hauntologies — / — trigger-inference — / —
creative climax — / — stylized dissemination**

Other Beats besides Ginsberg are on to
this spontaneous ejaculation of energy
that artist-mediums spill forthwith

Responding to the *Evergreen Review*'s
publication of Jack Kerouac's lofty
Essentials of Spontaneous Prose
LeRoi Jones / Amiri Baraka first grabs this pull quote:

> MENTAL STATE. IF possible write without consciousness in semi-
> trance (as Yeat's later "trance writing").

and then goes on to write:

> This is not to be interpreted as "clinical consciousness" (which
> hardly exists . . . but that is a philosophical question), but as other
> consciousness, that is, the "writer's voice" or the "painter's eye."

This is the level or stratum of the psyche that is the creative act. The "writer's voice" dictates the writing just as the "painter's eye" dictates the strokes the painter makes for his picture.

What Baraka refers to as the "writer's voice"
or the "painter's eye" dictating what gets made
becomes an inherited (or one might say) evolutionary
filter for the contemporary remixologist
whose practice of everyday life continually emerges
as a work of art in perpetual postproduction and
where playing without consciousness is not so much
the answer to a nonexistent philosophical question
but an activity of eureka mind digs networking
within the rhizomatic field of action (space of flows)

Baraka continues:

> This is the consciousness that supersedes or usurps the normal consciousness of the creator (though even the usual or uninspired consciousness of the creator can hardly be called normal). For it is during this so-called normal state that the artist's peculiar and/or latent impressions are gathered; but it is only during this "unconscious" state that the writer's voice becomes his only voice . . . and the creative act itself is accomplished.

Baraka then begins riffing on the "trigger inference"
where he tells the story of Billy the Kid who whips out his gun
and straight from the hip shoots a hole through a thin reed

When asked how he can do this without even aiming
Billy replies "I aim before I pull out the gun."

This is visionary Remixology as embodied praxis

An intuitively generated sense of measure
that unconsciously speaks for itself

Baraka goes on to write that this raw talent
to creatively shoot and ask questions later
relates to spontaneous writing as well

The spontaneous writer too
"aims before even drawing the gun.
That is, the spontaneous writer has to possess
a particularly facile and amazingly impressionable mind,
one that is able to collect and store not just snatches
or episodic bits of events, but whole and elaborate
associations: the whole impression intact, so that
at the *trigger inference* the entire impression and association
comes flooding through the writer's mind almost in toto."

i.e. artist-mediums as visionary remixologists
must turn to affection and the enabling filters of
their innate patchwork of propioceptive protocols
to even begin targeting their kinetic energy
into the open field composition they are playing in

"The resultant impression," Baraka tells us,
"has been thoroughly incorporated and translated
into the supraconsciousness or *writing voice* of the writer.
The *external event* is now the internal or psychical event
which is a combination of interpretation and pure reaction."

In pure and substantive remixological terms:

WYSIWYG

(what you see is what you get)

or from a more animated or behavioral perspective:

WYDIWYA

(what you do is who you are)

Becoming an inside-out upside-down artist-medium
whose simultaneous and continuous fusion into
a spontaneously generated and generating mobile force
cannot be taken for granted or ignored

rather it showcases the "pure ecstatic power of
the creative climax" of the writer writing
something that the readers can never fully achieve
even though they may have successfully traced
the writer's path toward an unconsciously projected nirvana
that Baraka tags "that final 'race to the wire of time.'"

"The *actual* experience of this 'race' is experienced
only by the writer," writes Baraka, "whose entire psyche
is involved and from whence the work is extracted.
And no matter how much we 'identify' or are extended
by the work, it remains always a *work* and not *ourselves*."

"Only the writer is 'relaxed and said' [Kerouac];
the reader is finished, stopped, but his mind
still lingers, sometimes frantically, between
the essential and the projected, i.e. what we are and
what the work has *made* us, which is the writer's triumph."

But is the contemporary remixologist in whose sight
we perpetually postproduce the world anew
ever truly relaxed and said—finished and done—
over and out?

Baraka
taking into account his own New Version of Creativity
answers emphatically in the positive
suggesting that by imaginatively tracing this race to the wire

the writer is **cooked**

emptied

ecstatic

while the reader could very well
be *left behind* by the force of writing
and feeling worse than insignificant

In fact

the experience may even be *a total downer*
for whoever finds themselves so inclined to attempt
to keep up with the writer who
alights that race to the wire of time
without a trace of conceit even as they forget
you Dear Reader are still there
proving yet again that by reading
our ultimate aim as postproduction mediums
is *to see the mind at work*

to see the mind *in* the work

There may be some passive-aggressive
mirroring going on here
but let's take what we can from the beatific strides made
by the usurping consciousness of the poet-agent
while at the same time inventing yet another
New Version of Creativity (this one digitized)

Perhaps the next version would immerse itself in
its playful use of an uncanny energy
that emits from the unconscious
whetting its appetite for what comes next
while the work itself auto-organizes
into a previously nonexistent structure
that may or may not resonate
depending on how fast you are
and if you have inherited these experiences yourself
as *you* play out *your* potential
to participate *(to co-evolve)* in the formal experimentation of
the artificial intelligentsia intersubjectively jamming
in the copoietic mix

**copoietic mix — / — pseudoautobiography — /
— spontaneous transmission — / — dreambook gesture**

Remixology presupposes the prophetic act of
making things *with* and *out* of code
whether it be a poet's *direct presentation*
a programmer's hacking aesthetic
a net artist's targeted action scripting
or a live AV artist's patchwork performance

Whatever the mediumistic delivery mechanism
(and here the artist can morph at will)
it still comes down to a root measure
a random association of selected thoughts
that come to the fore via intuitive memory trance
(an admixture of habit and novelty that informs
the remixological gestures of artist-mediums
as they perform the pseudoautobiography of their
always becoming narrative in the making)

Words rolling off the tongue
images conjured at the keyboard
sounds blasting through headphones
bodies bobbing off the balls of their feet
while *qi* electrical impulses structure
every pivotal move into makeshift
choreographed trance narrative space

Qi momentum making it impossible
to look back until much *much* later
when the sediment of Being accumulates
like ancient dust on the windowsill of
still unarticulated ruins

The fidgeting digits of the elliptical nomad
transfigured in trance narrative space
high on the experience of *qi* energy
while generating prophetic illuminations
running parallel to physiological currents
subtly manipulating psychosomatic flow

initiates the approach of neuro-expression
i.e. an ecstatic expression catalyzed
in the body as a measuring rod
that shape-shifts the creative advance
while playing

Vilém Flusser calls this *The Gesture of Writing*
but for Ginsberg this ecstatic expression
catalyzes into spontaneous transmissions
emitting from a body experiencing "physiological spasms"
in a heightened state of emergent-agency

If you are practicing spontaneous transmission
(Ginsberg lectures all wannabe bards)

and by this he means to say
"transmission of your thought"
"how do you choose then what thoughts
you need to put down" while in trance?

The answer (he says—playing Guru)
"is that you don't get a chance to choose
because everything's going so fast."

"It's like driving on a road
you just have to follow the road;
and take turns, 'eyeball it'
as a carpenter would say.
You don't have any scientific
measuring rod, except your own mind.

I don't know of any scientific measuring rod
that's usable. So you have to chance
whatever you can and pick whatever you can.
So there's also a process of automatic selection.
Whatever you can draw in your net is it,
is what you got."

Remixology forms as a process of
natural selection

intuitive netting of the source material

which then can be manipulated into
the physiological form of ecstasy
during your ongoing postproduction sets

(this interiorized postproduction process
turns the pure mobility of one's *durée*
into the ongoing satisfaction of becoming

more source material / experiential data
and during a heightened state of emerging-agency
can lead to Higher Phases of Experience)

Creativity as a form of novel advance
becomes an always live performance art
when embodied by the postproduction medium
whose spontaneous transmission
is transcribed into *more source material*

more hard code

embodied as the measuring rod
whose job it is to intervene

This measuring rod is the instrument
used in the principle of selection
"so you have to be a little athletic about that"
says Ginsberg

(If the species *remixologist*
is about anything at all
it's about aesthetic fitness)

The measuring rod vibrates
as a *sense of measure*
physiologically rooted
in the dreambook gesture transcribed
while writing (playing performing remixing)
and inhabits a transliminal space
where everything is biochemically
attached to everything else it connects with
and is subject to electro or alchemical
manipulation of its state of emerging-agency

(a "mind bank network" in whose neurosis
we tell the story of Remixology
and the habit of electrochemical dream writing

i.e. the creative act of
simultaneously improvising and revising
as a form of perpetual postproduction)

As Creeley wrote in relation to Whitman:

> *His constant habit of revisions and additions would concur, I*
> *think, with this notion of his process, in that there is not "one*
> *thing" to be said and, that done, then "another." Rather the*
> *process permits the material ("myself" in the world) to extend*
> *until literal death intercedes.*

~~Remixology is a habit-forming druglike behavior~~
~~where the aesthetics-junky is "always becoming"~~
~~the multiplier effect forever in pursuit of an experiential fix~~
~~that will heighten one's state of emerging-agency~~

> *Do I contradict myself?*
> *Very well, then I contradict myself.*
> *I am large, I contain multitudes*

What does it mean to become an artist-medium?

+1 +1 +1 +1 +1 +1 [...] = The Many ["always becoming One"]

Artist, Medium, Instrument

(The Nam June Paik Remix)

Accessing the **Source Material Everywhere**
not as ideas *or* things
but as intertwingled agitations of force
collectively composing the organism
that makes this life possible

I am reminded of a series of events
and/or aesthetic encounters
that catapulted my transient body
into currents of ecstatic expression
(prophetic illuminations in the mind bank network)

Perhaps one of the most significant events occurs
upon landing in Bremen Germany in 2006
as the first stop in my Professor VJ Everywhere Tour
where I am picked up by the world-historical figure
in the field of computer art
Frieder Nake

Nake has recently been experiencing
a second wave "late-in-life" boom of attention
with curators young and old reenvisioning
his significant contributions to the field of
computer/generative/algorithmic art
while championing his historical appearance as one of
the first of three artists to ever exhibit computer art
in conjunction with Max Bense in Stuttgart in 1965
where works of computer-generated imagery/graphics
resulting from painstakingly long algorithmic processes
are said to have first been witnessed inside an art gallery

This all happened during a time when semiotic machines
(as Nake refers to the language-based
computers he manipulates)
were VERY VERY SLOW (perhaps they should have
called it Patience Art back then since it took endless hours
if not days to render what now takes seconds)

But now (the year 2006) we were moving VERY VERY FAST
as I threw my bags into the car
and we darted off to the Kunsthalle Bremen
where in addition to permanent installations
such as the *John Cage Raum*
there are always temporary exhibitions as well

At this moment in history
Nake and I are arriving at the Kunsthalle as it features
a show called *40jahrevideokunst.de*
which basically translates as *40 Years of German Video Art*

(the title suggests an *all-encompassing* exhibition
since as far as an art-historical retrospective on video art goes
it doesn't get any older than forty years
and that's because for all practical purposes
it can be said that video art started in Germany
around 1963 with Nam June Paik's now notorious
Exhibition of Music—Electronic Television gallery show
in the small town of Wuppertal)

Speeding through the normal weekend traffic
at dusk on this otherwise uneventful afternoon
would seem unnecessarily risky for the two of us
especially given the fact that
the *40jahrevideokunst.de* exhibition
will be running during my entire stay for the week ahead

but there is a special event
about to take place at the Kunsthalle
and Nake prides himself on being punctual
which my slightly delayed arrival has made nearly impossible

As we approach the downtown area and use our Ouija-like
extrasensory perception to find a parking space
that is *simply not there* but opens up for us nonetheless

we immediately hop out of the car and dash
toward the museum with me (always) following
in Nake's footsteps as we approach the entrance
whereupon entry into the museum's foyer
Nake gives the receptionist/cashier a quick nod of his head
and we energetically proceed toward the auditorium
located somewhere past the first gallery full of artworks
to be ignored while steamrolling to this most important event

////////

 but I am startled by what I see and am unable

 ////////

 //////// un
 able

 to move ////////

 eventually ////////

 coming ////////

 to ////////

a complete ////////

halt. . .

Standing in the first gallery of the Kunsthalle Bremen
there is an eerie feeling of entering a timeless time
not like seeing a Rembrandt or Cezanne hanging on the wall
where you know you are in a museum that treats
ancient works of oil paint like animals in a zoo

but something more in the realm of autohallucination

as if time-tripping into another electronic era

The *40jahrevideokunst.de* exhibition in Bremen
is part of a five-city network of exhibitions
each city representing a different decade over
the forty-year span of video art creation
with an extra one for contemporary video art et al.
and Bremen is where it all starts: *the sixties*

I am halted in my VERY VERY FAST momentum
because this first gallery inside the museum
introduces the exhibition with the same artwork
that was shown in Wuppertal in the early sixties

a fantastic collection of Paik's
magnetically distorted and delayed video footage

Participatory TV is what he called it then
(created by drawing on a table surface
with microphones as the stylus)

but also tape loops and the beginnings of what
we would soon call video sculpture

all of it coming into view at once

not to mention a long thin glass case
where contained within its archival borders
like some now extinct specimen of an early life form
there resides a sequence of pieces of paper
with gentle handwriting composed as
a freestyle artist poetics by Nam June Paik himself

Upon closer inspection I see that this handwriting is
an improvisational riff titled "Experimental Television"
whereupon even closer examination
(the breath from my nose forming a rare
interactive spray of nasal condensation
on the glass covering the long narrow case)
I immediately become aware of the fact that
Paik is here in this succession of mental jottings
initializing his emergent video art theory
by writing:

> A is different from B
> but not
> A is better than B
> sometimes I need red apple
> sometimes I need red lips

(which reminds me of a few Dick Higgins quotes
from his artist essay "Innovation":

> Another implication of the neoteric fallacy—I can begin to call
> it that, by now—is that the "new" element in a work is of
> intrinsic value.

The new manner—any new manner—finds its only actual value in whatever new meanings it makes possible. Thus if in each generation a new meaning is needed, an appropriate manner of expression will be found—and this may or may not be a particularly new one.

Innovation—the "new" in art—is, then, not one-track but dialectical, neither "good" nor "bad," but an aspect of a process, an interchange between form and content, artist and public, now and then. It is relative, not absolutist. . . . What is new to me in some artwork, may not be new to somebody else, and vice versa.

as if to say what is new in art
is *feeling the need to create*
something different *now*

A instead of B because A
is different and not better

For example remixing Paik and Higgins
as my fluid source material always *in flux*
at *this* point in the creative advance

and *not* Ginsberg and Burroughs
or Whitehead and Antin
[they can play later!])

Neoteric Fallacy or not I am paralyzed
in the first gallery at the Kunsthalle Bremen
taking in the entire exhibition and wondering what else
the glass-encased handwritings might have to say to me
but unable to pursue this any further because
Nake is already at the first gallery's exit

waving me on so that we can move to the far end of
the building and enter the auditorium
for *the memorial is about to begin*

The memorial it ends up is
the European memorial for Paik
who only a few weeks earlier had passed away in Miami
(my mother city—literally the place of my birth)

There Is No Rewind Button for Life
is the memorial/homage/event's title

It is the third such event to honor
the life of Paik (the other two were in
New York City and Seoul respectively)

As we are all whisked into the auditorium
(there are about seventy-five of us in total
and our timing is suddenly impeccable)
the well-executed memorial program begins
and various anecdotal evidence emerges
recapping the life and playful *jouissance*
highlighting Paik's approach to his role as artist

For example when asked about his relationship
with art history Paik said it was like looking out
in a meadow and seeing a dead flower in the middle of it all
and having to go pick it up

Another story was told recapping how
sometime in the early sixties
while attending a very noisy almost
unlistenable triple concert
where there were three simultaneous orchestras playing
under the direction of three separate conductors

one of the conductors (Karlheinz Stockhausen)
stopped the music in the middle of the performance
reprimanding the third violin for being out of tune

at which point Paik decided right there and then
that if Stockhausen could hear that one out-of-tune violinist
in the midst of the cacophony of noise in the hall
then he (Paik) was in the wrong business
and ceased thinking of himself as a musical composer
which then opened the door to him becoming a visual artist

(this transition was then elegantly encapsulated
in the title of his first gallery show
"Exhibition of Music—Electronic Television"
the one now reenacted in the gallery I had just passed through)

More stories were told

Paik once applied for a Rockefeller Foundation grant
and in the section that asked what he wanted the money for
he wrote "to destroy all national television"

Or when he was speaking before a group of politicos
who were focusing their discussion on communism/Marxism
Paik silenced the crowd by asking

"But this brings up a very important question,
and that is, what happens when you cannot
find a parking space?"

Fortunately for me
one had suddenly opened up
upon our arrival into downtown Bremen

I believe I referred to it as
"our Ouija-like extrasensory perception
to find a parking space
that is *simply not there*
but opens up for us nonetheless"

Sitting in the auditorium I could not help but wonder
if the artist who loses sight of self while creating
is not also the impetus for an alternative lifestyle practice
that investigates what it means
to reinvent the general economy

Somehow this also relates to how Paik's handwriting
was to help me crystallize my own thoughts
on what it means to be an artist-medium
one who transforms into an instrument
that *acts* on whatever ground is available

Electronic Television — / — extrasensory perception — / — eternal presence — / — unconscious momentum

In his handwritten "loose ghost" poetic style
Nam June Paik's notes on "Experimental Television"
are situated inside the gallery with the original artwork
from his first-ever 1963 video art exhibition in Wuppertal

These notes feature an excerpt that truly connects
with my recent discoveries in the emerging fields of
hyperimprovisational new media art and performance
where the artist as postproduction medium
taps into the unconscious flow
detonated by the trigger inference

before conscious thought steps in and derails
one's signifying momentum

In "Experimental Television" Paik refers
to the word "ecstasy" (which is held up
at the top of the page by clawing quotes)
by writing immediately below it

to go out of oneself . . .

and then continues with the following
bullet-pointed words and phrases:

- completely filled time
- the presence of eternal presence
- unconscious, or super-conscious
- —some mystic forgets himself (goes out of oneself)
- abnormal
- the world stops for three minutes!

where the trick for stopping the world
(and this is exactly the same phrase used
in Carlos Castenada's *Journey to Ixtlan*
where the trickster-shaman Don Juan advises
his young disciple ways to "trip"/drift through life)
is to always stay a half second ahead of the game
creating on-the-fly DO-IT-YOURSELF MANIPULATIONS of
all of the source material you have at your disposal
(the phrase *DO-IT-YOURSELF MANIPULATIONS* comes
from the typewritten notes/theory of Paik's contemporary
the Fluxus artist Wolf Vostell whose art and writing

is also exhibited in the same large gallery room
at Kunsthalle Bremen along with Paik's Wuppertal show)

(DO-IT-YOURSELF MANIPULATIONS /
video art manipulations—
what is YouTube mashup culture if not exactly that?)

After Paik writes "the world stops for three minutes!"
he jots down a cryptic aside:

Dostoevsky before the spasm of Epilepsy

which reminds me of the "physiological spasm"
that Allen Ginsberg spoke about when discussing
his best poetry (according to Ginzy these spasms occur
when the body of the poet gets "lost in space"
i.e. totally immersed in other-worldly body chanting
instead of just talking per se)

This full-body spasm that ejaculates Creativity
as the first principle of *novelty*
is something most artists can relate to

But what about this *before* that Paik is referring to?

What low deep rumbles are stirring as the body
renders into vision its next great explosion?

Are the moments of before-spasm already indicative of
a fuse well-lighted or is it just a sign of "being chill"?

Speaking with students about this we often discuss
how one gets into this ex-static state of mind

unconsciously triggering the Next Version of Creativity
in whatever glorious field of composition
we happen to be moving our bodies in

Think of it as creating an active unconscious momentum
where proprioceptive artist-mediums *know*
where they are going without ever having been there before

> Video is
> part of my body;
> it's intuitive
> and unconscious.
> (Bill Viola)

Voilà!

Or imagine the artist-medium playing out
their aesthetic potential via *an innate body intuition
flushed with the illogic of sense (data)
operating on autopilot*

Is this what it means to stop the world for three minutes?!

Don Juan says to Castaneda's persona:

> I am teaching you how to see as opposed to merely *looking*, and
> *stopping the world* is the first step to *seeing*.

> *Stopping the world* is not a cryptic metaphor that really doesn't
> mean anything. And its scope and importance as one of the
> main propositions of my knowledge should not be misjudged.

I am teaching you how to *stop the world*. Nothing will work, however, if you are very stubborn. Be less stubborn, and you will probably *stop the world* with any of the techniques I teach you. Everything I will tell you to do is a technique for *stopping the world*.

The sorcerer's description of the world is perceivable. But our insistence on holding on to our standard version of reality renders us almost deaf and blind to it. I'm going to give you what I call "techniques for stopping the world."

Is this what Paik means by "to go out of oneself"
the way "some mystic forgets himself"?

This is my state of mind too
as I automatically generate fictional personae
as shareware while circulating in the networked
space of flows (think of it as experientially tagging
and/or remixologically inhabiting the socially infused data
that always floats throughout the electrosphere)

But how "to go out of oneself . . .
the way a mystic forgets himself"?

Acconci suggests we would need to shift our attention
away from specific media and disciplines
and "turn to 'instrument'"
to focus on *becoming* the instrument
that acts on whatever ground is available

which resonates with an Ornette Coleman quote:

I didn't know you had to learn to play. . . . I thought you had
to play to play, and I still think that.

This one line from the great jazz man
oddly resonates with something Miles Davis
another great jazz man once said i.e.

> Sometimes you have to play a long time to be able to play like
> yourself.

An on-the-fly remixologist in the making
would eat those quotes up with a spoon and
feed a totally "ill" version back into the set:

> I didn't know you had to learn to go out of yourself to go out of
> yourself. I thought you just went out. Sometimes you have to go
> out of yourself for a long time, the way a mystic forgets himself,
> to be able to reach ecstasy.

Playing your unconscious instrument
on whatever ground may present itself to you
requires continuous practice and play

You may even be able to stop the world
without even thinking about it

This relates to digital versions of Remixology
where the artist becomes a postproduction medium

although some questions emerge

for example

Do emerging new media environments
enable artists to enter a space of mind
where they can play out their *aesthetic potential*
in ways that allow them to forget themselves?

i.e. can they intuitively tap into their creative unconscious
as part of an embodied praxis modeled on
playing to play (like themselves)?

Is that really just a digitally networked condition
or is it more of an intermedial aesthetic state of mind
that transcends any specific media/mediums?

What does it mean for an *artist-medium*
to improvise digital performance via customized filtering /
programmed rendering / muscle memory tracing
and playful remixing?

Whereas not everyone will be able to truly
"stop the world for three minutes!"
some of the artists I know can relate
to a universal experience Henri Michaux
once described as his mind running

> at full speed, in all directions, into the memory, into the future,
> into the data of the present, to grasp the unexpected, the
> luminous, stupefying, connections.

To even begin to enter this zone of unconscious
readiness / aesthetic / mediumistic potential
artists recognize that they may have to reinvent
their artistic personae over and over again

But even with the continuous cycling and remixing of
player personae being constructed on-the-fly
as part of some *in fluxus* decharacterization of
said self ("said" who?)
there comes a time for meditation

for grounding out while revitalizing the instrument

Think of it as achieving mindfulness
while tuning one's instrument

Paik's *Zen for Film* (1964) reflects the influence of
his longtime colleague and composer John Cage
whose affiliation with Zen Buddhism is said
to have inspired his most famous work of art *4'33"*
(a sound composition consisting of silence
for that exact duration but that defies silence
by allowing whatever sounds are filling the environment
during the "performance")

Paik's *Zen for Film* consists of clear film leader
and is projected showing only the white light
and accumulated bits of dust and other debris
picked up by the film and caught in the projector's light

The critic Irving Sandler once thought Paik's work
especially his *TV Buddha* was a kind of Buddha Sitcom

As artist Stephen Vitiello notes in his tribute
to the late Paik and quoting Sandler:

> But it's not a one-line joke. What else can it mean? Does it
> demean an established religious icon in the spirit of Fluxus
> iconoclasm? Or, is it spiritual: the Divine looking at the Divine

without interference? Instantaneous holy feedback. God using
electronic media to contemplate Himself. Why not?

Why not, indeed!

Artists use electronic media to contemplate themselves too

And not just to contemplate themselves as *artist-mediums*
but as flux personae navigating the networked space of flows
where the resonance of all that has come before
pulsates like an archive fever waiting to be discovered
so that it too can be sampled from and remixed
into a temporary aesthetic form that struggles to exist
in the flow of readymade impermanence

**holy feedback — / — readymade impermanence — / —
pure relation — / — "buzzing of mind"**

Just as Paik unconsciously revealed the TV Buddha
we might now find ourselves
collectively and collaboratively revealing
the Networked Buddha

i.e. the impermanent and forever-in-flux
new media environment that artist-mediums circulate in
as part of a larger practice that Paik refers to as
"the science of pure relation or relationship itself."

As is the case when viewing all great works of
deep philosophical import and suggestiveness
watching Paik's projected *Zen for Film*
triggers an array of questions:

- Is reality always already a "(re)mixed reality"?

- That is, is it a blur motion fringe-flow sensation of what we consider the natural or organic with what we perceive to be virtual or other, and are these mixed realities continually being postproduced by the artist-mediums who generate them?

- What is the ultimate fate of an evolving and forever impermanent digital remix culture codependent on the proliferation of **Source Material Everywhere**?

- What is the connection between Paik's impermanent self as imaginary fiction and the unconscious *not-me* circulating in the networked space of flows?

- Are artist-mediums, the ones that are reflexively and proactively improvising the movement of their *bodyimages* as flux personae in the networked space of flows, capable of severing themselves from the world of ego?

- And if so, is this what it means to live on the cusp of one's unconscious, readiness potential?

- How long can one live on the cusp before giving way to inevitable spasms?

- *Three minutes?!*

If an embodied digital flux persona performing
his or her daily practice as an artist-medium becomes
a kind of compositional instrument acting
on whatever ground is available

might we not want to also view him or her as an emerging
fictional philosopher who like the electronic figure
identified here as *the remixologist*

is always already in the final stages of postproduction

i.e. is perpetually perishing while "making it new"?

But those final stages are never really final
or at least they don't feel that way
as we push ourselves further into the Infinite—
that unidentifiable space of mind where
the unconscious projections of near-future events
always keep us on the cusp of what it is we are
in the process of creating while experiencing
this *all-over sense* of "being in perpetual postproduction"
even as our remixological methods smudge together
with what we used to think of as simply being *in production*

What exactly is going on when artist-mediums
find themselves operating in perpetual postproduction?

For that matter
how does a work of digital performance
in the networked space of flows
suggest its "going-on-ness"
especially when you take into account
issues of duration / Internet-era attention span /
creative momentum / narrative / (re)mixed reality /
and the specter of interactivity?

Stan Brakhage spoke about
"a magicwork that makes itself"
i.e. a creative force that is filtered through
the unconscious and that can only happen

once one has freed oneself of the weight of
pursuing commercial success and other burdens
that come with a life fettered
with unnecessary attachments

This echoes Ginsberg's mystical rhetoric:

> Never deny the voice—no, never forget it, don't get lost mentally
> wandering in other spirit worlds or American or job worlds or
> advertising worlds or war worlds or earth worlds.

and also implies an unintentional remix of Duchamp
whose creative act is what makes the artist
an intuitive medium or techno-shaman

Only by enabling the magicwork to make itself
can artists finally blaze the path that they intuitively know
they *must initiate* (I'm adding my own associative
word thoughts here now)

Listening to Brakhage speak in Boulder
on community cable channel 8
I heard him frequently refer to the "buzzing of mind"
and "vision of muse" that fills his head like bees
in a beehive as the work gets created on its own terms
without any interference

He was always sensitive enough to make it clear
to those of us who took in his seminar poetry
that not every work will be a magicwork
and any artist who has stuck it out over decades of
trial and error art-research practice
knows this to be the case

Sometimes it just comes out that way
and sometimes not

And when the creative momentum one experiences
while making a specific work is lost—

you are never really sure if you will get it back—
ever—

you are free again to position yourself
as the artist-medium tapping into
your unconscious readiness potential

Is this a reasonable way to attempt to survive
within an all-consuming technocapitalist context?

These are the risks you take when developing
new material in a variety of media/mediums
especially when it's *time-based* new media
you are porting your poetic vibes through
while seeking recognizable outcomes

Recognizable outcomes?

Vision of muse is sometimes simply
condensed into vision of museum exhibition

and when the exhibition has finally ended
and all of the power cords have been unplugged
and once again there is really nothing to show for it

or at least nothing that can be physically grasped and carried
off into the sunset with a horse and buggy
transporting the wares to a distant and huge studio where
these artifacts take up space like so many

disenfranchised family members who have somehow
found their way back to the bodies that gave birth to them

we come to accept the fact that
these image sources have vanished

They are gone

The Disappeared

Out of sight *and* out of mind
yet still somehow vaguely recollected

There is something about dreamtime-based media art
that resonates with the deep interior projections of
an instrument unconsciously playing to play
that feeds into my ongoing aesthetic potential
regardless of the "loose ghost" notes that may have
played within the museum or gallery walls

More important things always come to the fore

What is it about surviving artist-mediums
that enables them to sync their practice
with the secret pulse of time?

The instrument needs constant tuning . . .

The beehive mind needs to buzz . . .

Some mystics need to forget themselves . . .

The unconscious experience of

the intuitive body

becoming new media . . .

"Video is part of my body; it's intuitive and unconscious."

Recognizable outcomes?

How about creating an active unconscious momentum
where proprioceptive artist-mediums
"know" where they are going
without ever having been there before?

(have we already said that or was it
an unconscious self-reference in the guise of
another sound-bite sample remixed
in a different "time-image" context?

I'm all for forever new refutations of time)

Or imagine artist-mediums playing out
their aesthetic potential via innate body intuitions
flushed with the illogic of sense (data)
operating on autopilot

The history of new media is the history of the world

If we time-travel back to Germany in 1805
we find a short yet very important essay
written by Heinrich von Kleist
collected in his now out-of-print *An Abyss Deep Enough*
titled "On the Gradual Fabrication of
Thoughts while Speaking"
where the author intuits the unconscious neural mechanism
that triggers all creative thought:

> For it is not we who know; it is rather a certain condition, in which we happen to be, that "knows."

How deep is deep enough?

innate body intuition — / — unconscious neural mechanism — / — art-making machine — / — cybernated life

The idea of constructing personae that distribute
themselves in the networked space of flows
relates to the work of interdisciplinary artist Eleanor Antin
who once said that when she started making visual art
she began constructing new personae to step into and out of
as a way to develop new work

These personae helped her produce what
in another context
she called "an art-making machine"

> I had a marvelous art-making machine—my personas. I never knew where it would go.

which resonates with the Vito Acconci sample
I will remix into the composition again:

> If I specialize in a medium, then I would be fixing a ground for myself, a ground I would have to be digging myself out of,

constantly, as one medium was substituted for another—so, then, instead of turning toward "ground" I would shift my attention and turn to "instrument," I would focus on myself as the instrument that acted on whatever ground was, from time to time, available.

One cannot be taught how to become
Acconci's "instrument"
Antin's "art-making machine"
Paik's "mystic who forgets himself"
nor my own "digital flux persona"

That fiction has to be generated by the human being
en route to becoming an *artist-medium*
one who trains to tap into
unconscious creative potential

i.e. one who is deftly aware of the fact
that these constructed personae need not be
construed as alien alter egos set in opposition
to the prefabricated realities of a "normal" consuming self
but in a more positive sense use these constructed personae
to advance the networked distribution of Creativity itself

a Creativity codependent on
a network of causes and conditions
that inform the experiential quality of the struggle
that persists throughout an artist-medium's life
as he continually fine-tunes his body (her *bodyimage*)
as instrument

Each artist has to figure out his own
unique creative path for herself

There is no sure-fire way of constructing
the "right" set of digital personae so that
you can build your own one-person

"art-making machine"

The ways are endless and yet the destiny
seems to be the same (call it the transmigration of
embodied destinarrativity)

This creates an unusual opportunity for
new media artists to develop alternative paths
in the construction of their flux personae
and to focus on the "cybernated life"

Paik's musings on the cybernated life
set the stage for a new philosophy of new media:

> Cybernated art is very important, but art for cybernated life is
> more important, and the latter need not be cybernated.

For the contemporary remixologist
this means that making new media art
is an important aspect to one's overall practice

but even more important is
the advancement of Creativity itself
via the interventionist acts of an (h)activist avant-presence
that continually initiate the always becoming of
the artist *as* postproduction medium
within networked digital culture

By consciously aligning oneself
with this postproduction imperative
as an artist-medium / (h)activist avant-presence
one inevitably finds oneself codependent
on the cultural milieu of "being digitally networked"

Which brings up an interesting question:

Is the move toward an Applied Remixology
as part of a larger networked performance
an indication of the rise of digital socialism?

But then what about the totally disconnected
disenfranchised and behaviorally dysfunctional
computer-illiterate artist-brute who converts
personal suffering into works of divination?

Paik also once remarked:

> The culture that's going to survive in the future is the culture that
> you can carry around in your head.

The Renewable Tradition

(Extended Play Remix)

Obviously there's no progress in art. Progress toward what? The
avant-garde is a convenient propaganda device, but when it
wins the war everything is avant-garde, which leaves us just
about where we were before. The only thing that's sure is that
we move, and as we move we leave things behind—the way we
felt yesterday, the way we talked about it. Form is your footprints
in the sand when you look back.

The quote above comes from "Death of the Novel"
a fictional short story by Ronald Sukenick
to introduce his artist essay "The New Tradition in Fiction"
which is collected in the groundbreaking
anthology of artist poetics titled *Surfiction*

The New Tradition (Sukenick used to tell me)
is the one we're always on the cusp of inventing
by strategically moving beyond *literature per se*

that is to say the New Tradition
is an expansion of "the rival tradition in literature"

For those who may not have encountered
this kind of literary thinking before
this is what the rivals of traditional literature do:
they take on traditional literature so as to destroy it
and in the process remixologically inhabit
its historical body while pushing tender buttons
all along the way

They do this so that they can then revitalize
literature's power as a renewable form of energy in nature
methodically breaking down its material components
into a potentially rich heap of source material
that they can then re-embody in whatever
formal experiment feels natural to them
at any given time in history

Think of it as *compostproduction*
where the leftovers of literature past
get reconfigured into innovative forms of art
meant to breathe life into an always on-the-verge

(of dying)

creative life force struggling for survival

(perpetually perishing while making it new)

Until recently the Narrative Form
Most Likely to Succeed
in the Creative Destruction of Literature
was unquestionably the Novel

In fact
it's been this way for centuries

but are things about to radically change and
what are the indications that these changes
are already well under way?

Sometimes we literary-minded remixologists
find ourselves innovating the mediumistic qualities of
the form we are working in without even necessarily
thinking about it (this happened to me when I was writing

my first novel—*The Kafka Chronicles*—I was completely
unaware of a so-called New Tradition and was just writing
the only way I knew how at that given moment in history
which was to sync my unconscious creative potential
with the narrative tracing of a trance ritual
transfigured in time

What manifested itself out of this trance ritual
was something that resembled a novel
but was itself a kind of antinovel
i.e. a work of art contained in book form
that used narrative and poetry and experimental typography
not to mention visible language and sound art
to creatively destruct the novel form it was inhabiting)

Other times we who create innovative works of remix art
are fully self-conscious of the rival lineage
we spring forth from
and knowingly take on other remixological styles just to see
what happens when we move inside
other writers' bodies (of work)

This is when remixologically inhabiting
the spirit of another writer's stylistic tendencies
or at least the subconsciously imagined writerly gestures
that illuminate his or her live spontaneous performance
feels more like an embodied praxis

In some ways this all seems *so* obvious to me:
I mean what is a writer anyway but
a simultaneous and continuous fusion of
remixologically inhabited bodies of work?

For the contemporary writer as interdisciplinary media artist
the lyrical conceptual poetic narrative movements

come in wildly assorted forms
everything from dance to cinema to performance art
to the scribbling of pen or pencil on paper

But for now let's stick with literature

For instance I remember a passage from Sukenick's
Down and In: Life in the Underground
where he self-consciously (and remixologically) inhabits
the style of Norman Mailer circa *Armies of the Night:*

> It dawned on Sukenick only much later when he read Mailer's book *Armies of the Night,* about the 1967 Justice Department and Pentagon demonstrations, that Mailer, by his own third-person account of himself, is no mere mimic but is a multiphrenic with a handy miscellany of personalities. Mimicry by itself was an impulse that Sukenick could well understand and sometimes justifiably indulge, as here that of the book in question, since such imitation, properly executed, brings along with it an intuitive comprehension of the ideas, attitudes, and modes of feeling that produced the style of expression at hand.

We can also see this kind of well-executed stylistic mimicry
being expressed in Amerika's second novel *Sexual Blood*
which was nothing if not a remixological inhabitation of
the style Count Lautréamont (aka Isidore Ducasse)
initiated with his acerbic *Songs of Maldoror*
where Amerika knowingly and even greedily
pla(y)giarizes Lautréamont's own pla(y)giaristic style
as more readily accessible source material

Why did he find it necessary to pla(y)giarize
Lautréamont's style *as* source material?

You'll have to ask Amerika that question

I (on the other hand) am now recalling
how my late colleague Kathy Acker
once told me that she took on *the body language* of
Hawthorne Faulkner Rimbaud and Verlaine
to name just a few
as a way to embody their spiritual unconscious
thus becoming the literary version of
this remixological figure I am proposing
i.e. the *artist-as-postproduction-medium*

Acker would embody these spirit precursors
as part of her intense investigation into
writing as an extreme force of (h)activism

In an essay she titles "Critical Languages"
where she is transcribing her presentation
on "the nature of art in a degenerating polis
inimical to all but its own centralized power"

Acker addresses her speech to a group of writers
whose work centers on contemporary art criticism

She meets them head on by saying:

> I want to talk about the body and languages of the body. Which
> art criticism has denied. And about what art criticism could
> come out of the languages of the body.

At which point she starts riffing on a list of
possible body languages that she would prescribe:

1. The languages of flux. Of uncertainty in which the "I" (eye) constantly changes. For the self is "an indefinite series of identities and transformations."

She also lists the languages of wonder materiality and play—but

8. Above all: the languages of intensity. Since the body's, our, end isn't transcendence but excrement, the life of the body exists as pure intensity. The sexual and emotive languages.

9. The only religions are scatology and intensity.

. 10. Language that forgets itself. For if we knew that chance governs us and this world, that would be absolute knowledge.

Which makes me wonder aloud
what is the new media language equivalent
that Whitehead refers to as *an intense aesthetic fact*?

In the heat of developing an Applied Remixology
these intensities are intersubjective—
part of a spontaneous jam session
with the **Source Material Everywhere**
indicating the rise of digital socialism
as collectively generated autofiction
or creatively dispersed bio-formalism

Acker's "Language that forgets itself"
resonates with Paik's form of ecstasy
where "a mystic forgets himself"

while unconsciously triggering
body languages out of principled uncertainty

Experiencing these transformations outside of time
is the only way to achieve absolute knowledge
as an intensely rendered aesthetic fact

In this regard I can use my own inhabitations
as an example of transforming remix practice
into unconscious/experiential knowledge
fueling Creativity's novel advance in nature

Much of what I write when composing my fictions
including the "Distributed Fictions"
planted inside *META/DATA*
inhabits the early developments of Laurence Sterne
(and in particular his work *Tristram Shandy*)
as well as the aforementioned Lautréamont
(all of what little he wrote)

For those who follow such things
this will make perfect sense
since one of these writers
is the Godfather of digressionary
(hypertextual) fiction (Sterne)
and the other is the Prince of Pla(y)giarism (Lautréamont)

Sukenick himself would be quick to point out
Henry Miller as the Godfather of
a pseudoautobiographical fictional style
that leads the disappearing writer into
acts of creative composition that sample from
the data of unconsciously generated experience
accumulated in the practice of everyday life
and that by manipulating these sampled bits of data

into pseudoautobiographical fiction
one is capable of producing new forms of knowledge
that (and this is me talking now)
the reader then attempts to mirror
by tracing the movement of the body language
embedded in the textual apparatus
we are perpetually postproducing *when reading*

For example reading Henry Miller novels
while moving through the streets of New York City
as a foot messenger in the 1980s
was a way for me to learn
how to embody my own pseudoautobiography
as source material for future fictional remixes
(Miller used his own real-world experiences
as a foot messenger and dispatcher to trigger
his pseudoautobiographical rendering of
the Cosmodemonic Telegraph Company
in *Tropic of Capricorn*)

In an e-mail dialogue I had with Sukenick
a few years before he passed away
he said that "Miller was the one who woke me up
to the fact that words on the page can be
a vital extension of the life of the writer
and therefore of the life of the reader."

The pseudoautobiographical experience of
remixologically inhabiting the body language
as well as the spiritual unconscious of those
whom we eagerly interact with via their work
is part of a larger attempt to correspond
with the rich resources of our precursors
in acts of performative postproduction
(of perpetually perishing while making it new)

To develop a mutually beneficial coresponsibility
with those in the rival tradition who came before us
is to simultaneously pay homage to while expanding out of
the discoveries they had already made themselves
via remixologically inhabiting not only their bodies (of work)
but the bodies of work generated by sources
with whom they too parasitically fed off of while writing

If Borges is correct in suggesting that we all
quite literally create our own precursors
by embodying their source material without
either their or our knowledge *while creating*
then these remixes included here could be considered
part of a larger biological imperative
providing sustenance for the future viability of the species
whose intellectual life depends on literary presence

(so much depends
on literary presence)

A primary issue Sukenick and I always traded notes on was
"How can the vitality of writing as an art form
survive in electronic/networked environments?"

or when things got really dark

"Is human culture preformatted
to kill literature as such and
what then will it mean to be
what we now still call a literary artist?"

We were not overly concerned about
saving literature for literature's sake

The important thing is to annihilate
the important thing (wrote Sukenick)
and we knew via our experiences
as writers practicing how to become postproduction mediums
that just *saving our own asses* by expanding
the concept of writing so that it too could infiltrate
and have influence on the emerging digital culture
was and still is our only way O U T

That is to say as interdisciplinary media artists
who formally experimented with language
we were going to write the only way we knew how
i.e. through a constant oscillation
between improvisation and revision
digression and pla(y)giarism
(hyperimprovisational Remixology)
and if literature wanted to come along for the ride
then (conjuring the spirit of Mailer circa *Armies of the Night*)
the Novelists would not stop it from doing so

The bottom line for type A metamediums
addicted to the rush of becoming
just-in-time skywriters operating on autopilot
while navigating the restless skies
was that as long as we were left to our incandescence /
our satori / our hallucinatory language adventures

then literature was always welcome to join us at its own risk

As much as we would be happy to kill it on our own terms
(after all this was not a job for Corporate America
and its Blockbuster Cable News / Hollywood Sensationalism /
Fakebook Culture—
No, killing literature was a job for the Novelists!)

we must accept the fact that it (Literature)
has earned our respect just for having survived this long
and like your rich old man with shiny new tooth implants
champing at the bit of careening postcareerism

if it is hungry for more historical relevance
then so be it

We will even acknowledge its tough-guy stubbornness
till the day it dies (just ask Mailer, R.I.P.)

Still there are many ways of outsurviving literature per se
while expanding the power of writing to hack
into the abyss and transform the world

and this will always be the mission of
the zealous participants in the rival tradition

Taking on the stylistic writing gestures of
other artists and then remixologically inhabiting them
in some ancient form of realtime manipulation
requires practice (and here I cannot help but think of
some musicians and athletes who always seem
to find that necessary physical and psychical balance
while engaged in their well-choreographed
scenes of experiential play)

Moving in and out of these "ghost tendencies" that
mark the outlines of a body language once performed
by another artist of the past also necessitates
a certain amount of lived experience—

experience at remixologically inhabiting
the spiritual unconscious of another body language

whose code has been transmitted to our own
neural network for postproduction processing

Is this not how we become postproduction mediums?

The bottom line is that

to remix Miles Davis again

sometimes it takes a long time
to become a postproduction medium

I think of it as an enduring embodied praxis

i.e. where the gesture of writing embedded in muscle memory
enables the postproduction artist to intuitively
mirror the neuron activity of the ones who came before
something that feels like a deep interiorization of
someone else's creative rhythm mediumistically
syncing with whatever filters one turns on
at any given time during the remix performance

What I learned from Sukenick and Acker
for example
came both from being with them in person
as well as reading them from a distance

Reading their body language and moving
through their books with them
kept me on my game as did engaging with them in person
or via e-mail dialogue so that we fed off each other
kicking up more spurs of intersubjective codework
to illuminate our collaborative sets with

"You're on fire," Acker told me in the first e-mail
I ever received from her (she was right—and knew it)

We may have been individuals in pursuit of
our own form of writerly nirvana
but collectively we were also always in pursuit of
"that final 'race to the wire of time'"

For now
I'm still in the race
but these artists were the ones who taught me
how to haunt the texts that came before me
even as these same texts haunted me back

Think of it as literary hauntology
i.e. the conjuring of loose ghost-note tendencies
but with a twist: by mediumistically transcoding
the resonant styles inherited from
the Rival Tradition in Literature

contemporary remixologists simultaneously
carry on the next phase of a more digitally inclined
Renewable Tradition

(a next phase that opens itself up to
the hacking priorities of other remixologists
who are positioning themselves
to carry on this same tradition)

By replacing the New Tradition in writing
with a formidable renewable tradition in
electronic Remixology or what Ulmer calls *electracy*
(the meeting of electricity and literacy)
we open up future channels of distribution
that are fueled by renewable energy sources

that come directly from the artist-mediums themselves
and can begin imagining how the future forms of
fiction(al) performance might emerge as hybrid vehicles
to transport our digital personae in

(and in this regard let's not forget that "Prius"
means *before* or *first* and so plays right in to
our avant-garde reckoning with innovation
as it applies to all things clever and entrepreneurial
but that also emerge out of necessity
as part of a pragmatic survival strategy
in the degrading environment that is gasping
for whatever remaining oxygen that may be out there)

How would contemporary remixologists
divining their own just-in-time context
for the compositional playing field of the moment
jump-start a renewable tradition made out of all of
the renewable energy sources (i.e. artist-mediums)
signaling from the past/present/future?

Renewable energy sources *back to the future*?

It's cosmic

Cosmic inflation snapping back to haunt us
in a way that gets our creative attention

Professor VJ (me-myself-an-Eye)
"an indefinite series of identities and transformations"
feels compelled to ask
in a momentary fit of multiphrenic distortion:

How can artist-researchers developing
new practice-based initiatives in Remixology

turn the immediate future into a renewable source of energy
that fuels their unconscious readiness potential?

Success in this area of practice-based research could lead
to the artist becoming a valuable postproduction medium
running

> at full speed, in all directions, into the memory, into the future,
> into the data of the present, to grasp the unexpected, the
> luminous, stupefying, connections.

This idea of an (h)activist avant-presence
codependent on the advancement of Creativity itself
relates back to Whitehead's idea of
an actual entity who spontaneously moves
toward Higher Phases of Experience:

> The "effects" of an actual entity are its interventions in
> concrescent processes other than its own.

An Artist-Medium embracing the Avant-Presence
(the Creatura)
remixes nervous life forces out of thin air
(the Plemora)

(each successive remix moment passing into the next

a synaptic summation of recombinatory impulses
postproducing the [never really] present

unconscious computations of poetic magnitude
charging language to the ultimate degree)

To me it feels as if I am a reality hacker
remixing levels of (un)conscious opacities/capacities
creating customized artist-apparatus filters
so that I can better manipulate the data
that passes through me as I process
my immediate life experience
which it ends up
is always (already) foreign
though still bound by the laws of attraction

or what we might call the laws of *strange attraction*

where the always live artist-medium-instrument-persona
navigates through the affective nature of
hyperconscious dreamtime situations
to filter specific patterned contrasts
from the flow of assemblages that are always
in the process of *becoming* my media environment

As a practice-based remixologist filtering
the meta-perturbations of **Source Material Everywhere**
the artist as postproduction medium choreographs
an ongoing structural improvisation projected from
the deep interior sense mechanisms of other artist-agents
copoietically postproducing a novel togetherness
that reconfigures the world into yet more renewable energy
that doubles as source material seducing us into our next
remixological becoming

This is where the aim of philosophy is revealed as
the charging nature of Creativity itself

Creativity as the ultimate source material
to unconsciously embody while transmitting
newly reconfigured aesthetic assemblages
for others to experience and selectively sample from
as part of their natural inclination

**nervous life — / — reality hacker — / — postproduction
player — / — visionary accomplice**

The laws of (strange) attraction

their relation to natural selection

and

the mutation of various sampled bits
that are cut/selected from the open field of action
(Source Material Everywhere)

relate to the evolving forms of electronic literature as well

as in

"Is the contemporary writer also a postproduction medium?"

> Everything is
> thrown into my
> writing.
> (Kathy Acker)

Capturing what Italo Calvino refers to as
"the data of experience and the phantoms of the imagination"
as part of your seminal style
so that you can then perform your "always live"
digital Remixology in asynchronous realtime
requires that the writer as networker
play to play

> Use your
> imagination or else
> someone else will
> use it for you.
> (Ronald Sukenick)

No matter what new media framework
may be hot at any given moment
in the history of contemporary art and literature
there is always this sense of succumbing
to the imagination even as the work itself
becomes seduced by the **Source Material Everywhere**

but also the available technologies of the moment

i.e. the moment our unconscious projections—
our intuitively generated creative impulses—
continually arrive in

You might say that for the literary artist today
"imagination imagining itself imagine" (to quote William Gass)
requires an applied aesthetics full of
visionary tactics as well as (let's call it) *antagonistic frottage*
with the technological moment

There's some kind of ambivalent force
that I find myself trying to paint here

From one perspective I can imagine
what it's like to work *with* new media technologies—

to trace a trajectory of unconscious projections
with whatever new media technology
is available while I'm creating—

but then from another perspective I can imagine
what it's like *to work against* these new media technologies
or—as Vilém Flusser has written in relation to the camera—

to "outwit the camera's rigidity"
to "smuggle human intentions into its program"
to "force the camera to create the unpredictable,
the improbable, the informative," and
to "show contempt for the camera"
by turning away from it as a thing and focusing instead
on information

For Flusser (and this comes from his
Towards a Philosophy of Photography)

> The task of the philosophy of photography is to question
> photographers about freedom, to probe their practice in pursuit
> of freedom.

and this in part means developing
"the strategy of playing against the camera."

Let me remix that and simply insert
the term "electronic literature"
so that we're on the same page (as it were):

The task of the philosophy of electronic literature is to question electronic literary artists about freedom, to probe their practice in pursuit of freedom.

Flusser suggests that this freedom be pursued via "the strategy of playing against the camera" which when remixed for my own ongoing riff would signal a need to develop a focused "strategy of playing against the media apparatus that potentially compromises one's relationship with an emergent electronic literature"

Is this strategy of *playing against* the apparatus while simultaneously playing *with* the apparatus indicative of self-contradictory behavior or is it part of a larger visionary agenda that buys into this avant-gardist notion of being ahead of one's time?

In the old days we used to call this style of literature that plays against the media apparatus while playing *with* the media apparatus *Avant-Pop*

a term generated from a Lester Bowie jazz album signaling the artist's willingness to play *with* but subvert from *within*

Is this still possible in the electronic literary scene especially given its rapid move toward academic institutionalization?

Or does the move toward electronic literature's academic institutionalization potentially *enable* a below-the-radar

(h)activist gesture that unassumingly aligns itself
with a desire to subvert from within?

Within what?

Within the institution?

Within the disciplines?

Within ourselves?

Resampling Ornette Coleman:

> I didn't know you had to learn to play. . . . I thought you had to
> play to play, and I still think that.

Perhaps playing to play
while staying ahead of one's time
requires a recalibration of one's inner time
catching the flow of their unconscious poetic rhythm
so that their intersubjective jam sessions
with the fluid personae *within and without*
take place in *asynchronous realtime*
what at times feels like a timeless time
a simultaneous and continuous fusion of horizons
that embeds itself in an ongoing formal investigation of
complex *event processing* where the visionary artist
always gyrating at pivotal locations throughout the narrative
becomes a multitude of flux identities and transformations
nomadically circulating within the networked space of flows

Operating in the tense field
I'm calling *asynchronous realtime*

situates the poetic apparatus in parallel
to Michaux's mescaline-induced psychic energy moving

> at full speed, in all directions, into the memory, into the future,
> into the data of the present, to grasp the unexpected, the
> luminous, stupefying, connections.

If *that* doesn't express what it feels like to become
a visionary on the cusp of an always morphing inner time
then I'm not sure what does

(Perhaps it also speaks volumes about
the megapotential of mescaline
as a *trigger inference* in the postproduction of
metamediumystically distributed experiential knowledge)

It could feel like a lifetime that you hope never ends
but upon awakening reveals itself as barely three minutes!

That's OK, *we'll take it*

This full-speed-ahead poetic apparatus
embodied in the personae of whosoever
find themselves ahead of their time
is a fantastic role-playing opportunity
for anyone who has the *will-to-aestheticize*
in the first place

What role you choose to play and how you choose
to name your transforming identity is always open to revision

We have all seen the roles come and go
while speaking of Nintendo

Call me Hypertext
Call me Net Art
Call me Codework
Call me Game Studies
Call me Digitally Expanded or Interactive or Live Cinema
Call me Video Blogging
Call me Locative Art
Call me Postproduction or Participatory or
Digital Performance Art

If you ever find yourself
triggering an unconscious readiness potential
that puts you on the edge of your compositional force field
while you write out your metamediumystic agenda
playing to play while acting out your *will to aestheticize*
whether as an electronic writer / a net artist
a digital performance artist / an experimental scholar
a new media theorist or ALL or NONE of the above
because you are TRANSdisciplinary
(thank you very much)

then you just may be simultaneously applying
for the role of visionary accomplice

(accomplice to *what* I'll leave to your imagination)

Which brings up another question:

Who is this persona that projects the visionary?

In his collection *The Uses of Literature*
Italo Calvino imagines this fluid persona
as a writer (of all things)

insofar as he enters into a role the way an actor does and identifies himself with that projection of himself at the moment of writing.

Perhaps this is what it means to *be* visionary
that is
to enter the role of the visionary the way an actress does
and to *project* the visionary at the moment of writing

Is this still possible?

Thanks to the wonders of Creativity
you'll be happy to know
our moment is *still* now

It's as if being ahead of your time
while applying all visionary filters to
your artistic literary/theoretical outputs
is part of a larger interrelational and distributed aesthetic
perpetually postproduced by the artificial intelligentsia
whose creative class struggle informs
our playing field's continual emergence

Are *We* ahead of our time?

Are *We* really the drivers of
a renewed visionary literature?

We are electronic performers
We are electronics

For as long as I can remember
many of us who have integrated emerging
new media technologies into our art practice

our writing practice

our performance practice

our theory practice

our *interdisciplinary* lifestyle practice

have signaled a belief that being ahead of our time
is more than just merely being experimental

It is also tied to a desire to *become innovative*

that is *to embody innovation itself*

to make it new
or
make news that *stays* news

that is *to stay aesthetically fit*

Is that a stylistic tendency
that we have somehow inherited?

Is that inheritance somehow
akin to kin relationships?

Am I my sister's source material?

Maybe the art of collaborative literary remixing is at root
all about stylistic inheritance and the variable speedism of

a global brain mutation that happens once
every ten generations and *we*
the Innovators
have to do everything in our power
to save literature from extinction

Of course the bug of being innovative
whether it's an inherited trait or mutant meme
that still manages to survive in the world
due to unleashed competition in the culture
thus requiring a certain kind of aesthetic fitness
on behalf of those of us who *play to play*

is not just a matter of
bringing in the new
but of *re*newing what has already been

as if the history of art and literature were
an unlimited renewable energy source
primed for aesthetic reconfiguration
so that we can power our collective desire
to turn the engine on and go the distance
(a durational achievement for the educated masses)

That's what the avant-garde antitradition tradition *is*

It's a renewable tradition

and in literature it's been referred to as
the Rival Tradition in Literature

Let me remix another gem from Calvino
since he too (like Flusser)
is great source material for my musings

In *The Uses of Literature* Calvino writes:

> The preliminary condition of any work of literature is that the
> person who is writing it has to invent that first character, who is
> the author of the work.

And now my remix:

> The preliminary condition for any work of electronic literature
> is that the community of writers has to first invent that literature.

A little twist—yes?
Or we might also say: the community of writers
has to first **envision** that literature
(even as its most avid practitioners may
self-consciously *play against* it *as* literature)

Is our ability to envision the visionary *still* evolving?

What does it take to *be* visionary?
It reminds me of something
George Carlin once mused

Carlin said:
"I'm a visionary. I'm ahead of my time.
The problem is that I'm only
an hour and half ahead of my time."

Now if *that* doesn't encapsulate
what it means to be part of

a digital avant-garde
I don't know what does

Interestingly enough Jean Cocteau
(who in some ways *embodies* the avant-garde)
also weighs in on this being ahead of one's time

> When a work appears to be ahead of its time, it is only the time
> that is behind the work.

Now *that's* something I can relate to

Given what's at stake for literature
in these times of technocapitalist intrusion
into all aspects of our lives
while we—the Innovators—
self-consciously charge language
to the utmost possible degree

can we say that electronic literature is ahead of its time
or is it too behind the work—the work
that readies itself for visionary manifestation?

Sometimes I think the *idea* of electronic literature
is FAR behind where I'm going with my work
but then on reflection realize that that's mostly because
I oftentimes refuse to contextualize
what I'm doing *as* electronic literature

But then I look at *what is* being contextualized
as electronic literature and rethink the possibilities

All of this digital poetic *talk story* makes me wonder:

Is it still possible to maintain an avant-garde difference
or oppositional stance within traditional commercial culture
via the practice of postproduction art and literature—
to actually enjoy doing it—to even make a livelihood
out of it—or is it already a lost cause?

Unfortunately there's no longer any time left
to answer this question directly

I have already become another
Professor VJ Postproduction
(an embodied digital image
improvising his next [pivotal] move)

[INSERT IMAGE]

New loop sample:

Remixology is a (de)constructive way of intervening or hacking
into the transmission of traditional media discourse and
empowers artists to renew all discourse

To elaborate:

Performing in a shared headspace of
hyperimprovisational cocreation or coproduction
one that feels like it takes place
in asynchronous realtime

opens up the creative process to external influence
but an external influence that is being parallel processed

internally by all of the other players intersubjectively
jamming in the copoietic mix

Think of it as simultaneous and continuous
experiential tagging

Or how about call-and-response parallel processing?

The dancing pulsations of literary bodies
socializing the network while mirroring neurons?

Sometimes I feel like an inside-out upside-down man
but then again I may just be taking on the characteristics of
one of my personae (Professor VJ as just one example)

parallel processing — / — axiomatic truths — / — Phun City — / — fusion of horizons

In the essay "In My Own Recognizance"
Sukenick writes:

> Collage and cutup are ways of interrupting the continuity of the
> controlling discourse—mosaic is a way of renewing discourse.

Was he being axiomatic?

Remixologists absolutely love remixing axiomatic "truth"

We look at it as an alchemy of emotions extracted
from the "truth serum of the moment"
(what did I just say?)

If I were to remix the above
on-the-fly I would write:

> Remixology is a way of intervening or hacking into the
> transmission of traditional media discourse and empowers artists
> to renew all discourse.

Sukenick's reference to the cut-up method above
reminds me of something William Burroughs said
in an interview found in the book *The Job:*

> You can cut the mutter line of the mass media and put altered
> mutter line out in the streets with a tape recorder. . . . For
> example, prepare cut-ups of the ugliest reactionary statements
> you can find and surround them with the ugliest pictures. Now
> give it the drool, slobber, animal-noise treatment and put it out
> on the mutter line with recorders. *(This comes from Richard C.*
> *French, "Electronic Arts of Noncommunication," New Scientist,*
> *June 4, 1970, page 470, and gives the clue for more precise technical*
> *instructions.)*

Spurred on by the electronic arts article mentioned above
Burroughs uses his own voice as source material
for an on-the-fly remixological method
that will crack language wide open
so that it can spill its demon leakage
into the sewage of media discourse
thus contaminating the media discourse of
the Control Freaks who always push him
back into the junky box

Role-playing the artist-writer-medium
who moves with Bruce Lee–styled forward momentum
so that he can *storm the reality studio*
Burroughs's version of Remixology is meant
to hack the propaganda machine that churns out
deterministic language patterns
produces complacency
and encourages slavish behavior toward
the Master Authoritarians feeding us their oligarchic *dreck*
from the "end of that long newspaper spoon"
(now modified into everything from Faux News Channel
to FacileBook to MySurveillance)

Burroughs demonstrates to us how he plays
the pre-Internet remixologist circa 1960:

> I took a short passage of my recorded voice and cut it into
> intervals of one twenty-fourth of a second on movie tape—
> (movie tape is larger and easier to splice)—and rearranged
> the order of the 24th second intervals of recorded speech. The
> original words are quite unintelligible but new words emerge.
> The voice is still there and you can immediately recognize the
> speaker. Also the tone of voice remains. If the tone is friendly,
> hostile, sexual, poetic, sarcastic, lifeless, despairing, this will be
> apparent in the altered sequence.

Revealing an American Pragmatism at its best
Burroughs delivers an embodied praxis
where the vocal intonations of
the artist are used as source material to discover
new aesthetic facts (don't forget it was Burroughs
who once riffed that a paranoid is someone
who has all the facts at their disposal)

Burroughs eventually calls this kind of
experimental audio cut-up *scrambling*

The DJ scratches the VJ scrubs
the net artist / computer programmer hacks
and the literary provocateur Burroughs—
back in the 1960s—*scrambles*

Professor VJ: "I'll take mine scrambled"

The Remixologist's mantra?

Source Material Everywhere

Burroughs: "Pick a card, any card."

Burroughs then charts out an imaginary large festival of
scramblers working with AV devices who would first of all
hack into entertainment products since
"in fact entertainment is the most promising field
for cut-up techniques. Imagine a pop festival like
Phun City"

and before you know it
he's drawing up a blueprint for a live AV hackfest
so as to "lay down a grid of sound over the whole festival."

The jam session would not be with a list of performers
on stage playing before the crowd

In Burroughs's festival the hacker audience
would produce the event itself and
it would take place ad hoc
in this massive field of play (literally "car park,

a camping area, a rock auditorium, a village with booths
and cinema, a large wooded area")

Everyone would be equipped with tape players /
video recorders / prepared and unprepared
source material / projection screens etc.

Fast-forward to 2011 and Burroughs's Phun City Project
is already happening in VirtualRealityLand
via cut and paste / mashup culture
yet under the guise of freeform Remixology
where an efflorescence of postproduction artworks that
are now being released over the networks
by the digital personae who create them
blends with the fusion of horizons
a networked art scene depends on
for its ongoing cultural sustenance

("for such a fusion of horizons to occur"
writes the late intermedia artist Dick Higgins
"the reader or listener must have some consciousness of
sher [sic] own horizons in order to have
something to blend *with*")

And that brings us back to scratch one—
"How does a contemporary remixologist
create a *sense of measure* that stylistically
blends with the fusion of horizons being projected
by all of the players in the copoietic mix?"

Does it have something to do with tapping into
one's unconscious remixological potential?

Is this emerging sense of measure
to be found in the prophetic qualities of

the performance? Or is prophecy itself mediumistic—
and if that's the case—what's more mediumistic—
the artist that remixes or the medium that performs
a remixological function? One and the same?

(Self-doubt/self-debt—but don't think about it—
just play it as it lies as long as it *feels write*)

How do we measure the differing values of
ongoing metamediumystic postproduction
as qualitatively high performance art
even while intentionally employing low-tech
devices that are meant to create DIY transparency?

That is to say
(borrowing lingo from the jazz scene)—
how do you account for one's remixological chops?

One way to measure remix chops
might be via generational influence
i.e. intensity of influence across generations

If there were an Academy Award for
Best Remix Persona in a Divination Role
one would have to consider Burroughs
for the Lifetime Achievement Award

His entire *scramble-the-code* methodology
was grounded in derailing the predetermined self:

> Consider the IS of identity. When I say to be me, to be you, to be
> myself, to be others—whatever I may be called upon to be or
> say that I am—I am not the verbal label "myself." The word BE in
> English contains, as a virus contains, its precoded message of

damage, the categorical imperative of permanent condition. To be a body, to be nothing else, to stay a body. To be an animal, to be nothing else, to stay an animal. If you see the relation of the I to the body, as the relation of a pilot to his ship, you see the full crippling force of the reactive mind command to be a body. Telling the pilot to be the plane, then who will pilot the plane?

(This excerpt comes from a section titled "Academy")

I improvise my own remix of the above into

When I say the IS of identity you see the full crippling force of the reactive mind command to be a body virus, to be me, to be you, to be myself, to be others, to be an animal, to be nothing else, to stay an animal, to stay a body virus. See the relation of the I to the body as the relation to a precoded message of damage: the categorical imperative of a permanent condition.

Acker sees this kind of writing as "William Burroughs's Realism":

Pretend that there is a distinct entity named self and a different entity named other or world. Define insanity as the situation when there occurs a nonnegotiable disparity between the self's version of the world and the world. According to this definition, American culture is now insane.

Is William Burroughs the patron saint of the so-called reality-based community?

Still one must ask what happens
when the language of identity
is cross-dressed with contemporary remix
and mashup culture?

Can an (always) emergent postproduction imperative
fueled by the rise of a digital socialism
enable artists-mediums (postproduction artists)
to intensify their body languages?

How could a more formally experimental
remix practice inform a politically charged
culture of intersubjective jamming?

Could remixologically inclined intersubjective jamming
signal the impending rise of the *real* sexual revolution?

In an interview titled "The Creative Urge"
Elizabeth Grosz is quoted as saying:

> That's right, there's something about art that is an abundance
> of excess. Art is the revelry in the excess of nature, but also a
> revelry in the excess of the energy in our bodies. So we're not
> the first artists and we're perhaps not even the greatest artists,
> we humans; we take our cue from the animal world. So what is
> it that appeals to us? It's the striking beauty of flowers, it's the
> amazing colour of birds, it's the songs of birds. In a way, it's that
> excess which, I think, is linked to sexuality rather than to creation
> or production directly.

Which then gets me thinking about
the forms of aesthetic fitness that
we are unconsciously becoming

Art as a product of sexual selection?

Randomly Google-searching the phrase "aesthetic fitness"
my click-happy networked persona comes on this:

> If art is an adaptation, what possible function could it have
> served? From the viewpoint of current animal communication
> research, art is a signalling system. There is a signaller (the maker
> of the art), and a set of receivers (who perceive the work of art).
> The prototypical functions for animal signals include long-
> range sexual attraction, short-range sexual courtship, sexual
> rivalry, territorial conflict, begging by offspring to solicit parental
> investment, warning signals to deter predators, and alarm signals
> to alert relatives of danger.

And a bit further:

> What sort of evidence could support this sexual selection theory
> of art? One clue would be an example of convergent evolution:
> the independent evolution of art-like abilities in another species
> through sexual selection. Bower-birds offer strong evidence
> along this line.

Bower-birds are natural collage artists
caught in their perpetual blue period
who create readymade nestworks
to attract attention to themselves
in hopes of finding their soul mate
(or maybe just an on-again off-again
affair with their love bird)

They are naturally inclined remixologists

They do not need paint or canvas or verbal constructions
to make the point nor do they need a white cube
to exhibit their animal instincts in

But humans treat their remix/selective/readymade art
in a quite different manner—no?

First of all there is always the art market and
if you are ready to launch yourself into it
a conceptual plan steeped in innovation
promising stylistic breakthroughs that reek of
What Is Happening Now

Of course what is happening now
may have happened then too
suggesting that role-playing a postproduction artist
playfully risks disrupting the progressive nature of
all markets that welcome acts of creative destruction

One can observe how over the course of art history
the media that artists work with may change
but the assortment of potential trajectories artists follow
tend to stay the same

Does the Internet and its online social networking apparatus
open up potentially new trajectories for artists
to make history?

It already has—but not to the degree it still needs to
in order to usher in a dramatic shift in the way we position
both the artist and artwork in contemporary network culture

What exactly is the relationship between making
contemporary art and history especially given the fact that
as Rimbaud once wrote
"To each being several *other* lives were due"?

This reminds me of one of the most frequently cited quotes
attributed to Robert Rauschenberg:

> Painting relates to both art and life. Neither can be made. (I try to
> act in that gap between the two.)

Is he suggesting that both are readymade
and always precede us?

And yet he kept making (and making and making)

My remix of Rauschenberg is simple and to the point
(and samples from the 1957 Duchamp quote
from his lecture in Houston on "The Creative Act"
that opens this book):

> The creative act relates to both art and life. Neither can be
> made without the other. (I intuitively make myself up in the blur
> between the two.)

Blurring the two (art and life)
the artist/medium selectively combines and/or
remixes the **Source Material Everywhere**
as part of an ongoing lifestyle practice

(The ghost of Allan Kaprow is hovering above the screen)

There's something almost primitive about
the art/life blur as remix

Grosz:

> I wanted to think in the most elementary way possible, in the
> most basic, simple way possible, what are the raw materials
> or conditions of art universally? Not the history of western art
> particularly, not the history of any particular kind of art, but
> the impulse to art in human beings, and I wanted to know
> where that came from historically but, of course, we don't have
> historical records that go back that far. So really, for me as a
> philosopher, the question was, what conceptual necessities does
> one have to have in order to think and produce art?

My own answer would be: **a body language**

Or

a body language whose inner choreography
can dance with the network

Acker refers to this body language
as the language of intensity

But as any artist developing this inner choreography
will tell you—for that to happen *we need discipline*

Sometimes it's hard not to wonder:

Where do we find the discipline?

Is it in the deep interior movements of
the postproduction artist-medium?

Where exactly is this discipline located?

Is it circulating inside the body that is
continuously triggering unconscious creative activity
as part of some historically modified durational achievement?

Can it be anatomically located within
certain regions of the brain where
an emerging agency role-plays
the oncoming burst of neuroaesthetics?

This ongoing activity of disciplined making is nothing
if not an aesthetically fit durational achievement

The artist essentially has no choice
but to *become* a kind of disciplined making

The process is viral

It's an overzealous contagious media event
that takes over the body and renders it creative
over and over again and again

Like they used to say about certain forms of jazz
"If you have to ask what it is, then you'll never know"

But once the work is made then what happens?

For the bower-bird everything is straightforward

It does its dance
its cool and gloating artist presentation

in front of its newly reconfigured plastic-blue collage work
and if all goes well
the viewer
the one who the work was made to seduce
succumbs

But humans have the weight of

History
Lineage
Precedent
Innovation
Creative destruction
Taste
Politics

and finally

the Market

One might ask:

What is it that modifies the trajectory of
the Rauschenberg "combine" as it enters the world?

It has to be more than just another instance of
the ongoing activity of a disciplined maker
creating its place in history

Rauschenberg was once quoted as saying:

> It's so easy to be undisciplined. And to be disciplined is so
> against my character, my general nature anyway, that I have to
> strain a little bit to keep on the right track.

Staying on the right track might mean
altering behavior (even regulating one's sexual activity)

Grosz:

> Darwin talks about two fundamental processes that regulate all
> of life; one is natural selection and the other is sexual selection.
> Natural selection is about survival, and sexual selection, for
> him, is largely about reproduction or about sexual seduction.
> And what I think is the origin of art, basically, is that impulse to
> seduction. So I take it that all forms of art are a kind of excessive
> affection of the body, or an intensification of the body of the
> kind which is also generated in sexuality. So it's something
> really fundamentally sexual about art, about all of the arts, even
> though they're very sublimated. What art is about is about the
> constriction of the materials, so the materials then become
> aestheticised or pleasurable. The pleasure of those materials has
> to do with the intensification of the body. So this impulse to art
> is to not make oneself seductive but to make oneself intense,
> and in the process to circulate some of that eros that would
> otherwise go into sexuality.

remixological chops — / — performing a function — / — metafictional tricks — / — grounding out

Are contemporary remixologists genuinely performing
a new author function? Are they abandoning the role of
literary content provider for something more personalized
like unconsciously becoming a postproduction medium
performing their metafictional tricks in unrealtime?

Calvino writes:

> Writing always presupposes the selection of a psychological
> attitude, a rapport with the world, a tone of voice, a
> homogeneous set of linguistic tools, the data of experience and
> the phantoms of the imagination—in a word, a style. The author
> is an author insofar as he enters into a role the way an actor
> does and identifies himself with that projection of himself at the
> moment of writing.

And yet the writer who self-identifies *as* writer must—
out of necessity—disappear when writing and in disappearing
transmit the work they intuitively generate as part of
their embodied praxis (basically you want to get to
the point where you can say "every part of me is working")

But you do process things as you navigate
your way through the multilinear routings of
your networked narrative environment
and so your "me" that has every part working
is in constant postproduction mode
and capable of a different version
with every overwrite function
you intuitively command while envisioning

Think of your ongoing story as a generative fiction
one that operates on the uncertainty principle
while riding that wave of quantum undecidability

As you mobilize your neurolinguistic thought processes
into whatever open compositional playing field
you happen to be jamming in at any given time
the key is to keep moving into the +1 of always becoming

In "Essentials of Spontaneous Prose" Jack Kerouac
writes out his artist theory as follows:

CENTER OF INTEREST Begin not from preconceived idea of what to
say about image but from jewel center of interest in subject of
image at moment of writing, and write outwards swimming in
sea of language to peripheral release and exhaustion—Do not
afterthink except for poetic or P.S. reasons. Never afterthink to
"improve" or defray impressions, as, the best writing is always
the most painful personal wrung-out tossed from cradle warm
protective mind—tap from yourself the song of yourself, blow!—
now!—your way is your only way—"good"—"bad"—always
honest, ("ludicrous"), spontaneous, "confessional" interesting,
because not "crafted." Craft is craft.

Ken Kesey crosses the border (to Mexico) and
catches a similar wave while patterning the postcognitive self:

It isn't by getting out of the world that we become enlightened,
but by getting into the world . . . by getting so tuned in that
we can ride the waves of our existence and never get tossed
because we become the waves.

That's groovy too

Meanwhile Sukenick from his 1968 novel *OUT:*

I want to write a book like a cloud that changes as it goes.

Skywriting, anyone?

Perhaps it is true of most poets that their (our)
heads are in the clouds (as I have been told repeatedly)

But I take that as a compliment

It does not mean that we are not grounded

Grounding out is part of daily practice and
I try to perform my version of physical well-being
with as little waste as possible

This means I must sustain my optimum economy of motion—
something athletes (particularly runners) are aware of
as is kung fu legend Bruce Lee

It's damn near impossible to physically train yourself
to ground out with optimum economy of motion
(unless you're Lance Armstrong in which case
you can improve your efficiency one percent a year
over seven years)

In general a fluid economy of motion is most likely
something that you are born with—the *with* in this case
being not just physical advantage but possibly intuitive
or unconscious advantage too (although
that's just my projection—
there is no scientific data available to prove the point)

What does this have to do with making digitally expanded
forms of art or writing electronic literature or performing
live AV (audiovisual) sets using new media technologies?

Could there be a way for us to measure
an economy of motion
in relation to Remixology so that we can begin to value
the output of one remixological style in relation to another?

Let's say that you are a creative writer or net artist
or live AV performer or interdisciplinary codesmith
who accesses all available source material to cobble together
your new work of conceptual sculpture

something that can be manifested in any number of
media-specific platforms or genres
for example a print or e-book
a work of cleverly designed net art
a series of VJ gigs on the Canary Islands
or an interactive installation in a Chelsea gallery

How would we determine the variance of value
for each of these outputs? How would we
differentiate the stylistic tendencies of artists
who remixologically inhabit a multitude of
multimedia forms of language and
how would we measure the value of
their work as postproduction mediums?

Does it all come down to a matter of taste?

Gut reaction?

Networked sensibilities?

Besides
 is taste not the ancient bugaboo of aesthetics per se?

How about PR mythmaking or
insider trading via friendly art-world criticism
and power marketing?

(The name Matthew Barney comes to mind)

That's certainly another way of imagining
(remixologically inhabiting)
an artist's "measure"
within the logic of late technocapitalism

The danger with networked art is that it becomes
a postcognitive distributed aesthetics
heavily indebted to ad campaigns conducted
by the meme-maestros of contagious media

OK OK OK OK—

BUT

could there be another way for us to create
a sense of measure for the contemporary remixologist?

Can we now begin to theoretically fictionalize
a more aesthetically fit lifestyle practice
in terms relative to an economy of motion
so that we can critically measure how
one remixologist performs more efficiently than another
even while exercising our spontaneously generated
personally wrung-out warm protective mind?

Is efficiency a useful criterion?

What about a media artist whose forte
is critically examining wastefulness
by exhibiting their own creative waste?

> There's a big difference between a *big* piece of art with a *little* shit
> in the middle and a *big* piece of shit with a *little* art in the middle.
> *(Lenny Bruce, emphasis mine)*

Seriously
what criteria would be useful
in measuring digitally distributed
remix/postproduction art?

Audience share?

Total sales on iTunes?

Incoming links from other sites on the web?

Invitations to festivals?

He or she who comes from nowhere and successfully
envisions a visionary lifestyle practice that
by all accounts is a dream come true?

Even if we could begin to measure
the remixological outcomes of all artist-mediums
how would it translate into real-world value
and what is real-world value in this sense?

MTV Real World value?

Street cred value?

Google search term "algorithmic value"?

How about a genuine smile that invites you in
so that you can really start getting down
bodyimage to bodyimage?

Rock star value?

Ubergeek aura?

What are we trying to model here?

The net artists Shulgin and Bookchin
write in their manifesto appropriately titled
"Introduction to net.art (1994–1999)"

> 4. Critical Tips and Tricks for the Successful Modern
> net.artist . . .
> B. Success Indicators: Upgrade 2
> 1. Bandwidth
> 2. Girl or boy friends
> 3. Hits on search engines
> 4. Hits on your sites
> 5. Links to your site
> 6. Invitations
> 7. E-mail
> 8. Airplane tickets
> 9. Money

If we approach our ongoing story as a generative fiction
one that operates on the uncertainty principle
then the idea of real-world value becomes supple

and the payback may appear via intangibles
(for example: interpersonal relationships)

By remaining flexible while simultaneously using
select new media apparatuses to help us expand our range
we can grab what we need from our data samples
and remix our lives so that we can begin envisioning
future forms of *bodyimage* that we intuitively know
we are programming ourselves to become

In the land of new age motivational speak
we would call this *creative visualization*

and what hardworking successful artist today
(success being measured in any way you like)
could argue with that?

In the late 1980s Flusser addresses the layers of apparatus
we all perform our postproduction processes in
suggesting that "the programs of apparatuses
consist of symbols" and that "functioning
therefore means playing with symbols and
combining them" and that the universe of
technical images "is a means of programming
society . . . to act as a magic feedback mechanism
for the benefit of the combination game."

"Cut the photograph" he says (sounding
oddly reminiscent of Gysin/Burroughs and
their adherence to the cut-up method)

"Cut out the photograph, send it on, screw it up—
all these are ritual acts, reactions to the message of
the image" which then leads to "ritual magic"

Is Flusser making fun of the postproduction tendencies of
the emerging artist-apparatus as remixologist?

To cut it out is to sample
To screw it up is to manipulate
To send it on is to channel it

but conducting acts of ritual magic
is perhaps something akin to becoming
a fully invested postproduction medium

Once a beast always an instinct . . .

Moving in or remixologically inhabiting narrative space
within an ideal economy of motion is moving away
from what's always gaining on you
("nothing ventured, always gained on")

In an ideal world how you move-remix
(how you affectively generate your *bodyimage*)
would translate into measurable value

With an intuitively generated economy of motion
activated by the fringe-flow sensations of the *bodyimage*
role-playing a networked "mover-shaker"
you don't even have to know how to move to move
you just move (and in moving *move beyond* knowing per se
as well as beyond meaning per se while still activating
your unconscious creative potential as the optimum
mode of presence—one that is performed in
a hyperintuitive state of perpetual postproduction)

I discuss this intuitively generated movement
in relation to VJ performance and athletics in *META/DATA:*

As any philosophically engaged VJ will tell you, the brain's readiness potential is always on the cusp of writing into being the next wave of unconscious action that the I—*consciousness par excellence*—will inevitably take credit for. But the actual avant-trigger that sets the image *écriture* into motion as the VJ jams with new media technology is ahead of its—the conscious I's—time. Improvisational artists or sports athletes who are in tune with their bodies while on the playing field or in the club or art space know that to achieve a high-level performance they must synchronize their distributive flow with the constant activation of this avant-trigger that they keep responding to as they play out their creative potential. Artists and athletes intuitively know that they have to make their next move without even thinking about it, before they become aware of what it is they are actually doing. There is simply no time to think it through, and besides, thinking it through means possibly killing the creative potential before it has time to gain any momentum or causes all kinds of clumsy or wrong-headed decision making that leads to flubs, fumbles, and missteps on the sports or compositional playing field. Artists and theorists who know what it feels like to play the work unconsciously, when everything is clicking and they leave their rational self behind, can relate to what I'm saying.

Others are on to this as well

In his book *Artist of Life* Bruce Lee writes that his martial arts practice is driven by an ECONOMY OF FORM in relation to an ECONOMY OF MOTION (all caps are his):

> The less confident we are in ourselves, the less we are in touch with ourselves and the world, the more we want to control.

NOW = EXPERIENCE = AWARENESS = REALITY

Gestalt therapy = phenomenological approach (awareness of
what is) + behavioral approach (behavior in the now)

Lee tells us that we need to initiate progressive
harmonious forward motion that minimizes
wasted movement while perfecting technique
(embodying praxis) but that we still must
"use variety" (or in the terminology of this writerly remix
we must develop multiple and hybridized styles of
remixological practice so that we can originate
our own lives as *an enduring aesthetic fact*
mixing ourselves into the **Source Material Everywhere**
while becoming active agents reconfiguring
the novel production of togetherness)

In his handwritten notes on gestalt therapy
the artist Lee also writes:

> Once you have a character, you have developed a rigid SYSTEM.
> Your behavior becomes petrified, predictable, and you lose your
> ability to cope freely with the world with all your resources. You
> are predetermined just to cope with events in one way, namely,
> as your character prescribes. So it seems a paradox when I say
> that the richest person, the most productive, creative person, is a
> person who has NO CHARACTER.

Those are excellent insights for those of us
who really want to go somewhere
without *wasting any time*

If I were to remixologically inhabit Lee's "voice"
while writing out his martial arts theory
I would say:

Once you have a voice, you have developed a rigid SYSTEM. Your
behavior becomes repetitive, predictable, and you lose your
ability to sample freely from and interact with the world with all
of your resources. You are predetermined just to act within social
networking and performance events in one way, namely, as your
predetermined voice prescribes. So it seems a paradox when I
say that the most interesting artist, the most productive, creative
persona, is one who has NO VOICE.

**economy of motion — / — gestalt therapy — / —
unconscious signal — / — idiosyncratic practitioners**

But using something like the economy of motion
to measure the value of different remixological styles
is still a science in development

Sukenick spent the last years of his life suffering
from inclusion body myositis—he was virtually
unable to move and yet he continued to defy death
by talking to his computer

His computer was loaded with voice-recognition software

As he would improvise his story by speaking slowly
into the microphone—the machine would translate
his spoken words as best it could

He would watch the words "move" on the screen
and every now and then the machine would
put the wrong word up

but he would just keep "moving" with it and riff
on the error as if it were a live jazz set
seeing where the supposed miscue could (re)direct him

The last stories he wrote ("Running on Empty" "77" etc.)
were like dropping hallucinogenic word bombs from
a place beyond this life we are all familiar with
and were doing things stylistically
that were part Ron on his feet
and part Ron frozen in immobility

In his final novel—*Last Fall*—a memoir-fiction
that remixes his emotional response to the attacks of 9/11
that he watched happen right outside the window to
his twenty-sixth-floor apartment in Battery Park City

the fluid persona that narrates the story speaks of
the inability to "experience coincidence"

Translation: the electrical charge of unconscious potential
that triggers the creative impulse toward "novel togetherness"
i.e. sending a signal that anticipates the present
so that an instantaneous movement will coincide with
the electrical charge spurred inside the brain—
is being initiated by the artist-medium
but the body does not respond

(does not co-respond or take co-responsibility for his action)

so what we normally take for granted as body timing
(or intuitive forms of movement like proprioception)
become impossible to experience

I don't even have to think about typing these keys
on my laptop as I zone out and compose my next entry

My creative unconscious does this *for* me
and the body responds

It's a kind of postproduction luxury
something that is built in or *comes with*
my operating system

But for Sukenick
toward the end of his life
this was not the case at all

The unconscious signal to twitter fingers
over a magical keyboard so as to remix emotional
alchemy in the form of innovative fiction
or daring narratological rhetoric
was no longer working

In *Last Fall* he refers to this as
no longer being able to experience *coincidence*

(the title of the novel itself is a multi-pun
referencing the season as well as his own
inability to stand up without occasionally falling
not to mention the total collapse of the Twin Towers)

The idea of "co-" as a necessary prefix—
one that informs all acts of creative composition—
is at the heart of Remixology

(for another literary precursor who also tapped
into this emerging element of style
see Julio Cortázar's *Hopscotch* and his idea of
the reader as a *co-conspirator*)

When we think of "co-" we think of "together"
"joint" "jointly" "mutually" or in raw terms
joining forces with a partner or associate in an activity

In Sukenick's case
and this would be worth studying from
a variety of interdisciplinary angles
when it comes to his persona's inability
to experience coincidence

who is the partner that is no longer participating
in the creative activity
and who is the partner that is—against all odds—
attempting to hack the system?

Sukenick circa inclusion body myositis:

> Gone is the aura of elite snobbism that once surrounded the
> avant-garde. Instead of a movement the avant-garde has
> become a matter of idiosyncratic practitioners interested in
> innovation.
>
> You can't dictate style. What would the right style be?

Perhaps measuring the value of
different remixological styles
has something to do with context

In addition to foregrounding the necessity of
employing the postproduction style of "co-"
into new media art and writing strategies
an emerging elements of style for electronic creation
would also need to take into account various media contexts
which would then ironically reveal how fluid
these electronic elements really are
especially when compared to the fixed apparatus
we generally associate with print literacy

Contemporary remixological practice is a creative space
where the postproduction style of "co-" rules and
an efflorescence of styles bloom

It is when the radical departure from writing *about* something
to writing *with* something comes to the fore and
challenges everything we know about more traditional
scholarly and literary text productions

Print works from the likes of Lautréamont
Jacques Derrida Raymond Federman Kathy Acker
Julio Cortázar Italo Calvino and Sukenick
to name just a few

anticipate the coming of the writerly "co-"
(and in writing "writerly" I am reminded of Barthes too
whom I now "co-produce" that last sentence with)

By enabling "co-" to become our primary element of style
we charge the art of Remixology to return to "serious writing"
while opening it up to its hybridized intermedia
collaborative potential

Yet there is something about the renewable tradition
rechanneling writing vis-à-vis context that agitates me

I immediately feel compelled to ask:
Is there a tyranny of context that overwhelms
the historical moment a work gets created in?

Ideology aside—what does it mean to succumb
to the new media apparatus and embrace one's own
poetic intuition while hyperimprovisationally performing
acts of multimedia "writing" over the network?

Does not the body itself provide an aesthetic context
for the creative work to filter itself through so that
it may then locate whatever distribution mechanism
the work necessitates for its eventual delivery?

If that were true (and who is to say it is? not me!)
then how could this distribution mechanism become
more of an embedded channeling process that is *inmixed*
with the work itself so that one can no longer separate
the one from the other—the creative work from the channel—
the filter from the remixologist—the context from the style—
the unconscious readiness potential from the act of creativity?

That is to say

What does it mean to *experience coincidence*?

(Or is it more about market timing?
Scary thought—but just as likely)

The list of "co-" postproductions by artists and writers
creating *with* the renewable tradition is long

The novelist and screenwriter Terry Southern
took this *writing with* process to its stylistic extreme when

as a young man he began literally writing out by hand
the works of Edgar Allan Poe

The Yes Men remixologically inhabited
the World Trade Organization website
and birthed the gatt.org site which then fed
into many remixological performance art spectacles
at major international economic summits
which were then remixed yet again into
The Yes Men movie where you can see their collaborative
cut-and-paste as-you-go methodology hybridize
net art / performance / fiction / hactivism

For the work *Society of the Spectacle (A Digital Remix)*
the art collective I belong to (DJRABBI.COM)
took Guy Debord's original scrambling of propaganda noise
from the days of May '68 and *détourned the détourner*
generating random video imagery by using his texts
as source material in Google Image Searches
while also mashing up an alternative *détourntablism*
with some of the audio productions he participated in
even overwriting the English subtitles translating
his monotonous Marxist voice-over

The renewable tradition is part of
an open source lifestyle practice
and is available to all

As Burroughs writes:

Cut-ups are for everyone. Anybody can make cut ups. It is
experimental in the sense of being something to do. Right here
write now.

In his novel *98.6* Sukenick
reformulates the Mosaic law and writes:

> The law of mosaics, a way of dealing with parts in the absence of
> wholes.

My own Professor VJ blog also plays
with these interventionist styles
by accessing available source material
while composing *within* a deconstructive creative space
that renews both cutup and mosaic
i.e. a performative flow of pla(y)giaristic action

> where what's being conducted "feels w-r-i-t-e"—as in: I'm feeling
> my way into writing and in feeling am becoming something
> altogether different than I was when I was cruising down that
> last digressionary tract.

**law of mosaics — / — blog performance — / —
masturbation journal — / — pirate hacker**

Debord wrote in his "Methods of Détournement"

> Any elements, no matter where they are taken from, can serve
> in making new combinations. The discoveries of modern poetry
> regarding the analogical structure of images demonstrate that
> when two objects are brought together, no matter how far apart
> their original contexts may be, a relationship is always formed.

Contemporary remixologists play on Debordian détournement
by détourning lifestyle situations that are coproduced with
the media environments they operate in as artist-agents
intervening in the creative process using whatever
inherited filters and processual residues they have stored
inside their image-making body-brain-apparatus

Though Debord appears to not be having as much fun
as the contemporary remixologists his work inevitably informs
he still challenges them to sample from
the available source material
so that they can then manipulate it to their heart's content
as a way of leaving the propaganda machine behind
or at least creating a counterpropaganda force
that will lead to more dynamic COMPOSITION BY FIELD

But can this propaganda machine ever truly be left behind?

Debord outlines *methods* of détournement
and in so doing suggests that
"only extremist innovation is historically justified"

Like Whitehead's "concrescence of prehensions"
but filtered through a radical anti-art political ideology
that at once feels premonitory and anachronistic
Debord informs the contemporary remixologist that

restricting oneself to a personal arrangement of words is mere
convention. The mutual interference of two worlds of feeling,
or the bringing together of two independent expressions,
supersedes the original elements and produces a synthetic
organization of greater efficacy. Anything can be used.

This carte blanche that Debord waves before remixologists
opens up his own pla(y)giaristic practice to détournement

Or to paraphrase a quote from a famous
law-and-order TV show
that will enable me to temporarily
disarm situationism from the get-go:

"Anything can and will be used against you."

For example
Alfred North Whitehead

Mashing up the process theology of Whitehead
where he writes in his "Theory of Feelings"

> A feeling is a component in the concrescence of a novel actual
> entity. . . . The process of the concrescence is a progressive
> integration of feelings controlled by their subjective forms. . . .
> Feelings of an earlier phase sink into the components of some
> more complex feeling of a later phase. . . . Each phase adds its
> element of novelty.

with the quotes from prototypically materialist Debord above

I tweak my own process filters and release
my latest microtrack of DIY philosophy
that reads in part:

> A feeling is an expression in the concrescence of a
> remixologically inhabited media space. The process of the
> concrescence can serve in making new combinations of

aesthetic experience forming an ongoing and progressive
integration of feelings that supersede the original expression of
an earlier phase producing a synthetic organization of greater
efficacy. Each expression of feeling sinks into the components
of some more complex feeling of a later phase and each
phase adds its element of novelty. If the production of novel
togetherness is to be historically justified at all, then it will occur
in the extreme reaches of remixological practice.

While articulating his methods of détournement
Debord turns to Lautréamont as the most advanced
early practitioner of these interventionist strategies
and writes that the controversies that have surrounded
his seminal works of pla(y)giarism
"only testif[y] to the intellectual debilitation" of
"these camps of dotards in combat with each other."

For Debord as for Whitehead
the premonitory proposition of the remixological act
is what is of utmost concern

and if cultural critics or connoisseurs
cannot just *get over it*
then that's their problem

The bottom line for Debord is that this is the direction
contemporary practice is heading and we better get used to it:

For the moment we will limit ourselves to showing a few
concrete possibilities starting from various current sectors of
communication—it being understood that these separate
sectors are significant only in relation to present-day techniques,

and are all tending to merge into superior syntheses with the advance of these techniques.

Of course Debord and Whitehead before him
could have never seen the Internet coming
(although Nicolas Tesla may have)

In late 2005 the DJRABBI collective I am part of
performed a twenty-four-hour multimedia
blog jam performance
as part of our commissioned installation at
the Scottsdale Museum of Contemporary Art

The work was called *24 Hour Count:*

> For this 24 hour online blog performance, the artists will use
> a variety of media including the Internet, mobile phones,
> digital video and photo cameras, mini-disk recorders, musical
> instruments, and many computer software programs to
> improvisationally remix, interpret, and respond to current events
> while filtering their "digital readings" through the prism of Count
> Lautréamont's *Les Chants du Maldoror,* a classic French text
> written in the 19th century, whom *[sic]* the Surrealists adopted as
> the progenitor of their significant 20th century movement.
>
> André Breton wrote that Maldoror is "the expression of a
> revelation so complete it seems to exceed human potential."
> Little is known about Lautréamont aside from his real name
> (Isidore Ducasse), birth in Uruguay (1846), and early death in Paris
> (1870). It has been said that "Lautréamont's writings bewildered
> his contemporaries but the Surrealists modeled their efforts after
> his lawless black humor and poetic leaps of logic," exemplified
> by his oft-quoted slogan, "As beautiful as the chance meeting

on a dissecting-table of a sewing-machine and an umbrella!"—a phrase that has also been sampled and remixed as an album title by the underground UK band Nurse With Wound. Rumor has it that Maldoror's shocked first publisher refused to bind the sheets of the original edition, all of which bodes well for this even looser but equally dark 21st century remix since all of the live data transmission will take place over the net and will contain links to whatever current events happen to be developing during the duration of the performance.

Lautréamont is generally considered
one of the first remixologists
because of his embrace of pla(y)giarism
as a primary aesthetic device in
the composition of his stories

He is famous in some circles for having written:

> Plagiarism is necessary. Progress implies it. It holds tight an author's phrase, uses his expressions, eliminates a false idea, and replaces it with just the right idea.

Remixologically inhabiting another artist's
stylistic tendencies and/or "body language"
with twittering digits manipulating the source material
is a kind of evolutionary ingress
and was Lautréamont's forte also

An early remixologist
Lautréamont would create his poesies
as a counterforce meant to deconstruct

the cult of genius by employing
the illogic of sense (intuition demystified)

His own style in *The Songs of Maldoror*
is decidedly multilinear/digressionary
or what we might call prototypically hypertextual
in its execution even though it was
(as it had to be)
published as a book in the nineteenth century

The Count was sampling heavily from
much of the gothic literature of his time
and I associate his punk antihero Maldoror
with what today is sometimes called
a "totally goth" style coupled with a "rad"
political agenda that fought against
conventional notions of beauty/originality
but that still located an alternative form of beauty
in the eye of the beastly beholder

(My second novel *Sexual Blood*
pays homage to *Maldoror* and teleports
his pla[y]giaristic consciousness to a cyberpunk world
where he can roam the dynamic fields of
creative destruction with a vengeance)

In the youthful parlance of my students today
we could call his methods "wicked" or "sick"
and if we read between the lines of his dictum above
especially in relation to the *necessity* of pla(y)giarism
we can see that he views his own remixological writing style
as part of a larger critique process
one we might think of as
a collective/collaborative peer review
or peer renewal process that writes *with*

those who came before him the same way that
over one hundred years later
an avant-pop performance artist like Acker wrote *with*
Hawthorne or Faulkner or Verlaine
or the cyberpunk novelist William Gibson
who published his *Neuromancer* after Acker
had already established her literary reputation
(some might suggest that Acker wrote *against*
these male literary icons but my personal discussions with her
suggested it was more *with* them as part of
a larger methodological approach to align herself
with [or to even become the radicalized spirit *of*]
the figures who preceded or followed her
in the rival tradition of literature

and in this way all remixological inhabitations
are radicalized coproductions with the artists
being sampled from as renewable energy sources

This is another way of saying that remix artists
willingly set themselves up for *metamediumystic becomings*
wherein their postproduction methods feed off the hosts
whose bodies of work they continually crave and suckle)

The key word in Lautréamont's quote above
especially for those who struggle to maintain
writing's vitality in a postliterary culture
is *necessary*

("Plagiarism is necessary")

Lautréamont is telling us that pla(y)giarism is necessary
for without it there is no renewal of discourse
and the rival tradition of literature would cease to exist

To remix Lautréamont's famous quote
I would improvisationally write:

> Remixology is necessary. Life depends on it. It inhabits the
> media language composed by other artists and takes on their
> expressive qualities while simultaneously attempting to remove
> their excess or outdated information, replacing it with a more
> valuable source material.

That's cool
but what is "valuable"
in this context?

(Measure for measure
these things are subjective
and politicized beyond belief

For example my last published literary novel
was initially rejected by my former publisher
whose editorial board consists primarily of
PhD professors of literature who creatively write
and the reason for its rejection?

From what I can make of their reports
my referencing contemporary phenomena
such as blogs / live VJ performance art /
webcams and even the World Wide Web
cut into its expiration date *as* literature
that is to say limited its literary-historical shelf life
[I kid you not! As if the WWW and blogging
would one day disappear and the Cult of Innovative Literature
would once again (did it ever?) reign supreme])

But let's not get too lazy here

Remixology is not the answer

(Remixology is the question—
the answer is "Yes!")

"Remix this, remix that"

We've heard it all before

It doesn't take long for buzzwords
to lose their usefulness as reference points
especially when challenged by an activist
new media intelligentsia

What happens when the new media artists
become a kind of mashup filter
sampling data from a variety of sources
who then consciously *(with intention)*
manipulate this data with their own
signature-style effects
and the experiential residue of a life
lived on Planet Oblivion?

When it comes to translating your own
experience as part of a larger relational aesthetic
is there an implicit politics involved in
the act of remixing?

Who controls the experiential opacity
the crunchy altertones
the asynchronous assemblages
not to mention all of the hyperactive *bodyimages*
that tremble at the touch of a keyboard?

A proposition:

Mixed Reality is (always already)
Remixed Reality (some assemblage required)

that is to say

Remixology integrates selectively manipulated data
into ongoing patterns of aesthetic intensity
that the *artist-medium* experiences as
"the novel production of togetherness"

This novel production of togetherness
is in constant flux and collectively emerges
as part of an intersubjective jam session
where remixologists/*artist-mediums*
reinvent their aesthetic lifestyle practices
by intervening in or *hacking into*
the transmission of traditional media discourses
(an idealized and romanticized hacking aesthetic
that empowers artists to renew ALL discourse)

Statement:

Remixology takes place bodyimage to bodyimage

Sample:

Henri Bergson once wrote:

> There is no perception without affection. Affection is, then, that
> part or aspect of the inside of our body which we *mix* with the
> image of external bodies; it is what we must first of all subtract
> from perception to get the image in its purity. *(emphasis mine)*

Professor VJ Remix:

> There is no source material without Remixology. Remixology is,
> then, that part or aspect of the inside of our body in which we
> *mix* imaginary situations with the image of external bodies; this
> *bodyimage to bodyimage remixing* is what it means to *become*
> procreative. *(emphasis also mine)*

Would it be too much to suggest that Remixology
is the contemporary aesthetic strategy
for continuing the thread of Bergsonian creative evolution?

Someone like my co-conspirator Acker
appropriation artist / remixologist extraordinaire
would say that it relates to
the language of the body
or *body language*

(as an aside I should note that
whenever we got together
we would schedule in some time
to go work out in the gym)

In a work she titles
The Language of the Body
she writes:

> I've begun a journey to make sex live, to find the relation
> between language and the body rather than this sexuality that's
> presented by society as diseased.
>
> My body seems to reject ordinary language.

If I can find the language of the body, I can find where sex is lying.

While I masturbate, I'll try to hear the language that's there.

She then proceeds to write in her *Masturbation Journal:*

As soon as my body relaxed into only being receiver, I entered into music or began a journey that was rhythmic, wave-like, in time. For waves in time = music. Each time a wave falls, I'm able to feel more sensation. Why? Something to do with breathing. When a wave falls, I exhale. Then, at the bottom of exhalation, the physical sensation has to be (already allowable allowed) strong enough and wanting or desiring enough for the whole to turn into physical sensation; at this point, still desiring where there's no body left to become desire, at this point failure, the whole turns over into something else.

I have described the entrance into the other world where all is a kind of ease. This other world is also the world within dream.

This world within dream is the beginning of
another world within our own world
a world fueled by psychosomatic flow and morphic resonance
where the artist-medium projects their body language
in a timeless time circulating within
the networked space of flows

Given these readymade evolutionary circumstances
how can the artist not become a postproduction medium
ready to tweak all customized filters accordingly

so that they may *remixologically inhabit*
the source material that naturally surrounds them?

Imagine transforming individual talent
into socially constructed forms of novel togetherness
i.e. mirroring neurons while aesthetically manipulating
the environmental data our personae perform in

Inside this world within dream
the source material is network connected
and can be sampled from at will
suggesting that for artist-mediums
who intentionally build mosaics of meaning
out of the renewable forms of media discourse
there is no longer an inspirational source
to turn to for enlightened expression
but that it's more of a co-conspiratorial practice
fed by a reservoir of source material
that one *hacks into* and *samples from*
to create novel forms of aesthetic intensity

Anecdote:

While she was visiting Boulder in the mid-1990s
Acker and I were invited for an interview
on the local public radio station KGNU
and the show's host though very sweet
was quite unfamiliar with Acker's work
and so asked a very general question

"Where do you find your voice?"

which is a joke for a pirate hacker
like Kathy Acker
who published books with titles like

Don Quixote: Which Was a Dream
Blood and Guts in High School
and *Pussy, King of the Pirates*

Without being rude she replied
"What voice? I just steal shit"

which was kind of funny given the fact
that *shit* is one of the seven words
the comedian George Carlin made fun of
when talking about the Seven Dirty Words
the Federal Communications Commission
ruled you can *never* say over the airwaves

(KGNU did not lose their license over this)

aesthetic intensity — / — generative flow — / —
unconscious buzzing — / — "forever composition"

Here's another remix/aesthetic fact
camouflaged as a pseudodefinition:

Remixological

> the capacity to affectively assemble data
> into an image (even if the image itself
> no longer exists, that is, becomes
> a virtual yet direct presentation of itself)

Given that pseudodefinition

what does it mean to *remixologically inhabit*
a dense distribution of data that slides through
one's processual media body
as it selectively filter-enframes it
and tags the generative flow of images
with unconsciously projected

signature-style effects

so as to give one's envisioning process
an extensive morphic resonance
in the networked space of flows?

For the live AV artist who is continually
remixing found footage with personal video data
with computer-generated imagery
with memories of various location shoots
with metempsychotic flashbacks of
images never rendered before

meaning has a way of smudging
into the experiential event itself
and is as difficult to cherry-pick
as it is to wade through endless
tracks of performance writing
and locate the artist's voice

Where is the artist's voice?

("What voice? I just steal shit.")

I first came into contact with my so-called voice
when I was in an experimental sound art
ensemble whose name said it all:

Dogma Hum

Dogma Hum had a rotating crew
of about five or six members of
which I was considered
the group's lead vocalist

although back in the day
we may have referred to my role as
performance poet or *spoken word artist*
but these terms do not adequately describe
my contribution either since I was also
resident novelist and theory-slut
as well as budding net artist (soon to bloom)
always sampling from and mixing in ideas
at times exact words and phrases
from other artists who were influencing me
while in the midst of performing my improvisational talking

I say *talking* because I could not sing
not in the way Frank Sinatra or Ella Fitzgerald
or John and Paul and George could sing
(Ringo could never sing either could he?)
and so this talk-rock sound art ensemble
that was embodied in the group dynamic
known to some (not many) as Dogma Hum
was not really being *led* by my vocals

My so-called voice was just more data
more live and totally ready for manipulation
source material awaiting digital effects processing
and whether it was the grain of the sound
or the gram of the potential meaning
or the rhetorical quality of grain and gram

remixed in *the measure of my delivery*
no longer mattered

What mattered was *the matter itself*
(that trajectory of nervous energy
where the source of readiness potential
encountered the physiological *materiel*
and the persuasive quality of grain and gram
spasmodically improvising
method over madness
would project my unconscious buzzing
even as the madness would break through
porous metaphors of structure
and deliver the occasional prophetic illumination
in its stead)

My fascination at the time was not words
although I needed some data to play with
and had endless scraps of paper
with anarcho-existentialist markings on them
somehow capturing the lossy bits of
this other world within the dream
that my body language was circulating in

(these almost hieroglyphic drawings
masquerading as meaning-laden words
could trigger unexpected noise performances
including the most popular track we composed
the title of which referred to these mental jottings
as "Somnambulistic Chickenscratch")

My real fascination was with the digital processor
that would change the so-called grain of my voice
into something other than I knew it to be
and that when remixed with my own supposed voice

the one that we would generally call *natural*
but that is really a *pigment* of our imagination
(one instrumental data stream among many
ready for instantaneous postproduction)
created a new processual version of "me"
just like writing my novels created
new processual versions of "me"

which then led me to unexpected questions
like "What am I when writing my fictions—
some kind of digital effects processor?"

(Maybe the remixologist is a contemporary
version of Whitman's body electric
but loaded with customized artist-apparatus filters
never quite put into use before now

This is especially relevant to me
given the fact that my forte
if you can call this sort of a thing a forte
is my ability to selectively sample
from the sea of source material
I am biologically swimming in
and spontaneously discover new uses for it
in my on-the-fly remixes no matter what medium
I happen to be working in [fiction photography
cinema/video dance performance art spoken word etc.])

In fact I look back at my relationship
to voice per se and realize that
there is *no voice to speak of per se*
and must self-reflexively point out
that even this semirant wanting to be
poetry narrative philosophy theory memoir
is really a conversational mix sampling heavily

from the style of many other artists
like David Antin Frank O'Hara Spaulding Grey

i.e. the so-called talk-poets
or *performativity-inclined*
processual agents of projective verse
whose "authority" (loose term used
by poet Michael Davidson)
derives from an ability to instantiate
physiological and psychological states
through highly gestural lineation
and by the treatment of the page
as a field for action

Remixologists move off of the page per se
and reconfigure what we used to call *the poet*
into an affective agent of live AV performance
who on (unconsciously) becoming a postproduction medium
intersubjectively jams within the copoietic mix of
the artificial intelligentsia they *play to play* in

(without thinking about it
I just coproduced that last line
with Ornette Coleman's already sampled
"I didn't know you had to learn to play . . .
I thought you had to *play* to play")

The embodied praxis of the always live remixologist
is transmitted *bodyimage to bodyimage*
which is another way of saying
I don't even have to know you're there to know
that this data I am porting through the network
is now infiltrating your boundaries
(but then again maybe you have no boundaries
or are experimenting with them so as to see

how much fluid inmixing you can tolerate)

As our transmissions get absorbed into
the networked space of flows and become
more source material for the artificial intelligentsia
to consider sampling from for a wide array of
remixological purposes

o
 u
r

b
 o u

 n

 d
 a

r

 i
e s

 be come more por ous

 than
ever

This is when the **bodyimage**
goes through various stages of becoming

a receiving station
a code processor

an affective remix engine
a flux persona emulator
a hyperimprovisational mystic who forgets itself . . .

in other words: **a postproduction medium**

If embodied digital flux personae performing
their daily practice as artist-mediums
become a kind of compositional instrument
acting on whatever ground is available

then we may also view them as a kind of
remixological body electric
affectively mixing their source material
bodyimage to bodyimage
via an oscillating string of excitation modes
accelerating on the edge of a "forever composition"
that is then experienced by the artist-medium
as *the ongoing becomingness of postproduction*

This "ongoing becomingness of postproduction"
catapults the artist-medium further into the Infinite
that unidentifiable space of mind where
the unconscious projections of near-future events
always keep us on the cusp of what it is
we are in the process of creating while experiencing
this *all-over sense* of being in perpetual postproduction
even as our novel togetherness smudges together
with what we used to think of as simply being
in production . . .

(Artist's aside: Can one perform this
[aesthetic? creatively destructive?
innovative? entrepreneurial?]

function within an economy of motion
i.e. one that wastes no time-movement?

For that matter *should* one pursue
this optimized state of self-efficiency?

What would the opportunity costs be?

I ask this because sometimes writing out
an artist poetics itself feels like wasted motion
as it takes away from the more primary bursts of
creativity immersed in its own potential

but then I have second thoughts in questioning
the interior need to write out my poetics
wondering if this is just more of the same in a different form
that like other forms I continually lose myself in
attempts to tap into the ongoing concrescence of prehensions
my affective remix engine continually engages with
thus rendering into vision the *bodyimage* rhythms
my meta/data longs to become while *in distribution*

What's an artist-medium to do?

My sense is that the reasons why many artists
novelists poets and performers still take on
the role of theorist or timely rhetorician are many

To be clear
it's not an attempt to overacademicize one's practice
or to generate extra brownie points
for some abstract reporting system
that supposedly benefits the workaholic professor

Hardly

This is unconsciously projecting an artist theory
or poetics on the contemporary state of
practice-based art research
period)

This kind of autocannibalizing discourse
generally evolves as a way to pragmatically
take into account why these primary bursts of
creativity immersed in their own potential
exist in the first place and how they may relate
to new forms of knowledge that grow out of
what has been remixologically inhabited in the past

Question:

Is Remixology Creativity's chosen methodology
for artists-cum–evolving postproduction mediums?

In Jonathan Safran Foer's excellent novel
Everything Is Illuminated
there is a book within the book titled
The Book of Antecedents
where in the section titled "Plagiarism"
it is written:

> God loves the Plagiarist. And so it is written, "God created
> humankind in His image, in the image of God He created them."
> God is the original plagiarizer. With a lack of reasonable sources
> from which to filch—man created in the image of what? the
> animals?—the creation of man was an act of reflexive plagiarizing;
> God looted the mirror. When we plagiarize, we are likewise creating
> in the image and participating in the completion of Creation.
>
> *Am I my brother's material?*

Are we each other's source material
and how does the art of seducing others
to sample from your own body language
correlate to your potential historical value?

Is our ability to remixologically inhabit
naturally selected source material
an innate trait based on inheritance and/or informed habit?

Are we genetically modified memory banks
bound by what Burroughs calls *the algebra of need*?

Maybe the art of Applied Remixology is at root
all about stylistic inheritance and the variable speedism of
an ongoing network mutation that happens once
every ten generations and *we*
the Innovators
have to do everything in our power
to save culture from extinction

**autocannibalizing discourse — / — algebra of need — /
— cargo of memories — / — total field of action**

For applied remixologists who perform
a new author function by hyperimprovisationally
tapping into their unconscious creative potential
in asynchronous realtime while employing
the use of network/digital technologies
as part of a larger aesthetic strategy
to hack into the commercial culture's
reality TV mindset that assigns
standardized role-playing characteristics

to whosoever chooses to play their game
(of Nielsenized viewer/one-upmanship)

there's no escaping the past

Every (instantaneous) process of renewal
depends on envisioning the visionary
i.e. the Next Version of Creativity *embodied*
which simultaneously reinvents the author function
with each writerly performance
(and remixologically speaking of renewal
I am reminded that even that rather short and insignificant
last sentence I just wrote was essentially coproduced
with Barthes and Foucault and Flusser and countless others)

To do this their bodies must be attuned
to the neural resonance of their relationships
with other people in their social network
as well as the accompanying neural resonance
they may have with all of the artworks they encounter
when engaging with activist reality hackers
whose aesthetic agenda includes designing
the distribution channels that these artworks
continuously pass through

(in *META/DATA* I refer to these distribution channels
as the networked space of flows
but when in the physical presence of others
it may all come down to the art of *mirroring neurons*
or proactively role-playing states of *literary presence*)

And yet even as we know that contemporary remixologists
cannot escape the past—the renewable tradition
they are the current manifestation *of*
demands that they perform their work in the *present*

while their processual media bodies
intuitively engage *with* the compositional potential of
Source Material Everywhere

Remixologists are in the process of learning
how to utilize their time-based media apparatus
and its concurrent filtering mechanisms
so that they can tap into the reservoir of
inherited source material
at their disposal (and in the process not so much
sift literary presence into just-in-time aesthetic information
but distill select samples of cultural data
into digitally processed forms of lit[art]ture)

Marshall McLuhan in his 1968 TV bout with Norman Mailer
now available global village–style via YouTube
wins a round when he flatters Mailer
while simultaneously chinking his armor
by countering Mailer's helplessness
in the face of information overload

Sampling televised McLuhan compressed into YouTube diction
as he engages in what now feels like
anachronistic verbal fisticuffs:

> The artist, when he encounters the present, the contemporary
> artist, is always seeking new patterns, new patterns of
> recognition, which is his task. . . . His great need, the absolute
> indispensability of the artist, is that he alone and the encounter
> with the present, can give the pattern recognition. . . . He alone
> has the sensory awareness to tell us what our world is made of.

(**Remixologist's note:** who still talks like that? McLuhan—whose sixties' metaphors helped launch our present-day Wired fashion culture—

sounds like an instructional audiobook on *telepresence* when he speaks in this fascinating TV show produced by the Canadian Broadcast Company)

Listening to McLuhan in this YouTube video it all comes down to one basic idea:

The Artist and the Present
perform together in a
Total Field of Action

This is something that I can relate to

As a contemporary remixologist
I am always turning toward the intuitive present
and make my necessary moves
in a **Total Field of Action**

That is to say I am forever finding myself
moving-remixing and/or naturally selecting
my source material while evolving whatever
stylistic tendencies that seem appropriate
in order for me to survive in the network culture

Staying on my soon-to-disappear McLuhan kick
I quickly scan the World Wide Web (global village)
and grab this famous pre-Internet quote from him:

It is the speed of electric involvement that creates the integral
whole of both private and public awareness. We live today in

the Age of Information and of Communication because electric
media instantly and constantly create a total field of interacting
events in which all men participate.

But then I take a break away from the computer
and jot down some notes phrases and other
potential source material from David Antin's book
what it means to be avant-garde
(originally sampled from for this book's opening remix)
and now have this Antin "source" in my stash as well:

> all that unites us in this country is the present / and the difficulty
> of recognizing it and occupying it / which is why it's so easy to
> slip into prophesy and the emptiness of the future / that is so
> easy / to occupy because of its emptiness / that we fill up so
> quickly with a cargo of memories and attendant dreams

immediately reminding myself
that the cargo of memories I carry around
are always already being compostproduced
into multilayered dream tracks and writing riffs
all of it meshing into One Text Exactly

one that I continually self-appropriate as part of
my open source lifestyle practice

As an "always live" networked performance artist
who willingly constructs digital flux identities
for my role-playing personae to circulate in
I uncontrollably/unconsciously create a poetics
that highlights this "cargo of memories and
attendant dreams" as prime source material

to remix into my narrative trajectory even as I too
risk slipping into the cosmically inflated empty future
full of prophetic illumination–cum–mystical vision

But as I conduct these on-the-fly remixes
using my various portable apparatuses
to capture the data my body projects
while affectively assembling the flickering images
that swarm my every move

it becomes clear that there is no choice in the matter

the choice has already been made by my biological condition

Given the fact that there is **Source Material Everywhere**
I will survive in network culture
by compostproducing the present
into an intense aesthetic experience
that will simultaneously historicize my performance
as a durational achievement in mutant fictioneering

Perhaps this is what it means to be avant-garde
in that it never feels as though I am emptying myself
into the blank canvas of the American future
as much as it feels like I am composing
a Totally Other digital art persona
who is both ahead of his time and *of* his time
but also fully engaged with select bits of data
sampled from the past and utilized as source material
to postproduce the creative immediacy of Now

Antin has little use for any detailed account of
a so-called tradition even an avant-garde tradition
or antitradition tradition:

the tradition will resolve itself in the present . . . and all you have
to do is find it / but if you don't it will find you.

In this way I often feel like someone who does what he does
because he does not know any better
and continues doing what he does regardless of outcome
intuitively generating an ongoing Conceptual practice
that experiments in the field of distribution
which then somehow strategically situates me
as part of the avant-garde tradition

But then the question emerges
"Whose avant-garde tradition?"

In digital cultures this tradition of finding
or having been found by one's unconscious creative potential
can be rendered as a formal experiment in the creation of
an even richer copoietic network environment
that facilitates the moving-remixing of
one's aesthetic potential
where going with the flow is feeling w-r-i-t-e
(i.e. feeling w-r-i-t-e as the only way to acknowledge
Creativity's all-inclusive *resolutionary* agenda
[and here I am reminded of something Charles Bernstein
once said to me over lunch referring to writing/publishing
in "high P-R-I-N-T resolution"])

Summoning the ghosts of Burroughs—
McLuhan—Williams—and Charles Olson not to mention
the recent idea riffs of Ornette Coleman and Bernstein above
I have no choice but to write

(Capturing) **Source Material Everywhere**

In a Total Field (of Action)

Watch the (Remixed) Personae **Play to Play**

Intuitively (Projecting) **Composition by Field**

Distributing (Their Intervening) **Poetic Measures**

Into the (Resolutionary) **Copoietic Mix**

(etc.)

Source material is not just data for data's sake either

Nor is it just hackworthy computer code
in an open source environment that the programmer
can manipulate to alter the functionality of the program

Source material can be found within interpersonal
relationships via the body language gestures of
those whom we used to or still hang out with
as well as the stylistic tendencies these same people
have revealed to us through their various artworks
(think of it as *The Aesthetics of Mirroring Neurons*
or *The Simultaneous and Continuous Reinvention of
What for Lack of Better We Still Call Literary Presence*)

Antin (again) in *what it means to be avant-garde:*

the best you can do depends upon what you have to do and
where / and if you have to invent something new to do the work

at hand you will / but not if you have a readymade that will work and is close at hand and you want to get on with the rest of the business / then youll pick up the tool thats there / a tool that somebody else has made that will work / and youll lean on it and feel grateful when its good to you / and youll think of him as a friend who would borrow as freely from you if he thought of it or needed to / because there is a community of artists / who dont recognize copyrights and patents / or shouldnt / except under unusual circumstances / who send each other tools in the mail or exchange them in conversations in a bar

These "friends" are crucial spigots of source material
and when added with the free-flowing excess of
our simultaneous and continuous mashup of
cultural influences that endlessly spur us on
to actively participate with a social network of
collaborators (creative co-conspirators)
we start feeling ourselves awash in an amniotic fluid
where it's only natural to experience a kind of
body-brain-apparatus achievement while giving birth to
on-the-fly remixological discourses in asynchronous realtime

This happens regularly in the life of artists
even those who become hermits or whose
situations are out of their control as they become
totally isolated from any local community
that might turn on the spigots

I have been lucky because I am always fluid
using my open-ended wanderlust
to move around the world and meet up
with those whose work has most turned me on

Moving-remixing for the nomadic artist-medium
is just another way of saying *I am a writer*
i.e. that I identify with writing because it's the only
thing that keeps me alive and gives me such pleasure

Acker (who desperately tries to avoid writing
about her writing because "if I had something
to say about my writing outside my writing,
something written which occurred outside my writing,
my writing wouldn't be sufficient or adequate")
insists that everything is thrown into her writing
and that she started to write "fiction" (which for her
is nothing more or less than "making") because
she hated the life she was living and also
hated the society she was living in (America:
New York: Lower East Side: late seventies)
and sensed that because she and her friends
could not differentiate between these equivalent hatreds
it was only normal to turn to the art of writing
as the last recourse to locate an elusive freedom
that would enable her and her friends to initiate
a "radical change" (one that would happen magically
since there was no rational way to defeat
the controlling forces of society she was ready to blow up
with the limited tools her language gave her)

At age twenty or twenty-one Acker left New York
for San Diego where she sought out Antin
sitting on his doorstep and eventually began
babysitting his kid whom she would play a game with:

Our favorite game was "Criminals"; a sample question: "Would
you rather hold up a small bank in Kentucky or poison a rich
creep who's already dying?"

Fiction = Magic (revelatory making)

This
she insisted
was the only way to
MAKE IT NEW

Which brings up another question
we might want to address to postproduction artists:

Would you rather pretend to be creatively inspired
or just make shit up out of whole cloth
ripped off the bodies of those who came before you?

Acker never felt comfortable with the kind of male
fallback position into the philosophically pure regions of
what I am referring to as Creativity:

> Fiction is magic because everything is magic: the world is always
> making itself. When you make fiction, you dip into this process.
> But no one, writer or politician, is more powerful than the world:
> you can make, but you don't create. Only the incredible egotism
> that resulted from a belief in phallic centrism could have come
> up with the notion of creativity.

This writing is indicative of the give-and-take
one could always expect from Acker
who did not see herself as an appropriation artist
although I have out of convenience referred
to her as such:

When I copy, I don't "appropriate." I just do what gives me most pleasure: write. As the Gnostics put it, when two people fuck, the whole world fucks.

Multimedia writing as Remixology should not be lazily
analyzed as a simple exercise in appropriation
as in "Oh, collage art, yes, that's been done"

Think of it more as a way of life
an alternative form of spirituality
that emerges within artist-mediums
as they play their neural instruments
triggering unconscious readiness potential

In her essay "The Path"
Acker writes:

I never liked the idea of originality, and so my whole life I've always written by taking other texts, inhabiting them in some way so that I can do something with them.

Writing as Remixology for Acker
has more to do with *body inhabitation*
i.e. metamediumystic *becoming*
or what was undeniable for her
something akin to *language fucking language*
long and hard with constant ripping
bodyimage to bodyimage
as a political form of psychic research

(just ask any of her lovers)

But at what point do these crucial spigots
pouring more source material into our lives
tweak our knobs so that we can become
radically politicized while investigating
our own looking-identity as sexual desire?

For Acker *écriture* was hedonistic pleasure
beyond the prefab morality of good and evil
true and false
normative and perverse

and she knew it when she wrote it out of her body

"A boy is looking at me"
she writes in reference to Caravaggio
in particular his *Self-Portrait as Bacchus*

> What's his look? I see: his flesh's thickness, that, though the
> muscles are showing in his upper right arm, which is facing
> me, and in the part of the back below the shoulder blade, the
> musculature is round and soft; his lips are thick; the nose is blunt
> and wide. He's sexy. This is his look: he's looking at me sexually.
> My looking is his identity is his look. This triangular relation (the
> painting) is sex; desire is the triadic look. The boy is sex.

She cannot stop herself now:

"What's his expression? Sex."

"What's my look? Sex."

"This sexual, soft and round, world
is (one of) connection."

She is convinced that Caravaggio has set up
this sexual relation between her and him:

"Since my seeing's (I'm) sexually connected to him,
I'm curious who he is. If his identity's sexuality,
what's sexuality? Who is the boy?"

Would it enflame her to know that I am convinced
that the boy is none other than Creativity's identity?

A marked identity spurring her on
so that she can tap into Desire

but a Desire that is itself in flux
able to embody random personae

"I could do this," she once said to a married couple
of which I am a member

"I could go for these walks" through the beautifully
maintained suburban community we were ambling through

"I could do this as a couple," she said
as the three of us took in the wide expanse

The triangular relation is nagging at her
but she can imagine it as her +1 +1

The world of connectedness as revealed
in Caravaggio's beautiful boy
is tricky and even untrustworthy
to the point where she has to write it out
as the every only way to commune with her love god

The looking-identity forces her to go deep inside
wondering if there really is some kind of desire
being transmitted or if it's something completely different

an aesthetic force triggering body mutation

"This picture (this looking, this sex) is now about
setting up a language. Defining words and their
intersimilarities. The world of connectedness."

Suddenly she feels connected (again)

Plugged in to what's happening as she feels it

Acker knew that this was all a setup

She was going to have to "dip into the process"
and get down and dirty with the "unlogical
or mysterious" need of her own sexual desire

its simultaneous eternity and momentariness

its agelessness

its ability to tap into the "realism of being itself"
even as she metafictionally asks herself:

"What is being communicated by this 'realism'?"

realism — / — *potentia* — / — medium spectrum — / — remixological tendencies

We don't even really have to be aware of
our past influences while we participate in
these "primary bursts of creativity immersed
in their own remixological potential"

They reside in the body like a second
or third or fourth—nature . . .
something that enables us to play ourselves
without having to think about it
(and who better to play *you*
than that on-the-fly persona you keep
generating in asynchronous realtime)

Acker and Sukenick are in me
in ways I have no control over
(and this makes me more creative
than I would otherwise ever be
even though they might have totally
disagreed with me and thought that
I was making it all up [as I go along])

Another question emerges:

Where do these creative *potentia* reside in our bodies?

Even as I pull these stories out of my networked persona
magically tapping into the keyboard console
it is more apparent than ever that the memory residuals
are nowhere to be found inside the body
even though that's where they *must* be stored

You don't have to be a twenty-first-century Einstein
to know that there are still some things that
one must believe will never be discovered

Like where the residual effects of moving-remixing
are stored *as* images in the body

Crack open my brain
and all you have is brain mush

The images won't leak out then or ever
(especially if you crack open my brain—
let me live a while longer and I'll remix what I've got)

Besides

as Einstein himself once said:

"The secret to creativity is
knowing how to hide your sources."

As far as I can tell there is no advanced biophotonic
imaging technology on the market that can come close
to visualizing our past influences in any concrete way
so we are left to our imagination—our dreams—
our advanced mnemonic devices triggering neural fireworks
in the thick pod-pool of body-brain-apparatus achievements

My experience in making art across the medium spectrum
suggests to me that the subjective events we process
while we tap into our unconscious readiness potential
are themselves the only creative acts worth investing in
and that they are generated by an ongoing sequence of
embedded remixological *styles*—styles that organically mature
via a process of innovation that—in an ironic twist of

unintentional alliance—seem to sit well with
the herding charge of technocapitalism and
its insistence on the direct presentation of
the creatively destructed things we bring into the world

(Artist's aside: if the market crash of 2008–9 indicates
what the early theorists of entrepreneurialism
refer to simply as *creative destruction*
then that's one helluva way to initiate creativity—
global financial meltdown where the very few
totally made off like Ponzi scheme bandits)

Acker writes,

> If a work is immediate enough, live enough, the proper response
> isn't to be academic, to write about it, but to use it, to go on.
> By using each other, each other's texts, we keep on living,
> imagining, making, fucking, and we fight this society to death.

This often leads to the inevitable love-hate relationship
one always has with the thing it is codependent on

Yes it's true there is **Source Material Everywhere**
so that I can perpetually postproduce the present
with each new technological advance making that
postproduction process all the more intense for me
as a digitally inclined applied remixologist

but if it's everywhere all the time
does that also not mean that I will never
be able to truly get away from it?

This can lead to some serious contradictions
in one's ongoing lifestyle practice

(Another artist aside: just last night [12.27.2008]
the power grid crashed on the island of Oahu
where not only I but President-elect Obama are staying
in the small windward town of Kailua
and from 7 p.m. until 6 a.m. this morning
there was literally NO POWER
i.e. totally pitch-black darkness

Question:

What do you do when it's totally pitch-black silent
and everyone [hundreds of thousands]
finally give in and are forced to meditate?

You close your eyes and actively dream

It was the best night of sleep I can ever remember having)

If we assume that innovation depends on
what comes before it then how does aligning oneself
with the remixologists of the past while engaging
with new media technologies of the present
constitute anything more than an attempt
at mythologizing a radical stance within
the rival or renewable tradition of art and literature
(what Acker referred to as "the black tradition")
so that we can then lead ourselves to believe that
WE the emergent network of keyboard-punching
electronically charged animal creators
are experiencing a unique moment in history
a moment suffused with a many-layered value?

Are we looking for links to the mythologized past—
something leashed to the human imaginary
like the so-called rival tradition in literature—

as a way to build whatever measurable momentum
there may be left for us to tap into as revolutionary
artists writers performers and digital prophets
whose multimedia writing gestures seek
distinctiveness but may be nothing more than
a just-in-time fashion statement for the politically obscure?

The fact of the matter is that the forever renewable traditions
have already left us behind and either
we have to find them ASAP
or—as if we really have to wait—*let them find us*
as we unconsciously trigger more readiness potential
to launch our remixological tendencies

Sitting at our Death Terminals waiting
for the next big bang of creative potential
to immerse ourselves in—we cannot help
but wonder: Is there another way out?
Which way is out? This way? Or maybe this way?
How do we move beyond the newness of
a tradition typecast as being avant-garde
but always trending toward the innovative?

Sukenick:

> Innovation bears the same relation to the mainstream as does a
> concept car to a factory model. Or even better, a hot rod to the
> mass production version. The former comparison stresses the
> experimental aspect of innovative work; the latter stresses the
> excitement, the extra intensity, the pure thrill that comes with
> the riskiness of high stakes.

Remixologists who play with innovative genres
are knowingly experimenting with forms of intense Creativity
but here the term *innovative* also brings to mind
other terms like *creative destruction*

in that the further you can push the envelope
the more entrepreneurial your writing gesture may be
especially in relation to the way one employs
new media technologies that challenge
the concept of writing to its core

Is it not inevitable that the degree to which one is
more likely to find ways to create measurable value for
their embodied praxis using new media technologies
is directly correlated to the more attracted
they will become to the latest innovations
being invented in the commercial marketplace
or that as conceptual personae initiating innovation
they are aligned with the drivers of the new media economy?

Inventing a remixological style that is distinct
and can easily be associated with your personal narrative
even as the bulk of the source material you remix
into your story is inherited from other artist-writers
who came before you

runs the risk of playing it too safe
by essentially saying "Look at me—
I am part of the rival tradition in literature
or a self-aware new media artist
and I am doing a damn good job of taking it
to its next level of innovative development
thanks in large part to my inventive use of
the latest wave of new technologies
that I have successfully employed

the way other creative artists did with
the new media technologies in their day."

Sukenick was right when he wrote
in his short story "Death of the Novel":

> Obviously there's no progress in art. Progress toward what? The
> avant-garde is a convenient propaganda device, but when it
> wins the war everything is avant-garde, which leaves us just
> about where we were before.

But then again
that excerpt came from a short story
which by its very experimental nature
could theoretically be referred to
as an innovative fiction—yes?

Or was it an innovative form of theoretical fiction?

When it comes to theory
like Sukenick I too dislike it

and yet sometimes it's impossible to ignore it
especially when its viral presence
inexplicably rises to the surface
demanding the artist's attention

Sukenick said it best when
before passing away
he wrote in his own recognizance:

> Theory for me is like the ink emitted by a squid when attacked.

Why Video Games Suck

(The Ad Reinhardt Remix)

Why work?

If Creativity is the *principle* of novelty
and following Ornette Coleman
we no longer need to *learn* to play
but must (out of necessity)
play to play

then when art making is reconfigured
into advanced forms of novelty generation
that come naturally as we ourselves
become postproduction mediums
moving-remixing in "the novel production of togetherness"

work per se is no longer part of the equation
which) is not to say that by not working
we are not able to make *artworks*

Another way of looking at it
would be to imagine ways
to turn not working
into a work of art

Or would it be a not-work of art?

The art of not working
if it produces recognizable outcomes
would then need to be reconfigured
into something more playful

The trick is to not slip into dogma
or if you do then turn it into art
because dogma in art is not dogma

The way Ad Reinhardt used to imagine it
"the meaning of art is not meaning"
since Art-as-Art revolutionizes creation
and Artists-as-Artists value themselves
for what they have gotten rid of
and for what they refuse to do

For example—*work*

"A work of art is not work"
wrote Reinhardt

"Working in art is not working.
Work in art is work.
Not working in art is working."

This somehow all makes sense to me

although I am inclined to remix it
from the angle of an intervening context

What I mean is

the context of *this* artwork is not working

Even if you take its entire premise
out of context

it's still a work of art
therefore working in it
is not working

And it almost goes without saying that
even though taking things out of context
is itself not a work of art

the actual *art* of taking things
out of context inevitably *is*

Reinhardt continues his ongoing
"Art-as-Art as dogma"
by listing what is and is not
art and not art in various contexts
while also challenging what is
in and of itself
not itself
when contextualized as art

For instance

"A color in art is not a color.
Colorlessness in art is not colorlessness."

Does this all sound unnecessarily avant-garde?

"All progress and change in art
is toward the one end of
Art as Art-as-Art" writes Reinhardt
and then tweaks things just a bit
by mixing in the avant-garde as in
"An avant-garde in art advances
Art-as-Art or it isn't an avant-garde"

In this way advancing Art-as-Art
via the trajectory of an avant-garde
syncs with Whitehead's dictum that
"Creativity is the principle of *novelty*"

Contextually speaking
once we rid ourselves of the work context
for making works of art
then Art-as-Art can present itself
as a revolutionary force fueling
Creativity as the primary principle of novelty

I would suggest that the "advance" of novelty
in pursuit of transmuting aesthetic moments
is triggered by the intensity of experience
which for an "artist of life" (Bruce Lee's phrase)
becomes an *enduring aesthetic fact*
and informs "the production of novel togetherness"

Whitehead's "production of novel togetherness"
is the ultimate notion embodied in
the term *concrescence*
and in this way when what Jung
refers to as the Collective Unconscious
gets remixed with Whitehead's Creativity
and Reinhardt's avant-garde Art-as-Art
we begin to see how the *avant-garde organism*
a Total Sum in Formation
is part of a larger alien agenda
that taps into the somatosensory system of
an embodied postproduction medium
that develops an experiential methodology
designed to achieve an ongoing sense of satisfaction
while creating intense aesthetic experiences
that one learns to spontaneously compose
as a way to totally love their creative life process

Art-as-Art — / — revolutionary aimlessness — / — ludic lifestyle — / — oscillating chaosmosis

Loving life via an anti-aesthetic aesthetic
that serves as the gift that keeps on giving?

The trick is in not working
at making Art-as-Art
because if you work at it
then it is no longer art

("Work in art is work.")

But if working in art
is not-working and not working
in art is also working
then what is it that drives
artists to realize if not fulfill
their aesthetic potential?

Is it somatosensory flow techniques
in sync with perfect *bodyimage* rhythm?

Is it the potential of experiencing
an awakened intuition
a prophetic illumination
a piercing eureka moment?

Is it a process of creative visualization
powering the artist-medium juggernaut?

Or is it simply one's embodied praxis
stimulated by the collective unconscious?

Spur me on Dead Man

Or perhaps it's the quick draw of love

This seems a far cry from Acker's
killer instinct to love texts to death
(or to let them fuck each other to death)

and in loving (fucking) them
politicizing them
as part of some practice-based
research investigation into the social psychosphere

What would an applied remixologist
intersubjectively jamming with their ludic crew
distributed in the networked space of flows
have to contribute to the collective unconscious
especially in the name of psychic research?

A mirror neuron dance with
the musing buzzwork of
the temperamental spheres?

Perhaps we need to elasticize
the potential poetic moment
while (not) (working) (our) (way)
(out) (of) (this) (situation)

Ginsberg deliberate in his prose
tells us that we have to stretch things
as far as we can take them—
"you go so far out you don't know
what you're doing, you lose touch
with what's been done before by anyone,
you wind up creating a new poetry-universe."

Stretch it out as far as it will go
rubber band style—poetry as
unconscious cosmic inflation

i.e. *our natural processes at work*

The calculating social scientists
and business gurus would have you think
it all has to do with *work flow*

yet how can *work flow* be
the driving force of Creativity
especially within the context of
a sustainable Praxis of Action
that transmits its energy patterns
from within the artist-medium's Deep Interior
that space of postproduction mantra
where the illogic of sense data
(embodied *prima material*)
evolutionarily stabilizes itself
in an ongoing autoremix mode?

Talk about a new author function!

Can *work per se* be overwritten
by the vague promise of a higher purpose?

What higher purpose?

The higher purpose of unconsciously projecting
the disseminative power of playing oneself
while operating on autopilot?

To do that while simultaneously being *of* one's time
and totally unquestionably *ahead* of one's time—

In an ideal world . . .

"The avant-garde resists all categorization"
(really? even its own categorization as avant-garde?)
and is just as likely to locate its source material
in the heavenly music of the spheres
as it is in the welcoming bowels of hell
(daily life on Planet Oblivion)

Remixology temporarily unglued from purpose
feels its way into Higher Phases of Experience
so that it can create the Next Version of Creativity
it is composing for itself
as the latest form of avant-garde expression
informing its ongoing narrative in the making

("Artists Ahead of Their Time—Take 317— Action!")

The artist-medium strategically injects
novel forms of Art-as-Art
into an invasive and debilitating creative class struggle
the thing that wants to keep Creativity down
or at the very least neuter it and absorb
its radical potential into easily digested
chunks of fantasy-play consumerism
so that local economies can flourish
in the context of an amenities-driven money culture

The necessity of Art-as-Art to counter creative class struggle
with defamiliarized and compostproduced source material
is meant to free Creativity from its economic imperative

In its ideal form Creativity does not compete
with itself or with anything else

Indeed it is simultaneously and continuously
fusing into a symphony of sense data
and is driven by what the composer
John Cage called "purposeless play"
which he identified as "an affirmation of life
not an attempt to bring order out of chaos
nor to suggest improvements in creation
but simply a way of waking up
to the very life we're living."

(Reinhardt:
"Order in art is not order.
Chaos in art is not chaos.")

Achieving a lover's embrace
is not about *work flow*
(although sometimes it may feel that way)
nor is it about the sum total of images
accumulated over a lifetime
cohering into a Dream Cum True
(but it may be closer to the latter)

Basically speaking
IF work in art is work
THEN Art-as-Art in work is "viral" Art-as-Art
undoing work as compulsory production
ELSE "not working" in life is equivalent
to the rise of a revolutionary aimlessness
thriving on an oscillating chaosmosis
that circulates in one's Deep Interior
(the Power of Inertia compounded
by the disinterest of the Silent Majorities)

OR to put it another way
why work when you can just as easily

play to play as a way to measure
your ongoing aesthetic experience
while remixing and rendering
your vision into existence?

It almost sounds too pure
a Third Way
that sidesteps both working and not working

Let's just play at making visions—
at envisioning the visionary

Which makes me wonder:

Is postproducing one's presence
as a form of purposeless play
an antiwork ethic at heart?

Or is it quite the opposite
i.e. an *always working overtime*
even and especially when immersed
in the tribal forces of dream work?

Is it a total buy-in to neoaristocratic thought
i.e. the pampered aristocracy it inevitably secures
in its embrace of appearance/play/artifice?

In his notorious essay
"The Abolition of Work"
Bob Black writes:

> The point is that the consequences, if any, are gratuitous.
> Playing and giving are closely related, they are the behavioral
> and transactional facets of the same impulse, the play-instinct.

They share an aristocratic disdain for results. The player gets
something out of playing; that's why he plays. But the core
reward is the experience of the activity itself (whatever it is).

Is the purposeless player so unreasonably selfish
i.e. not willing to contribute
to the greater whole
i.e. so immersed in their own
sense of Total Creative Oneness
even when feeding off
the social energy force fields
they depend on for remixological sustenance
that they cannot help but hungrily compete
for whatever source material is
making itself available for sampling?

("You're living off the fat of the land,"
my father used to summarize
my instincts to *play to play*)

Are competitive instincts hardwired into
remixologists' recombinant DNA
even as they perform their postproduction sets
in pursuit of the ultimate form of purposeless play?

Are remixologists who can sustain
optimum aesthetic engagement within
Whitehead's Higher Phases of Experience
and yet who simultaneously succumb
to a competitive work ethic
an evolutionary biologist's wet dream?

(Maybe I *am* living off the fat of the land
but have reconfigured it in my own thinking as

perpetually postproduced source material
sampled from the cosmic fluctuations
of our abundant/expansive universe
chock full of renewable forms of energy)

And yet while applied remixologists
become totally immersed in
the always live performances of
their ongoing postproduction sets
it becomes clear that their projective
somatosensory flow techniques
and occasional prophetic illuminations
have absolutely nothing to do
with either work or ethics per se
nor a feeling of creative one-upmanship
(for all of that I invite you to enter
the growing field of Game Studies)

Creativity as the principle of *novelty* beckons
from within the artist-medium's
unconscious readiness potential
and spontaneously discovers
whatever deep interior shots
are ready to be captured
at that particular moment in the journey

and that's all that matters

Or at least it matters to those
who transmute their avant-garde Art-as-Art
into successive moving-remixing images triggered
by fringe-flow sensations postproducing
all that has been naturally selected
from the Total Field of Action

Question:

What is the formula for remixologically inhabiting
the every only love god
one unconsciously projects at the moment of writing?

Formulaic Answer:

Embodied Praxis + Creativity +
"avant-garde Art-as-Art" +
all that matters = what it means to become
a postproduction medium

These successive moving-remixing images
embodied in the novel production of togetherness
are processually transformed into
intense aesthetic experiences
by the media body that enframes the artist-medium

Creativity via Embodied Praxis transmutes
the fringe-flow sense data
into networked forms of connectivity
that feed off the renewable energy sources
that have the potential to materialize into
avant-garde works of art experienced
in what feels like asynchronous realtime
that is to say
an ongoing process of envisioning
ludic lifestyle dreamtime happening space

but in fact happens in a timeless time
or the timelessness of cosmic inflation

This happens to every any "illimitable star"
sending its signals from the distance

so that they always make themselves
feel present while creating

To feel present when creating
is a sham of the highest order
since we know what is really happening
in the cosmological fluctuations of the future
are rediscoveries of inherited literary gestures
that have mutated into what?

I'm just improvising here—

that have mutated into what?

Hallucinatory forms of pattern recognition
selectively contrasted with experiential metadata
so as to proactively postproduce the pseudopresent?

Monkey see monkey do

The pseudopresent manifests itself
in feelings of networked connectivity
even when Art-as-Art chooses to take a different path

Networked connectivity in art
is not networked connectivity
just as form in art is not form
and (as Reinhardt reminds us)
"the formlessness of art is not formlessness."

But not if *concrescence* has any say in the matter
and how can it not?

(Art in networks is not networked art)

The Products of Pure Prehension
cohere in an oscillating chaosmosis
that thrives on the social energy of
mediums remixing aesthetic potential

("Order in art is not order.
Chaos in art is not chaos.")

But is chaosmosis in art still chaosmosis?

How can we stop ourselves
from leaking context?

Where would this always "leaking context"
leave the next incarnation of
"the novel production of togetherness"?

Will it be swallowed whole by Inertia
hoping to thrive on its big chance
to ride out randomness in ecstatic turbulence
as a way to mature and profit
from its organizational capacity
to intensify as the ultimate form of
becoming an enduring aesthetic fact
while maintaining balance in its need
to remain a stable unit in the flow of life?

Sounds like a business plan!

Or at least a potential art career trajectory

clawing its way through creative class struggle

But is it a struggle worth investing
one's entire lifestyle practice in?

The entrepreneur in me wants to throw
the dice so as to never abolish chance
but maybe that's just more wishful thinking?

(Reinhardt: "Chance in art is not chance.")

Every postproduction set performed
by the contemporary remixologist
puts into play a series of calculated risks
that continually seek to profit
from the law of diminishing returns

Pure Prehension — / — ecstatic turbulence — / — compostproduction — / — bio-becoming

In his book *A New Kind of Science*
Stephen Wolfram suggests that
to get randomness in a particular system
there is no need for continual interaction
between the system and an external
random environment since there is
always randomness in the initial conditions

Basically
as a system evolves it *samples*
more and more of this always randomness
which then results in behavior that is itself random

Becoming a postproduction medium
that randomly evolves as it samples
from the initial conditions of its
given compositional environment

(Source Material Everywhere)
initializes the process of concrescence
starting with an array of random feelings
which then leads to subsequent phases of
more complex feelings that integrate
the earlier (more immature) feelings
into optimal flows of ongoing satisfaction
(the sediment or residue of experience
coating the datum every step of the way
until the randomness of what emerges
feels as though it is itself *calculated*
into the always live performance equation)

As the complex of feelings grow and mature
into these Higher Phases of Experience
and every random gesture is a calculated risk
that generates more potential concrescence

the strange avant-garde formalism that emerges
from an enframed media body via autoremix mode
reconfigures the role of the artist
(what Whitehead calls an "actual entity")
into a postproduction medium whose always live performance
fuels the ongoing trajectory of novelty
(the primary *principle* of Creativity itself)

But are the random gestures of calculated
risk takers who fight their own inertia
as a way to realize creative potential
encoded in unconscious behaviors
embedded in the socialization of work?

Are they not also manipulated
by the compostproduction of
our turbulent social energies

compounding *actus* and *potentia*
in the raw source material mix?

Is processing the social energies of
intense aesthetic experiences
into fields of morphic resonance
another version of avant-garde formalism?

Reinhardt: "Formalism in art is not formalism."

Maybe not formalism per se
but could it be a bio-becoming of
autofictional performance?

What does it mean to transmute
the processual fields of social energy
into renewable source material
that the remixologist can then
filter into a work of avant-garde art
that unconsciously autofictionalizes
the bio-becoming of another artist-medium
circulating in the networked space of flows?

In other words

(to sample in the title of a Kurt Vonnegut short story)

Who Am 'I' This Time?

Formulaic Answer:

The Next Version of Creativity + "all that matters" . . .

Can a work of avant-garde art
be satisfactorily achieved as
a work of art that is *not* work?

Art is an activity—no?

Why work?

Black suggests we may want to call
this new form of nonwork activity *ludic*

Not working "doesn't mean
we have to stop doing things"
Black reminds us:

> It does mean creating a new way of life based on play; in other
> words, a ludic conviviality, commensality, and maybe even
> art. There is more to play than child's play, as worthy as that
> is. I call for a collective adventure in generalized joy and freely
> interdependent exuberance. Play isn't passive.

But is it truly purposeless too?

Play in Remixology is *protoinventive*
(what Ulmer refers to as a *heuretic* method)
and as such it opens the door for us
to reconfigure one's narrative in the making
into a fictionally generated journey
triggered by the unscripted behaviors of
the intuitive postproduction mediums
one is always collaborating with
as they tap into their own unconscious readiness potential

As Nietzsche once wrote
in his *Twilight of the Idols*
"We invented the concept 'purpose':
in reality, purpose is *lacking*."

(Was he tapping into his inner Buddhist?)

With the stakes as high as they are now
(and don't they always feel higher now
than ever before in our lifetimes?)
Black wants to play *for keeps*
and why not—especially given the fact
that the world we live in today is
Made for Ludic Activity

(as Black reminds us "To be ludic
is not to be quaaludic")

In his *Into the Universe of Technical Images*
the follow-up collection to the short treatise
Toward a Philosophy of Photography
Flusser writes in a chapter called "To Play"

> Information is a synthesis of prior information. This holds true not
> only for the information that constitutes the world but also for
> man-made information. People are not creators but players with
> prior information, only they, in contrast to the world, play with a
> purpose to produce information. The evidence for this difference,
> this intention, is that human information is synthesized far more
> quickly than so-called natural information. New architectural
> styles and scientific theories arise from earlier ones much faster
> than mammals arise from reptiles, for example. And this is
> because nature plays without purpose, by sheer chance, and
> human beings play using dialogue.

Remixing Flusser with Whitehead and
Black and Mondrian and Reinhardt
as well as some of my own artist theory
a variant mashup might read:

> Data is a synthesis of prior data. This holds true not only for the
> data that constitutes the world but also for the metadata that
> spurs creatures on while they create their intense aesthetic
> experiences. Human creatures are postproduction mediums
> who remixologically inhabit prior data, and if they wish to sync
> themselves with nature, they may employ a purposeless play so
> that they may simultaneously and continuously postproduce the
> (meta)data into avant-garde forms of Art-as-Art. The evidence
> for this more ludic lifestyle practice whose intention is to locate
> the pure prehension of play is that the creature as novelty-
> generator is unconsciously synthesized into its compositional
> environment as if it were the most natural thing in the world with
> no preconceived agenda attached to society's ongoing creative
> class struggle. It is the opposite of work ("work in art is work"). It
> is an ongoing natural selection of the source material triggered
> by deep unconscious projection. And this is because nature plays
> without purpose, by sheer chance, and human creatures have the
> capacity to play with their human nature.

But Reinhardt gets the final word:

"Art in art is art.
The end of art is art as art.
The end of art is not the end."

Mark Amerika Nature Photography

(Studio Remix)

"Do what comes naturally to you."

How many times have I heard that?

Reinhardt's radical separatist agenda
insists that Art as Art-as-Art
"is a concentration on Art's essential nature.
The nature of art has not to do with
the nature of perception or with
the nature of light or with
the nature of space or with
the nature of time"

to which I would add

The nature of art has nothing
to do with the nature of working

The nature of working is not nature
just as the work of nature is not work

In this regard I have been investigating
a new iteration of the term *nature photography*

Nature photography is not nature
nor is nature photography *photography*

There is no nature photography per se
but in the concrescence of prehensions
activated by the somatosensory system of
the creature becoming a postproduction medium

there may be an advanced form of life
that grows out of what we have previously
referred to as nature photography

But first

"What is the nature *of* photography?"

For me it's all about (what we used to call) the photographer
i.e. the postproduction medium that experientially remixes
their perceptions / their memories /
their fantasies / their hallucinations
as well as their proprioception (auto-affect mode)
with the image world they are always capturing
and manipulating for their own philosophical uses

Think of it as an ongoing moving-remixing
performance art momentum that plays
on whatever compositional field of action
one happens to finds oneself navigating through

So instead of asking
"What is the nature of photography?"
maybe we should ask
"What is the nature of the beast?"

There is this phrase we use in America
where we say "nature's calling"
and we usually take that to mean
that it's time to go to the bathroom
and relieve yourself of excess waste

But for me the idea of nature calling
is more complicated

When nature is calling me
it's not metaphorically ringing me on my mobile phone
("Hi Mark, this is Nature, where the hell are you?
You were supposed to go to the bathroom over an hour ago!")

Rather
my experience of nature calling
is something like me working in my studio
listening to music while I manipulate more data
on my computer but then out of nowhere
other images begin presenting themselves to me
from what feels like great interior depths
and are thus becoming rendered in realtime
(somewhere in my unconscious abyss)
even as I am supposedly lost in the flow of
a moving-remixing groove with the data
I am manipulating on the screen in front of me

These being-rendered images are calling me out
to leave my studio and go into the woods
whereupon I find myself in an unresolved/conflicted
state of being where I want to go and
experience the "outdoor" images

to *capture* them as intense aesthetic *facts*

to render them into visionary experience
(even if it be a kind of visionary-lite)

Notice I did not write
"the idea of going outside crosses my mind"
and that I then feel obliged to go and see the images

The images actually speak to me
by asserting their presence in my active remix

and before I know it I am walking zombie-like
out onto the social footpath near my studio
as the next phase of postproductivity
begins (re)layering the scenic resources
into my immediate state of emerging-agency

What I am referring to here is something different
to what I think of as conventional nature photography

This version of ongoing image generation and manipulation
inform my constant state of creative advance
where the images are *experiences* passing through my body
and are part of an ongoing hactivist moving-remixing strategy
something prolific in that I do it *all the time*

The motivating forces of my aesthetic agenda
nudging me to move my body in such a way
that it positions my *performance-inclined* flux identity
to experience a shift in the imagery
enable me to render into vision another transitional occasion
one that I automatically remix as I inhabit
this *always live* narrative in the making

This imagery is not just an external other
that I have to go out and look at so that
it then becomes real while I contemplate it
from a distance of my choosing

How can it be?

Even as I just described this transition by stating that
"images are *experiences* passing through my body . . .
nudging me to move my body in such a way
that it positions my *performance-inclined* flux identity
to experience a shift in the imagery"

I am well aware of the fact that I do not even know
where that description itself comes from

that is to say

the data is circulating inside of me the same way
the imagery is moving-remixing inside of me
and let's not forget that I am an image too
or (if you will) a digital image processing other digital images

This act of processing digital images is part of
a simultaneous and continuous performance
I am always taking part in so that I can experience
new subject positions with(in) the expansive pool of
imagery-cum–source material that circulates
in the networked space of flows

Think of moving-remixing as a creative methodology
for making new artwork that is facilitated by
a very nervous and codependent feedback system

one where postproduction artists processually infuse
their environmental source material with modes of
mediumistic affectivity that may then trigger
formally innovative eureka-like moments of discovery

Knowing this doesn't make the dissolution of work
in the context of becoming a postproduction medium
necessarily any easier

And yet it is somehow in my nature to discover
alternative ways of expressing this creative process
within the coded construction of digital words
materializing on the screen as I unconsciously script
my emerging-agency into the postproduction process

the creative process

the hybridized remix process

the inherited process of rendering digital imagery
as experiences passing through my body
so that I can then layer and relayer my cumulative
sets of feelings into ongoing states of satisfaction
derived from my life becoming an enduring aesthetic fact

This ongoing hybridized remix process is me
morphing into an image of human nature
I had no idea I was capable of innovating
but which I am now quite self-aware of due to my immersion
in the creative act of programmatically researching
the unconscious readiness potential that informs
my advance into avant-garde forms of Art-as-Art

This imagery *is* nature
 and
nature *as* imagery
is my source material

The artist as Nature's remixologist?

Could it be true that the postproduction medium is
Nature's own performance artist
remixologically inhabiting the source material
that informs their flux personae even as they
know deep inside that each gesture toward
the further manipulation of the strings of datum
that converge into so-called natural experience
is also an intuitive hack into the Real
so as to spontaneously discover what it means
to be an emerging-agency of change?

Taking pictures is no longer an option
for Nature's own remixologist
as it all comes down to capturing data
that then clusters into virtually rendered
creative visualizations of *images becoming*
whereupon we simultaneously role-play
a postproduction medium
that spontaneously composes formally experimental
works of avant-garde Art-as-Art
not as an individual artist-genius
but as a creative node in a collaborative network of
artist-mediums circulating in the space of flows

How to put it in Reinhardt-styled dogma?

***Not working* in art is Aesthetic Lifestyle Practice**

But then again this text itself feels so purposefully
avant-garde in its theoretical execution
(something that I am more than happy to wear
on my sleeve like a badge of honor)
that one cannot help but be reminded of Flusser
when he discusses the new status of the photograph
in a posthistorical sense:

> Historically, traditional images are prehistoric and technical
> ones posthistoric . . . Ontologically, traditional images signify
> phenomena whereas technical images signify concepts.
> Decoding technical images consequently means to read off
> their actual status from them.

For me technical images are digital images
and I am forever in the process of being a remixed
technical/digital image that is meant to be read

Can you read off my actual status here in this image-text?

If yes—then what is it saying to you?

Status: creative (and alone . . . sort of)

If no—then does this mean my image is too lossy
or does it say more about your reading skills?

Somehow it feels like *a crisis resolution moment*

Is it possible that my hyperimprovisational poetics
playing itself out here in the open space of
the blank screen presenting itself to me
like a virgin desert awaiting its new-fangled
experiential mark-up language (XML)
is really the result of a digital single reflex
capturing my imagery-cum–source material
as a way to technically signify envisioned concepts?

Is this what writing has come to?

Coded/conceptual images?

A posthistorical form of nature photography?

I mean

at the risk of ruffling endless feathers

what kind of serious nature photographer
takes into consideration composition / shutter speed /
aperture / exposure / depth of field / resolution
and everything else you are taught in art school?

Sorry but I can't help myself here and yes
it's true I rarely if ever take these technical details
into account as I wield my various cameras
(digital single-lens reflex—mobile phone—HDV—etc.)

For me there is so much more at stake
when morphing into this figure that
we have come to call a *nature photographer*

Perhaps I am not a nature photographer at all
but an *unnatural thoughtographer*
i.e. an alien transgressor of the Real who operates
in an evolving and everlasting age of aesthetics
as a phantom figure whose signature style
is to continuously become a postproduction medium
that captures the *prima* source material
for its ongoing remixological practice while moving-remixing
in the utopian space of asynchronous realtime
and whose avant-garde agenda is to locate
the pure prehension of play

(and to do it in a supposedly purposeless way
even as I knowingly set up strategies and
program desired outcomes to prophesize
near-future body-brain-apparatus achievements
that Whitehead suggests come into perception
in the "mix mode of symbolic reference")

How can I put it?

As part of my practice of everyday life
it's in my very nature to remix (culturally compost)
not only the recent past with the near future
in moving states of emerging-agency
but *all* of my daily functions as well

The most obvious example of what I mean here
can be understood in the context of foodstuff
i.e. the organic food I cook and eat and that is grown
in the local environment I stroll through
while capturing the multilayered scenic resources
I surround myself with not to mention
the self-correcting environmental system
that circulates inside my body as it fluctuates
through various states of mediumistic affectivity

(Queries to the author/artist *while writing:*

1. Is this also what it means to feel *natural*?

2. Is participating in a locavore slow-food movement
as close as I'll ever get to a heavily remixed
avant-garde Art-as-Art lifestyle practice?

3. Is the nature photographer who defies
both nature and photography *as is*
a moving-remixing postproduction medium
that uses fringe-flow sensations
and flux persona(e) to investigate what it means
to charge language to the utmost possible degree
ultimately rendering the static image dead on arrival
while intuiting the next phase of experience
before it even has time to make its ghostly appearance
i.e. embeds itself deep inside the turbulent waters
flooding my riverrun embankment?)

riverrun embankment — / — scenic circumstance — / — rogue denaturalizer — / — autocompose

The media body is an organic body

Being a nature photographer one should feel
compelled to ask the obvious question:
"Just what exactly *is* nature?"

Is it a sense of measure revealed in scenic circumstance?

Who/what transmits it? I don't mean in a religious
or even spiritual sense but rather in regard
to subject positioning (my intuition itself
a by-product of what we must in some way
consider the natural tells me that
nature is in constant flux
or "is the is" that *is* constant flux
but that it [nature] also gets rendered in my body
as a kind of digital image
one that I unconsciously process
when positioning my subject formation in the world
i.e. as yet another digital image remixing and being remixed
in the [post]production of novel togetherness)

These positions are interrelated to my moving-remixing—
my circuitous affectivity of network conduction—
and may manifest themselves as physical movement
(walking along a trail outside my artist studio)
dynamic movement
(driving my hybrid vehicle through
Rocky Mountain National Park)
interiorized movement
(imaging memory imaging itself)

or even proprioceptive movement
(knowing where I am without necessarily
seeing where I'm going
i.e. projecting an embodied sense of measure
as an unconscious moving-remixing body
role-playing force speed intensity duration
while shape-shifting through space)

In fact this last one
"proprioceptive movement
(knowing where I am without necessarily
seeing where I'm going)"
may be closer to what nature truly is
than any rudimentary image of colorful trees
captured by my Nikon Coolpix camera

This is not to minimize the effect of
these beautiful images that I
as artist-medium
have captured
on my trendy megapix gadget

These trace recordings of beauty
are capable of transmitting another
aesthetic experience to those who view them
and can access them as they would
any other cluster of data resonating
within the Total Field of Action
where our endless supply of source material *thrives*

They also reveal the simple fact that *I was there*
an always-becoming presence capturing and recording
just as I am doing now by writing about it
and further suggesting that *I am still here*
articulating it the best way I can

Besides I know how beautiful these supposed nature scenes are
because they present themselves to me as an occasion of
intensely experienced aesthetic composition

But the value of the experience is not
in the compositional integrity of the enframed
nor in the fact that I am the one who clicked
the camera button at the right moment in time

For me the value is in the sense of measure
my body-brain-apparatus achievement
conducted while my role-playing media body
intuitively clicked into autoremix mode
even as I shot (and killed) every image
my trigger-happy apparatus felt compelled
to put out of its misery once and for all

Does this mean that I as an artist-medium
participating in open clickual realities
am a rogue denaturalizer of everything beautiful
while finding myself easily seduced by
the logic of invention and succumbing
to the thrill of colonizing both digital and natural space?

(and who is to say there is a difference anymore?)

Or does my continual shooting and killing
as if I were a first-person video game junky
destroying my creative potential working for the man
suggest that I have already given up the ghost
so that I can share my solitaire with every other loner
the world has inevitably produced as part of
its unending quest to stifle the creative advance of
avant-garde Art-as-Art and the artists who make it?

The artist-medium is a filter
whose settings are in constant flux
and who out of necessity must allow
for the preferences of those who use *them*
to arbitrarily set the parameters of
every collaborative postproduction event

Proprioceptively becoming
a moving-remixing media body
that invents their Lifestyle Practice
one that like a cloud changes as it goes
reconfigures the artist as nature photographer
into a postproduction medium

Now is when the remixologist-cum–creative shaman
becomes an inside-out upside-down media body
who processes (surfs samples manipulates)
the (sense) data for their own pseudoautobiographical uses

You might say that this process
that enables the novelty generator
to stimulate the avant-garde organism
into a concrescence of prehensions
that autocompose their narrative in the making
is always already *second nature*

**second nature — / — VirtualRealityLand — / —
thoughtography — /— Buddha-bot**

"Nature always wears the colors of the spirit"
writes Ralph Waldo Emerson

and yet what is nature in virtuality
and do we wear the colors of the spirit
while postproducing in VirtualRealityLand?

This is not an exercise in Second Life
new age self-flagellation
nor is it a reactionary Get a Life
doctrinaire formula for those who are feeling irrelevant

It's more about going deep inside
the biochemically triggered postproduction studio
circulating inside your media body
as part of your going back to nature

Your nature

But a nature that has become overdetermined
overbought oversold overstretched
always overcompensating for its supposed *lack*
while it still attempts to maintain ultimate value
in that **Total Field of Action**
where the promise of an interventionist Remixology looms

As an avant-garde agent of formal radicalism
standing fast before the brave new world of
digicash paracurrencies funding subprime
point-and-click megaconsumerism high
on the gutted bellies of their SOMA sanctuaries
artificially juiced by their mixed reality TV boxes
stoned on the engorgement of organic Gee Whiz
Melting Plastic Fantastic Time forming dense molds of
plastered brains saturated with excess lies
that artificially inflate one's sense of self-esteem
even as the wet dream of climbing Trumped towers
leaves them feeling on the verge of collapse

the remixologist must out of necessity
reveal a narrative in the making
composed of stylistic tendencies
that will enable the aesthetic nature of
Creativity's ongoing enterprise to survive
in the networked space of flows

This is creative class struggle in a nutshell

Meanwhile all of these autogenerated 3-D boxes
keep sprouting around your media body's aura
trying to close you in and categorize you
so that you can be easily packaged and neutered
into the soft blue funk of an ethereal oblivion

Who are you this time?

Creative Art Think!
Designer Guru!
Interactive Pipe Dream!
User-Generated Content Blob!
Mobilized Mega-Hype Star!
Long Lost Messiah!
Metempsychotic Meshugana!

This is when your Second Life begins boxing you in
layering multiple personae over your avatar body
as it swiftly navigates through the faux environments
your artwork gets ported through as part of some
ongoing social energy force field of commercial relatedness

Welcome to the Land of Deterministic Demographia!

Meanwhile your creative spirit has become compromised
and you're wondering if maybe you are losing touch

with the necessary angel of animal magnetism
your physical body has been moving-remixing *in*

Imagine another life beyond Second Life
beyond the totally immersive video game of your dreams
a life where you see yourself throwing off your avatar skin
a kind of creative molting process
but where you have multiple layers to shed away
every layer stripped off a deeper peeling of the onion
as more and more of the unknown opens up to you
and you get closer to what you can only imagine is
the heart of the source material

As you continue shedding away the layers of skin
with increasing force speed and intensity
and the Outer You keeps disappearing faster than ever
you inevitably become hyperaware of the fact that
you will never really truly get to the core of the matter
because the core of the matter does not exist as a core
but is an all-encompassing source material (Nature)
and these layers you keep shedding and discarding
reveal the molting process in fast-forward motion
since new layers keep growing back faster than you can molt
and so now this screaming fast coming loose of the avatar
becomes a never-ending quest to reveal to yourself
everything you don't know and will never know
until *there is nothing left but the dreaming-molting*
i.e. the sensation of letting yourself go as you tap into
the molten lava of what hides just underneath
the skin's surface
the skin of your role-playing avatar as it shakes everything off
and you go back to first skins best skins every only skins
meanwhile the rumble of the deep interior anticipates
your next inside-out creative eruption
and somewhere in the middle of this molting-lava striptease

where your inside is out and your outside is in
you ask yourself "What is it that seeks?"

The minute you ask yourself that question
you become paralyzed with an awareness of
life's impermanence and the state of flux
your ongoing sense of measure takes for granted

But that's not all

After having asked yourself "What is it that seeks?"
now imagine a doctored-up programmable Buddha-bot
enters the scene and immediately kills you
kills you just by making an appearance

BAM!

Just like that

You're dead

Game over

But you don't really die

because you have been given a Second Life

a Third Fourth Fifth Sixth Seventh Eighth Ninth Life

the still unpeeled avatar still standing

still

 still

 still

life . . .

The rabid antitradition traditionalist
rising from the ashes

O fiery Phoenix!

A combustible medium
whose ongoing compostproduction
rumbles just beneath the surface
building up a heat intensity
waiting to be turned yet again
so as to release even more creative energy

Perhaps the live-action remixologist
who goes meta with the data of digital life
can locate another way to become
an enduring aesthetic fact
in contemporary culture?

Is it still possible for the artist-mediums
as postproduction novelty generators
to perform their creative functions
in a way that feels totally *natural*?

The ability to generate novelty
in the form of a work of avant-garde Art-as-Art
that is part of a community of concrescent occasions
intimately attached to the renewable tradition
and its adherence to evolutionarily stable strategies—

is this not at the core of human nature?

To each being several other lives were due.

evolutionarily stable strategies — / — Networked Buddha — / — memex apparatus — / — embodied destinarrativity

Mind you
I'm not a self-identified Buddhist
not by a long shot
but then I read this by Brian Rotman
on "Becoming beside Oneself"

> Computer scientist Marvin Minsky's phrase "Society of Mind" (1987), perhaps the most cited contemporary metaphor for this inside-the-head parallelism, is a rediscovery of past rediscoveries. A century before him, the idea was widespread. William James wrote of an inner mental multiplicity; Robert Louis Stevenson asserted: "Man is . . . truly two. I say two, because the state of my own knowledge does not pass beyond that point. Others will . . . outstrip me on the same lines; I hazard the guess that man" (and he means individual humans not mankind) "will be ultimately known for a mere polity of multifarious, incongruous and independent denizens." Whilst Nietzsche, ahead of the game as usual, suggested: "The assumption of a single subject is perhaps unnecessary: perhaps it is just as permissible to assume a multiplicity of subjects whose interaction and struggle is the basis of our thought and our consciousness. . . . My hypothesis: The subject as multiplicity." More than a century before this, David Hume likened the mind to "a kind of theatre" and argued that "the true idea of the human mind is to consider it as a system of different perceptions or existences, which are linked together . . . and mutually produce, destroy, influence, and modify each other."

Talk about mashup culture!

Reading the long Rotman quote above
I was reminded of a conversation
I once had with one of the Zen Buddhist monks
who invited me to Seoul in 2007
to deliver a keynote address on "Buddhism and New Media"
and who upon hearing me riff on the subject of
the Networked Buddha
asked me: "Can you show me this state of mind?"

How would we begin to visually exhibit
a networked state of mind?

My answer was a nonanswer
as I dropped some names the Buddhist monk
was not very familiar with
for example Derrida whom I suggested
saw the networked mind as an inventive remix machine:

> Deconstruction is inventive or it is nothing at all; it does not
> settle for methodical procedures, it opens up a passageway, it
> marches ahead and marks a trail.

I then mentioned Vannevar Bush to the Buddhist monk
saying Bush conceived of the networked research mind
via the memex apparatus that would facilitate
the linking/distribution process
while envisioning yet more trails:

> The human mind . . . operates by association. With one item
> in its grasp, it snaps instantly to the next that is suggested by

the association of thoughts, in accordance with some intricate web of trails carried by the cells of the brain. It has other characteristics, of course; trails that are not frequently followed are prone to fade, items are not fully permanent, memory is transitory. Yet the speed of action, the intricacy of trails, the detail of mental pictures, is awe-inspiring beyond all else in nature.

Finally I brought in to the mix
the situationist Guy Debord:

> In a dérive one or more persons during a certain period drop their relations, their work and leisure activities, and all their other usual motives for movement and action, and let themselves be drawn by the attractions of the terrain and the encounters they find there. Chance is a less important factor in this activity than one might think: from a dérive point of view cities have psychogeographical contours, with constant currents, fixed points and vortexes that strongly discourage entry into or exit from certain zones.

"These are just samples to be used as source material"
I continued my soft sell
and the Buddhist monk nodded politely
as I then began spontaneously remixing my thoughts
in front of her using the sampled bits of
Derrida's *inventio* network
with Bush's associational linking and thinking machine
and then performed *an inner psychogeographical drift*
allowing myself to be drawn by the attractions of the temple
we were walking in while having this polite discussion

Later that night I was back in my Seoul hotel
reading through a rough draft of a translation of
Flusser's *Into the Universe of Technical Images*
where I reassembled this networked state of mind
in relation to what he calls "a consensus":

> Today we have access to deeper insights into brain function and
> telematic technologies that would permit us to turn a stupid
> society into a creative one, specifically on the basis of a circuitry
> that does justice to the interaction among brain functions.
> In such a social structure there would be no more broadcast
> centers. Rather each point of intersection in the web would
> both send and receive. In this way, decisions would be reached
> all over the web and, as in the brain, would be integrated into
> a comprehensive decision, a consensus. That which is known
> in the biological sciences as the leap from individuation to
> socialization, for example, the shift from single-celled to
> multiple-celled organisms or from individual to herd animal,
> would here be achieved at the level of the mind: intention,
> decision, freedom. The single "I" would maintain its singularity
> (as does the single cell in an organism and the single animal in
> the herd), but the production of information would take place at
> another level, namely, at the level of society.

Rotman writes:

> According to historian Anne-Marie Willis, "The means of
> production of . . . visual imagery is undergoing a mutation as
> significant as the invention of photography." The mutation is
> digitization, the enabling technology of the post-photographic
> practice behind the vast upsurge of contemporary semiotic
> images that Richard Friedhoff glosses as the "second computer

revolution." And, as with its predecessors, there is the question of the transformation of the self accompanying it.

Is it possible that the digitization and
mutation of what we used to call "self"
is now entering a postphotographic
universe of technical images
one that transforms the self into an avatar
forever linked to and linking with the networked mind
that renders our unconscious sense data
into the flow of an embodied destinarrativity?

For hyperimprovisational remixologists
the transformation into autoremix mode
is not about experiencing a religious epiphany
rather it feels more like an always already *just-in-time*
cut-and-paste open source lifestyle
that is intuitively structured within the flow of
an imaginary time line that blurs all tense fields

one that is equanimous while embracing impermanence

To this last riff the Networked Buddha responds:

The body is a great void.

The state of confusion and general lack of clarity preceding the creative breakthrough in any work of art is an indication of the prophetic (and hauntological) tendencies of the artist as medium.

Technologies attach themselves to the interface between our conscious and unconscious states so, in a sense, they are alive. Or at least they seem to be.

To which I might add:

Becoming a postproduction medium
that randomly evolves as it samples
from the initial conditions of its
given compositional environment
(Source Material Everywhere)
signals the process of concrescence
starting with an array of random feelings
which then leads to subsequent phases of
more complex feelings that integrate
the earlier (more immature) feelings
into the always-live performance art time trip

In other words

always becoming a postproduction medium
requires a multimedia sense of measure
an optimum aesthetic fitness
an unconscious readiness potential
and the urge to merge

 with

Source Material Everywhere

Situationist Comedy

Probe the deconditioned mind

That's the way we approach
each performance set of writing
letting go of our thoughts
from the moment we venture
into the compositional playing field
opening itself up to us so that we record
the various energies and perceptive forces
ganging up on us as we welcome
the one true fact of tracking
our imagination sprinting
to the end of all time zones

I think of it as *using up the process*
a Total Body Energy Burn
that eventually reminds me of dank
decomposition as if creating what's next
requires my entire apparatus to mold

Or perhaps I mean *to molt*
as in the Latin *mutare* (to change)
from one layer of breathing deep
to an even lighter interior depth
before recoating the spirit
with another Furry Freak Brother
ready to slip into creative unconsciousness

On TV the other day the writer
E. L. Doctorow spoke with PBS
talk show host Charlie Rose

and said something very precise

He said

"You write to find out what you're writing"

which made immediate sense to me
and the other handful of writers who
might have been watching the show

The talk show host Rose was surprised
so surprised that he turned Doctorow's
comment into a question pointedly directed
right back at him

"You write to find out what you're writing?"

I went to bed thinking Yes
and simultaneously realized that
the beauty of deterioration
is exemplified by the figure of the writer
since I too would have to say without second thought
that I used to know how to write
but now I just write
to find out what I'm writing

Writing is not routinized
in a pathetic attempt to repeat
what has already been written
but is a projected energy pattern
something embedded in muscle memory
and clarified through improvisation
and constant re/envisioning

If it sounds a lot like writing comedy
that's because it is

Slowly perception by perception
each instant timed to sync with each
next instance of measurable body flow
the poet and the comic must relate
their own internal superclock
with the feel of vibratory becomings
so that the nuance of experience
cannot only be captured but *triggers*
an alternative sensory universe throbbing
with unexpected patterns of communication

Whether performing one's act
stand-up / spoken-word / deadpan /
plain idiom or even esoteric collage of
the simultaneous data reconfigured in
the immediacy of the event itself

however it is composed

it all comes down to timing

body timing
mental timing
sense timing
delivery timing
world-historical timing
the timing of reception

This is where the compositional playing field
topographically morphs into shape-shifting
metamediumystic event

a space where there is no out of bounds per se
but where the players still locate a framework
to unravel their elastic duration *in*

Is comedic timing visionary?

Let's not forget Carlin's visionary "time take":

"I'm a visionary. I'm ahead of my time.
The problem is I'm only
an hour and a half ahead of my time."

Every comedian who knows their shtick
will tell you first and foremost

Timing is everything

and being *in* time with your material
is one way to get a leg up
in any performance's pure potential to embody
the force field of being funny
(even when doing absolutely nothing)

In fact many of the best comedians
are known to *pull a Heidegger* every now and then

Pulling a Heidegger is engaging with
the useful philosophical themes of time and being
making them funny within a kind of linguistic force field
where absolute nothingness rules the day
i.e. locating a performance art shtick where
time and being transform into
an existential riff on being and nothingness
but then backfire into deep situationist comedy

(this is when pulling a Heidegger is further complicated
by simultaneously *pulling a Sartre*)

Jerry Seinfeld writes in *SeinLanguage*
(which I translate as Being Language
as I similarly translate his name Seinfeld
as meaning "Being-Field" or "field of being"):

"You can measure distance by time.
'How far away is that place?'
'About twenty minutes.' But it doesn't work the other way.
'When do you get off work?'
'Around three miles.'"

And yet we might all agree that even *the idea*
of eventually getting off work sometimes feels
like it is light years away

unless you approach your creative practice
as an avant-garde Artist-as-Artist
who has nothing *but* time to deliver
what amounts to One Ongoing Work of Art
that is manifestly *not* work
since it's Art-as-Art-as-Life

But then there's Death

Carlin once said that Death
is caused by swallowing small amounts of
saliva over a long period of time

Even the most deadly serious writing
from the ancient poets of numerical Life
their lines already foreclosed with no bailout in sight
still resembles an abort reboot try again

posture of going back to the drawing board
and tightening up one's act
before they lay it on their next hostage audience

The comic's dilemma of stealing
someone else's material or of having heard that joke before
if not in exactitude then in precise sensibility
relates to remix culture and the art of writing

I am constantly reading and remixing
my morning bowl of caviar insecticide
even as my latest polka ringtone
dots the audio landscape
beckoning my immediate response
while mold forms over Muse and injects
all brainwave functions with stinging blue poison

Or that's how it feels today

For today's "performance set"
remixes a variety of cultural influences
that come to me as resonant gestures
from the likes of Seinfeld Ginsberg Olson
and the conversational middle mind of
my Public Broadcasting Network
(the *Charlie Rose* show above)

Someone else perturbs me as well
in the best of all possible ways
a mocking art collector named Steve Martin

The most successful comedian of all time
the artist-writer-filmmaker Steve Martin
has just come out with his memoir
Born Standing Up: A Comic's Life

and in the book he documents his rise
from the heart of America's suburban culture
to the apex of comedy central in Hollywoulda shoulda
starting with his teenage gig at Disneyland
to his next promotion at Knott's Berry Farm
eventually entering TV writing in the sixties
up to his grueling stand-up comedy tour through the USA
before eventually becoming the seminal comedic figure
that those of us who have followed his career know he is

As he traces his trajectory through time
and relives his strategies of building sets of
what comics still call "original material"
he makes it very clear that early on
most of his work was "borrowed" from other comics
and that he gradually embedded lessons learned
from tracking these various comedic precursors
into his own act and soon transformed them via
new perceptions that came to him out of nowhere
into what ended up becoming his durational sets
and that as his confidence built and he knew
he was catching the psychosomatic wave of
a particular moment in time
he then had to POUNCE on that opportunistic moment
and see how far he could take it

In other words Martin reveals to us
the same way Ginsberg or Olson
might reveal to us via their poetics
how he taught himself *to see*

That is
to incrementally develop a sense of measure
that would enable him to visualize
what it means to become a comic artist

In the book Martin views himself
as carrying forth an avant-garde sensibility
that was "turned fully toward the surreal"

> I was linking the unlinkable, blending economy and
> extravagance, non sequiturs with the conventional. . . . I believed
> it was important to be funny now, while the audience was
> watching, but it was also important to be funny later, when
> the audience was home and thinking about it. . . . I didn't worry
> if a bit got no response, as long as I believed it had enough
> strangeness to linger.

At one point during his cosmicomedic search
he sent a postcard to his girlfriend describing
his trip to Cambridge where he visited the house of
one of his favorite poets e. e. cummings

At the end of the postcard he wrote:

"I have decided that my act is going
to go avant-garde. It is the only way
to do what I want."

and although he was not sure what he meant
by those words he was still seduced
by the thought of becoming Art-as-Art

(Yes—artists are still seduced by becoming
what they think of as avant-garde
in that they want to locate
the ultimate measuring rod
for their own derangement of the senses)

Early in his career Martin would strum his banjo
and sing lyrics that were mildly deranged

Live in a swamp and be three-dimensional.
Put a live chicken in your underwear.
Go into a closet and suck eggs.

At this point he was just getting started
but soon would develop an act that defied logic
in that he would get laughs without having
to deliver a never-ending stream of punch lines

Throughout the book he makes reference
to feeling himself become a comedian
by developing an interiorized movement
that runs parallel to his being able to
sync in perfectly with his bodily gestures

"I felt as though every part of me was working."

He was now able to generate laughter from the visuals
he was producing both propwise and gesturewise
and was even able to get the audience slaphappy
over enduring silences that would punctuate his act

Finally, I understood the cummings quote I had puzzled over in
college: "Like the burlesque comedian, I am abnormally fond of
that precision which creates movement."

A cross between Ludwig Wittgenstein
and the neighborhood kid who would beg you
to please oh please let him show you his magic act

Martin's friend the comic Rick Moranis called
his brand of humor "anti-comedy"

(something I can relate to having been called
at various times antinovelistic anti-art
anti-aesthetic and most recently anti-academic)

"I'm so depressed today," Martin would tell
his audience: "I just found out this 'death thing'
applies to me" (eventually he had to excise that line
from his act—too much new material was fighting
for placement in his perpetually postproduced comedy sets)

He used to end his act with the line
"Well, we've had a good time tonight,
considering we're all going to die someday."

Martin writes:

> Comedy is a distortion of what's happening and there's always
> something happening.

And yet as Martin who was a writer on
the heavily political *The Smothers Brothers* show
confesses in his remarkably easy-to-read memoir
he eventually stripped his act of all political references
so he could focus on being funny even if being funny
to him would take on the flavor of Art-as-Art
and challenge his audience to reset their timers

As if avant-comedy and politics were mutually exclusive—
try telling that to someone like Stephen Colbert

In his exploration of *truthiness*
which the American Dialect Society voted
Word of the Year in 2005
the mock political pundit Colbert
suggests that facts may not always tell us
what we want to hear and so are therefore
no longer reliable gauges of what is true

In an interview with Colbert focused on
comedy improvisation and *The Daily Show*
he reflects on his calculated truthiness:

> Truthiness is tearing apart our country, and I don't mean the
> argument over who came up with the word. I don't know
> whether it's a new thing, but it's certainly a current thing in that
> it doesn't seem to matter what facts are. It used to be everyone
> was entitled to their own opinion but not their own facts. But
> that's not the case anymore. Facts matter not at all. Perception is
> everything.

"How does one report the facts," once asked
actor Rob Corddry on *The Daily Show*
especially "when the facts themselves are biased?"

Referring to the forever "Mission Accomplished"
Iraq war started by George W. Bush in 2003
Corddry explained to host Jon Stewart
who played straight man
that "facts in Iraq have an anti-Bush agenda"
and therefore can't be reported

Corddry's parody of journalists who believe
they must be "balanced" even when the truth
isn't balanced continues to ring true today

Basically what we see happening is that facts
are just more potential source material
for so-called journalists and pundits alike
to remix into whatever portrayal of the Truth
they so deign as part of their role-playing shtick
in what some view as an endless *Comedy of Errors*

Which brings up the question:

"Is fake news more informative than so-called real news?"

From the perspective of Remixology
much of the *Daily Show*'s and the *Colbert Report*'s success
is due to their ability to mash up media elements
that (sampling Ginsberg) "go so far out
you don't know what you're doing, you lose touch
with what's been done before by anyone,
you wind up creating a new poetry-universe."

The best *Daily Show* and *Colbert Report* routines
resonate with Burroughsian routines and cut-ups
and are inevitably connected to the show's writers'
ultimate skill at remixologically "going meta" with the data

During spring 2006
at the White House Correspondents' Dinner
Colbert's keynote performance was dark comedy at its best
and harshly ridiculed not only Bush
but the docile and masochistic Beltway media
who underserved their country when it came
to reporting the news in the lead-up to the war in Iraq

Colbert's performance at the DC event was compared
by the online journal *Salon* to the situationists and their
"ironic mockery 'détournement,'
a word that roughly translates to
'abduction' or 'embezzlement.'"

The writer continues:

> It was considered a revolutionary act, helping to channel the
> frustration of the Paris student riots of 1968. They co-opted and
> altered famous paintings, newspapers, books and documentary
> films, seeking subversive ideas in the found objects of popular
> culture.

Situating Colbert's performance in the lineage of
situationist détournement or even Lautréamont
reveals how Colbert's shtick released Maldoror-like
"deadly emanations" from the explosion of his comic barbs
so that they would "soak up our souls like water does sugar."

The funny yet also sad thing is that
the clueless Washington press corps
did not even realize this was happening to them
and that the entire event was a pitch-black joke
delivered at their expense

(most did not laugh and clearly did not know what to do)

Six months later we had the 2006 elections
and the blurring line between truth/fiction/truthiness/spin
and straight-out lies and deceit had become
one of the top metasubjects after the campaign

Who to believe?

In one of his Sunday *New York Times* columns
just before the 2006 election Frank Rich wrote:

> The 2002 midterms were ridiculed as the "Seinfeld" election,
> "about nothing," and 2006 often does seem like the "Colbert"
> election, so suffused is it with unreality, or what Mr. Colbert calls
> "truthiness." Or perhaps the "Borat" election, after the character
> created by Mr. Colbert's equally popular British counterpart,
> Sacha Baron Cohen, whose mockumentary about the American
> travels of a crude fictional TV reporter from Kazakhstan opened
> to great acclaim this weekend. Like both these comedians,
> our politicians and their media surrogates have been going to
> extremes this year to blur the difference between truth and
> truthiness, all the better to confuse the audience.

The Colbert and Borat characters are very direct
in their role-playing personae's in-your-face immediacy
and suggest a remixological inhabitation of both
Steve Martin characters from his political humor days and
his Hollywood-driven caricatures like The Jerk

Of course comedic jerks are one thing but the Real Deal
in the form of the president of the United States is another

Rich continues:

> But there's one important difference. When Mr. Colbert's fake
> talking head provokes a real congressman into making a fool of
> himself or Mr. Baron Cohen's fake reporter tries to storm the real
> White House's gates, it's a merry prank for our entertainment.

By contrast, the clowns on the ballot busily falsifying reality are vying to be in charge of our real world at one of the most perilous times in our history.

Rich closes his argument by writing:

In retrospect, the defining moment of the 2006 campaign may well have been back in April, when Mr. Colbert appeared at the White House Correspondents' Association dinner. Call it a cultural primary. His performance was judged a bomb by the Washington presscorps, which yukked it up instead for a Bush impersonator who joined the president in a benign sketch commissioned by the White House.

Colbert who unlike Martin has been able to situate his jerk into the belly of the beast because his political material openly remixes Bush ideology with Faux News enthusiasm in mock-hysterical extremist monologue

had this to say at the big dinner:

But the rest of you, what are you thinking, reporting on NSA wiretapping or secret prisons in eastern Europe? Those things are secret for a very important reason: they're super-depressing. And if that's your goal, well, misery accomplished. Over the last five years you people were so good—over tax cuts, WMD intelligence, the effect of global warming. We Americans didn't want to know, and you had the courtesy not to try to find out. Those were good times, as far as we knew.

With the President right by his side
and all of the media elite
sitting in front of him
Colbert persisted:

> But, listen, let's review the rules. Here's how it works: the
> president makes decisions. He's the decider. The press secretary
> announces those decisions, and you people of the press type
> those decisions down. Make, announce, type. Just put 'em
> through a spell check and go home. Get to know your family
> again. Make love to your wife. Write that novel you got kicking
> around in your head. You know, the one about the intrepid
> Washington reporter with the courage to stand up to the
> administration. You know—fiction!

The media lashed back:

> Mr. Colbert had gone through a litany of his own branded,
> harsher barbs, courtesy of the persona and in some instances,
> the scripts adopted on his cable comedy show, *The Colbert
> Report*.

The Persona— sometimes scripted—
sometimes not—wrote his way into the event
so that his "well-worn shtick" (their term)
would have its final say on the political farce
that passed as our contemporary federal government
run by so many crooks cronies and liars that it became
difficult to outfarce them (it's as if the Bush administration's
"well-worn shtick" [my term] got wearingly one-note-ish

and whenever they went out to "try new material"
the audience booed them off the stage

except instead of going back to the drawing board
and trying to find new material that would jive
they instead dug deeper into their bunker mentality
declaring the rest of us part of "the reality-based community")

The *Salon* article on Colbert and Situationism
attempted to quote Guy Debord as a source:

> "Plagiarism is necessary," wrote Guy Debord, the famed
> Situationist, referring to his strategy of mockery and semiotic
> inversion. "Progress demands it. Staying close to an author's
> phrasing, plagiarism exploits his expressions, erases false ideas,
> replaces them with correct ideas."

Of course as noted earlier in this book
that quote is from the nineteenth-century writer
Count de Lautréamont, not Debord

but the dark violent comedy from Lautréamont
(the author of *Maldoror*) does not get its props here
because reporters rarely do their in-depth homework
and besides when the dark humor of the artist-terrorist
overtakes the political intentions of that same artist
it's hard to make the necessary connections
one must account for when writing journalism
(this is also why most of the journalists
at the Correspondents' Dinner didn't get it—not because
they are dumb although some of them may be that too
but because they have not done much investigative research
into their own and America's dark side)

Have you ever read a story in the *Washington Post*
about how the darkest psychic undercurrents of American
social behavior feed into the manufactured fear factors
produced by the in-cahoots politicians
and their none-too-subtle attempts
to rule over our individual thought processes?
That would never happen as they have to control
the kind of *truthiness* they work into their "stories"

Fortunately we have the Comedy Channel
for these leaking remixological truths
that mash up the media narrative
and turn it into Swiftian metafarce

And with that in mind it would be best to say:

We need more Situationist Comedy

In *Laughter: An Essay on the Meaning of the Comic*
Henri Bergson writes:

> There may be something artificial in making a special category
> for the comic in words, since most of the varieties of the comic
> that we have examined so far were produced through the
> medium of language.
>
> We must make a distinction, however, between the comic
> EXPRESSED and the comic CREATED by language. The former could,
> if necessary, be translated from one language into another,
> though at the cost of losing the greater portion of its significance
> when introduced into a fresh society different in manners, in
> literature, and above all in association of ideas. But it is generally

impossible to translate the latter. It owes its entire being to the structure of the sentence or to the choice of the words. It does not set forth, by means of language, special cases of absentmindedness in man or in events. It lays stress on lapses of attention in language itself. In this case, it is language itself that becomes comic.

Premonition Algorithm

Premonition Algorithm

Premonition Algorithm

Premonition Algorithm

Premonition Algorithm

Premonition Algorithm

How can an angelic hipster
one bound by the bohemian tradition
prophetically illuminate
their mind bank network
while staying true to their
gut-level pocketbook issues?

Is Deep Recession a prelude
to massive global meltdown
and is that the green-screen dream of
every undercover poetry agent
ready to unconsciously project
his visionary agenda into the world?

According to Ginsberg what we hope
to discover as we compose the ongoing experience of
novelty generation is "the final revelation of
the irrational nonsense of Being"

But does this "final revelation" relate to
inequitable markets awakening
as if from a prolonged stupor?

Were the interactive info drones
ever really rising above it all
or was it always part of some cruel joke
where they were destined to fall
precipitously into the subgrime gruel?

Will we ever witness the day where we see
a total cleansing of the whores of Tomorrowland
hosing excess soot off their dirty money
and turning to other minted forms of print technology
for their high-resolution hijinks and terminal
degradation of the soul slipping into oblivion?

A conditioned indetermination?

Recession is like poetry
we only know we are in it
after the fact of its discovery
which happens of its own accord
like magic but still part of a cycle

(or so goes the Austrian theory of business
which tells us that a savings-induced boom is sustainable
while a credit-induced boom is not)

Boom boom out go the lights!

Tomorrowland — / — multiple observers — / — eternal inflation — / — utility program

Out of the pocket universe
a dark energy soars
freaking out multiple observers
caught in cosmicomic tragedy
as the fertility bubble bursts

Momentary fluctuations
in the catastrophic currencies market
flip well-planned real estate investments
into volatile moneyed rape scenes
creating improvised soap operas
where everybody gets screwed
by unmasked men and their administrative accomplices

Buying into a reincarnation of eternal inflation
expanding beyond the wounded galaxies

the info drones spin themselves dizzy
going nowhere really fast

while assuming eternal returns
on a series of bad investments
will have some tonic effect
on the wherewithal of creeps everywhere
as if time really were on our side

(it is not

 nor are we capable of flipping *it*)

Having said that
given the protocols of this eternal inflation
do we eventually come back into this world as ourselves
yet reincarnated as time trippers
from the future that never was?

Or is our imaginative stretch a result of *durée* elasticity?

Maybe it's time to deflate egos worldwide
(to catapult Rip Vein Wrinkled zombies
into the impossible-to-imagine future
that never was or will be)

Watching the shoveling masses
keep digging their own graves
even while unearthing the sweet nothingness of
loose change "they can believe in"

we cannot help but seriously wonder
"What does it feel like to be indebted
to a systemic problem the size of the world?"

In the dark where no devoted consumer
would ever want to hide while appearing
to have already secretly sidestepped Death
and its perfectly executed utility program

one cannot imagine the face they were given
before they were born and bought and sold
and perfectly executed in base utilitarianism

For this they need some kind of artificial light
oftentimes produced by the flickering screens of
their computer monitors stealing their eyes
and even then the face they see is merz cosmetic

A dull populace hoodwinked into complacency
is given new battery life with a stimulus of cash
targeted at transcending the Great Inevitable

Meanwhile they find themselves transforming
their formerly winning brand into a reality TV farce
documenting the Biggest Losers devouring time

What shall we consume today?

A stainless steel cookie cutter
bought on eBay (plus shipping): $10.25

A tank of gas to continually go to and fro
the processed-food market: $80.00

A night's supply of party favors: $200.00

Global warming?

Global warmongering?

Priceless.

And yet we could see it coming all along

Premonition Algorithm

Premonition Algorithm

Premonition Algorithm

Premonition Algorithm

Premonition Algorithm

Is there another way out?

Can we reach a Brown Rice Accord?

**merz cosmetic — / — calculated dreaming — / —
viral contagion — / — premonition**

In the aftermath of calculated dreaming
mildly relaxed drinking Zen green tea
bought in the airport in Seoul Korea
the sounds of the gentle ocean approaching
in rhythmic clarity not because I am on the shore
(though I will be in less than an hour)
but because I have recorded these sounds
on my flashy video iPod so that I can listen to them
while wearing my Sony DJ headphones
and can take myself back
to the fast-forwarded dream of another Tomorrowland
bending time as loose as an old rubber band stretching
to the point of eventually breaking
whereupon I can finally be me
that once-stoned hallucination of not being me

It's one thing to say that you
are becoming an avant-garde artist
and quite another to actually innovate
new modes of postproduction
that will take on the necessary
memelike effects of a viral contagion
compounding collective interest
in your aesthetic currency

Self-meditation may be overrated
but still I cannot help myself
and soon hear my guru-other speak:

"If you can even begin to follow
the flow of my language as I write it here
and can autogenerate random bits of meaning
out of my on-the-fly philosophy
that blurs the distinction between art and life

then you may have the total capacity
to radically alter the way you approach
both your art and your life as one
simultaneous and continuous expression of Creativity

Maintaining optimal synchronicity with the flow of
this simultaneous and continuous creative expression
as it circuit bends your art and your life into One
+1 +1 +1 +1 +1 +1 +1 +1 +1 +1 +1 +1
will provide you with everything you need
to not only survive in the art world
but to seriously *transform* it into something else

something that better reflects
where you as an artist want to see this world go
as you yourself create openings for your art-life
to expand *in* while staying *on the edge of*
everything you never knew you had it in you
to create (this is what it means to be *avant-garde*
and [surprisingly not] to be *entrepreneurial* too)

Staying on the edge of who you are
while maintaining core principles of remix practice
is not necessarily conducive to pretty pictures
or traditional tales of human culture

and in fact sometimes you have to strike out
at the faux environments the corporate entities
fill your brain up with so that you will stay comatose
and benign while submitting to their commercial claptrap
and the manufactured ideas and opinions
they propagate as a way to keep you sleeping

Instead try and surmise what it means to awaken
to envision the visionary agenda
in full force ready to creatively cultivate
protruding tender nuggets from the burgeoning
marketplace of ideas [info-corn]
and to convert them into alternative forms of energy
distributed through your nonbinding neural network"

Meanwhile

Somehow you have to find a way to make art
while simultaneously innovating your practice
while simultaneously spiritualizing your practice
while simultaneously marketing your practice

and so what if you are anarchic and refuse to work
and/or Marxist and want to belabor the point?

Can you still be an avant-garde Artist-as-Artist
who finagles innovative ways to survive in the ramped up
world of turbocharged technocapitalism?

And what happens when what is ramped up
and turbocharged begins its market meltdown?

Will you be lucky enough to "just get by"
or will you need to go against your better
avant-garde Artist-as-Artist self and sell out?

What is selling out anyway?

Especially when you're already *buying in*?

Is this too black and white?

Yes

Always

Creative class struggle is much more complex
than anything we can approximate in a poem
or a work of moving visual art that passes itself off
as a thinking fuck machine experiencing the latest
in premonition algorithm technology

Even as I write the words *premonition algorithm*
I wonder where on earth they come from
(or do they even come from earth?
 in this regard
 what does it mean to transmit
 a thought frequency from another
 totally different world
 a dream world within our own world
 a world that creatively de[con]structs
 this world we can no longer live in?)

These suddenly appearing words *(premonition algorithm)*
just come out in random expectoration
like some visionary spam generator
that wants to compete with language artists
in that part of the market devoted to High Conceptualism

But it may be something more than that
perhaps a memory bleed that feeds

into my ongoing expectoration of chance connection
a kind of seeing-form or Eye-Ching roll of the dice
that spills its nuance with every novel episode
revealing sensory data points requesting entry
into the portals of my throbbing unconscious
as it creatively visualizes my next mediumistic becoming

The memory bleed reminds me of a panel discussion
somewhere in Europe or maybe it was the UK
(are the Brits still not defining themselves as Euro
or are they lightening up the heavy Pound Away
at what could be inevitable though possibly not?)

On the panel there was a divide between those
who would tell us that the power of programming languages
and the protocols that run computer networks
are the beginnings of alien life forms that are projecting
their all-encompassing goal to totally control the universe
and that as artists we must hack these languages
as a way to maintain the antitradition tradition of
the avant-garde

and those who on the other side while acknowledging
the phenomenological certainty of
such protocols and programs
were wondering if it were not just
one aspect of life among many
that the avant-garde artists could take into consideration
when investigating their aesthetic potential to generate
novelistic interventions into society's controlling systems

A question that had been on my mind for days
was how do we (avant-garde artist-agents)
generate what we have come to call premonitions
and is it something that can only manifest itself

from within the interior depths of an unconscious beast
or would it be possible to program such an occurrence?

What then is the premonition algorithm?

Thanks to Wikipedia we soon come to realize that
no formal definition of algorithm exists although
the readymade explanation has determined that an algorithm
is a definite list of well-defined instructions
that once executed will terminate in the completion of a task

In this sense we venture away from the readymade
and bring into the realm of possibilities the idea
that effective parsing of the premonition algorithm
must be articulated in the grammar of Creativity

Creativity in this instance as the principle of *novelty*
would always be tapping into unconscious syntax
taking on the role of embodied processing agent

In this sense every artist can say "I am Creativity"
(i.e. "I am an embodied processing agent")
and somehow get away with it (why not?
Whitman got away with the "body electric")

The reason the premonition algorithm *must*
be articulated in the grammar of Creativity
is because the source material that informs its data set
is codependent on the aesthetic potential
released by Creativity's own processual grammar

It ends up that writing into vision
a premonition of the "future beyond"
is already conditioned by the creative process

as it moves-remixes within the unconscious
(conceived here as an indeterminate neural mechanism)

Of course this does not mean that fashionable beasts
who live to play with their unconscious readiness potential
are actively hoping to mimic the process of computers
or that computers are syncing with avant-garde artist-agents
so that they can then sneakily *become* the artist programmers
who invent their code so as to create
their aesthetically pleasing data visualizations
for art appreciators the world over to see

Rather
affective agents of embodied moving-remixing
become postproduction mediums by *envisioning*
novel forms of Creativity that are generated
first by conducting intense aesthetic experiences
within the conditioned context of an organism's trajectory
through given impermanence and the contrast of
manipulated/manipulating flux identities

regardless of what new or old media technology
they happen to be engaging with at the given time

Envisioning a channel of ongoing becomings
that transmute images into visionary experiences
is what writing the premonition algorithm is all about

But what triggers these visionary experiences
and the images they project into the scene?

Is it the art-making apparatus?

The artist as postproduction medium *as* art-making apparatus?

Or is it more benign than all that
i.e. some experientially developed codework
driven by an intuitive impulse to hack reality?

Can visionary experience itself be programmed
and routed through a series of protocols
that enable its output to attain some kind of
inherent value that goes beyond the market
(financial art academic commodities etc.)?

The answers are not even remotely available
in any observational format or research study
and speculation leads to more complexity and confusion

To elaborate:

the premonition algorithm is written in
an unconscious programming script
that comes about due to artists' ability
to tap into their creative agency while actively remixing
the metadata of their always live performances
what we might otherwise call their proclivity toward
becoming a postproduction medium
i.e. the artist-medium as remix apparatus

One might say that this is how we *make discoveries*

For example
think of the many great scientific and social discoveries
that have happened in the middle of dreams

Stories abound of creative thinkers sleepwalking
into their studio/lab spaces and jotting down
their latest discoveries while experimenting
with the premonitional possibilities of the Deep Interior

Or what about self-identified
Buddhist-inspired mystic hipsters
experiencing prophetic illuminations while tripping?

(The Nam June Paik Refrain: "A mystic forgetting himself")

This is an indication of where the avant-garde artist
as serial entrepreneur and activist novelty generator
can begin to locate methods of operation
that may enable them to not only thrive on chaos
but to take their practice to Higher Levels of Experience too
(i.e. where avant-garde artist-agents
as postproduction mediums
discover Creativity as they compose their lives
in accordance with the Whiteheadian dictum that
an intense experience is an aesthetic fact)

Let's take for example
(it's non sequitur within non sequitur time)
something completely off the top of my head
where I am imagining how
an evolutionary biologist becoming-poet
or poet becoming–evolutionary biologist
might respond to the global financial crisis of 2008
and without even thinking about it
begin remixing all available source material and write:

Feeling the frequencies
a punctuated equilibrium
spurting high volume change
makes the romantic volatile
in its search for stimulus

The unconscious reservoir coalescing
in pools of primitive moisture rank

with the odor of inherited tribalspeak
mixes parallel tracks of mother tongues
lashing out at circadian circumstance

while navigating the mission creep of
genetically modified versions of DNA

Elliptical sensations of ping mechanism
leaving a trail of traces that exfoliate
mannered memory and shake rattled
role-playing functions in modular tempo

appear to be gradual and stabilizing
but are really camouflaging all bills due
in mossy phenotype of cladistic muckwork

Any random nucleotide that tries to tell you different
may arise not only from unresolved biotrends
hovering in morphological stasis

but may also be refining the next approach
to intensified instances of variable speedism

In other words

Mr. Toad's Wild Ride

Which leads me to believe that *first*

Find a way to make art
while simultaneously innovating your practice
while simultaneously spiritualizing your practice
while simultaneously marketing your practice

and do not worry about what comes second
since it's the trigger inference that counts

Is that new age enough for you or *what*?

(or is it *more* than that i.e. is it eternal Beatnik wisdom?)

One of my more esoteric avant-garde math formulas
would translate the above italicized lines as

**Making Art + Serial Entrepreneurialism +
Daily Spiritual Practice + Guerilla Marketing
(PR Hacking) Skills =**

**Evolutionarily Stable and Tactical Approaches
to Novelty Generation in the Marketplace of Ideas
(and how to turn that into Cold Hard Cash
or if not Cold Hard Cash at least
Valuable [Intense] Experience)**

Marketing Amerika
is not as easy it looks
and getting into that special groove of
parallel processing that inextricably links
Creativity with Monetization
has very little to do with making money per se
and everything to do with *making do*
(and out of making do making money)

Monkey see monkey do

Making do is something that goes beyond
the clichéd notion of just getting by
as in "How are things going?"

and in response

"Oh, I'm making do"

It's much more than that
since the idea of *techne*
when remixed with *copoiesis*
suggests that without making-doing
(what here I have referred to as moving-remixing)
there is no status quo
to *move beyond*

Why?

Because making-doing just like moving-remixing
is all about the creative process and novelty
i.e. the aesthetic agent's ability to aggregate
experiences and feelings over the course of
an organism's trajectory which as it evolves
becomes influenced by and is itself influencing
the ongoing morphic resonance of the art world

(Meet the Remixologists)

Which brings me to some necessary dogma

i.e. the world artists compose their
open source lifestyle practice *in*
is the art world

The art world is not the art market

Art in the art world is art

Art in the art market is art

The art market is in the art world

The art world is not in the art market
(rather it contains the art market
or you could say it enfolds or better yet enworlds
the art market as more commercial by-product)

The making-doing of avant-garde artists
is connected to the moving-remixing process of
always making art in the art world

Being an artist-medium who intuitively
enworlds the creative act requires that
the ensuing postproduction occurs in auto-affect mode

From the core of his belief system
Henri Bergson was succinct in his assessment
and so it must be looped back into the performance:

> There is no perception without affection. Affection is, then, that
> part or aspect of the inside of our body which we *mix* with the
> image of external bodies; it is what we must first of all subtract
> from perception to get the image in its purity. *(emphasis mine)*

Affection is the well-executed program
that all remixologists turn to for their
ongoing postproduction sets (of data)
so that they may affectively assemble
their unconsciously manipulated source material
into an enduring aesthetic experience

(parse the remix at your own danger!)

Making avant-garde art in the art world
is the same as living life
as a serial entrepreneur
in that by becoming avant-garde per se
we begin to intentionally develop
an affinity toward novelty generation
as the primary principle of the creative process

(although in the art world
it is always clever to never admit this
in hopes that it will lead to more value
in the art market)

(Meet the Entrepreneurs)

Being avant-garde in this context
means moving beyond the status quo
and maintaining feelings of ongoing satisfaction
as artists become aesthetic agents of transformation
(their own transformations but possibly others too
what are artist friends to other artist friends
but the social networking equivalent of
professional lifestyle coaches able to commiserate
on the ups and downs of a makeshift life
devoted to perpetual creative class struggle?)

If an avant-garde Artist-as-Artist
is about anything at all
it's about this idea of *moving beyond*
i.e. going meta with the data
i.e. affectively generating their next iteration of

novelty (via spontaneous moving-remixing)
and in so doing staying ahead of one's time

Moving beyond the status quo
as a prolific avant-garde Artist-as-Artist
requires a protracted presence
in the marketplace of ideas
that muddied space of social competition
where consumers crunch numbers
only when forced to comply with
legal loan sharks baring mouthfuls of teeth
ready to tear into complacent flesh

(Invasion of the Paycheck Snatchers)

flesh that has been so enamored of
its capacity to consume everything in sight
that it usually forgets what flesh is best at
i.e. sinking/molding into other flesh and anchoring
swollen connections while electrifying impulses

Find a way to make art
while simultaneously innovating your practice
while simultaneously spiritualizing your practice
while simultaneously marketing your practice
while simultaneously enflaming your practice

Henry David Thoreau was crunching the numbers
all throughout his epic struggle
as documented in *Walden*
and if you read Andy Warhol's diaries
you will find yourself bored to tears
glazing over the lists of expenditures

he meticulously notated for his daily entries
so as to try and keep the IRS off his back
("Laundry: $1")

In one of my new artworks

*How to Succeed in the Art World
During the Coming Global Economic Crisis*

I outline a series of artistic methods
and business strategies not to mention
tactical media interventions
that will enable collectors/gallerists
curators and most especially struggling artists
to reconfigure their subject positions
within a volatile marketplace of ideas

I also use this artwork to demonstrate
via my own example how artists can embody
the universal tenets of an *open source lifestyle practice*
that enable them to manipulate the media ecology
our panic-driven economy depends on
for its psychological ebbs and flows

This new artwork loudly declares that

Understanding Media is OUT

Misunderstanding Mediums is IN

It is really about learning how to (mis)read
the emotional codework of global number crunching
while counterintuitively playing *with* the contraindications
and once you use my new artwork to decode
the myths of the marketplace while revealing

to yourself the secrets of novelty generation
you will have the power to turn what you lack
into something that sustains you for the rest of your life

(Look at me
 I'm writing this to you from a beach in Hawaii!)

When I'm done with today's writing stint
I am going to walk on the beach
and generate new premonition algorithms
via my ongoing study of *moving-remixing*

Moving-remixing is how I generate my ongoing aesthetics
or to put it another way it's my operational mode of
postproducing new artwork using my body
as the medium as the message

There can be no doubt that for me
perambulating on a beach with mild trade winds
is the key to rendering high-definition artistic vision

I call it *meditative walkology* and with the breeze passing
through my body and into my eyes gently massaging my brain
I can instantaneously imagine shapely reconfigurations of
my otherwise random thought processes
swelling from the Deep Interior
where the source code is just dying to be manipulated

What does it feel like to be automanipulated?

Hitting the space key over and over again nothing appears
but the cursor keeps moving and I feel my swelling body enter
a flow-space where I can sense my filtered energy patterns
become sculptural indications of inexpressible changes

re-verbing in the vibratory consequence of each micro subtlety
while my heart transfuses new blood music
into whatever sensations are generated
on-the-fly even as my life is on its way
to last-chance emptiness of everything I ever envisioned

s p a c e

Tracing the route of its specific narrative circumstance
while shining in the particulate light with sun beheadings
and an early morning fog complicating
this caffeinated dream of jacaranda Jacuzzis
and 100 percent organic Kona coffee
there comes a mellowness beyond all rational control
so that the rhythmic consistency of incoming waves
if you can call these soft-spoken guests waves
make themselves at home in my writerly comfort zone
that lazy *lanai* of run execution run slow-walk *molt*
where the only thing preprogrammed is my midmorning
wake-up call from the sound of pigeons mourning
the loss of yesterday
too

p a c e

Writing this from the moving edge of the shoreline
along the windward coast of the island of Oahu
I am reminded of the different interpretations of
the word *kahuna*

Some say *kahuna* is derived from the word *kahu*
which means "caretaker" and in this case
refers to the High Priests in Native Hawaiian culture

Others though suggest that when you break it down
Ka means "the" or "light" and *Huna* means "secret"
as in something hidden within that must be discovered

 a c e

In this latter sense the *premonition algorithm*
is something that visionary avant-garde artists
are always generating new ways to unearth
reinvesting some tactical legendary status
into what it means for one to devote one's art-life
to becoming a moving-remixing technoshamanic
postproduction medium who can really *talk story*

> **(Meet the Talk Story Professionals:**
> **Uncovering Conversational Metadata**
> **in Coded Scripts with Gestural Tagging)**

c e

How this transformation manifests itself
will always have to come out in the artwork itself

(a spontaneous deliverance of creative matter
autogenerated from the Deep Interior)

but that's all I can say

e

Source Material

Acconci, Vito. "Steps into Performance (and Out)." In *Theories and Documents of Contemporary Art: A Sourcebook of Artists' Writings*, ed. Kristine Stiles and Peter Howard Selz. Berkeley: University of California Press, 1996.

Acker, Kathy. *Bodies of Work*. London: Serpent's Tail, 1997.

———. "The Language of the Body." *ctheory*. http://www.ctheory. net/articles.aspx?id=1.

Air. "Electronic Performers." *10,000 Hz Legend*. Astralwerks, 2001.

Amerika, Mark. *The Kafka Chronicles*. Boulder, Colo.: FC2, 1993.

———. *META/DATA: A Digital Poetics*. Cambridge, Mass.: MIT Press, 2007.

———. Professor VJ. http://professorvj.blogspot.com, 2006–.

———. *Sexual Blood*. Boulder, Colo.: FC2, 1995.

Antin, David. *What It Means to Be Avant-garde*. New York: New Directions, 1993.

Antin, Eleanor. Interviewed on *Art in the Twenty-first Century*. PBS, 2003. http://www.pbs.org/art21/artists/antin/clip2.html.

Baraka, Amiri [LeRoi Jones]. "Letter to the Evergreen Review about Kerouac's Spontaneous Prose." In *The Portable Beat Reader*, ed. Ann Charters. New York: Viking, 1992.

Barthes, Roland. *S/Z*. New York: Hill and Wang, 1974.

Bergson, Henri. *Matter and Memory*. Trans. Nancy Margaret Paul and William Scott Palmer. New York: Zone Books, 1988.

Black, Bob. "The Abolition of Work." http://www.inspiracy.com/ black/abolition/abolitionofwork.html.

Bookchin, Natalie, and Alexei Shulgin. "Introduction to Net.art (1994–1999)." http://www.easylife.org/netart/.

Bruce, Lenny. *Let the Buyer Beware*. Shout! Factory, 2004.

Burroughs, William. "The Cut-Up Method of Brion Gysin." In *The New Media Reader*, ed. Noah Wardrip-Fruin and Nick Montfort. Cambridge, Mass.: MIT Press, 2003.

———. *Naked Lunch*. New York: Grove Press, 1959.

Burroughs, William, and Daniel Odier. *The Job*. New York: Grove Press, 1974.

Bush, Vannevar. "As We May Think." *Atlantic*, July 1945. http://www.theatlantic.com/magazine/archive/1969/12/ as-we-may-think/3881/.

Cadigan, Pat. *Synners*. New York: Bantam Books, 1991.

Calvino, Italo. *The Uses of Literature: Essays*. San Diego: Harcourt Brace Jovanovich, 1986.

Castenada, Carlos. *Journey to Ixtlan: The Lessons of Don Juan*. New York: Simon and Schuster, 1972.

Cocteau, Jean. Quote referred to is available at various Internet quotation sites.

Colbert, Stephen. Interviewed by Nathan Rabin. *Onion's A.V. Club*, January 25, 2006. http://www.avclub.com/articles/ stephen-colbert,13970/.

———. Transcripts from the 2006 White House Correspondents' Dinner. http://www.radio4all.net/index. php?op=script&program_id=17953&version_id=20967.

Corrdry, Rob. As quoted by Paul Krugman in "A Fair Balance." *New York Times*, January 30, 2006. http://select.nytimes. com/2006/01/30/opinion/30krugman.html.

Creeley, Robert. *Was That a Real Poem & Other Essays*. Bolinas, Calif.: Four Seasons Foundation, 1979.

cummings, e. e. *100 Selected Poems*. New York: Grove Press, 1954.

Davidson, Michael. *Guys Like Us: Citing Masculinity in Cold War Poetics*. Chicago: University of Chicago Press, 2004.

Davis, Miles. The quote included here can be found in various iterations on the Internet.

Debord, Guy. "Methods of Détournement." http://library. nothingness.org/articles/SI/en/display.

———. "Theory of the Dérive." http://www.bopsecrets.org/SI/2. derive.htm.

Derrida, Jacques, and Peggy Kamuf. *A Derrida Reader: Between the Blinds*. New York: Columbia University Press, 1991.

Doctorow, E. L. Interviewed by Charlie Rose. *The Charlie Rose Show*, January 24, 2008.

Duchamp, Marcel. "The Creative Act." http://www.iaaa.nl/ cursusAA&AI/duchamp.html.

Emerson, Ralph Waldo. *Nature*. Boston: Beacon Press, 1998.

Ettinger, Bracha L. *The Matrixial Borderspace*. Minneapolis: University of Minnesota Press, 2006.

Flusser, Vilém. *Into the Universe of Technical Images*. Trans. Nancy Roth. Minneapolis: University of Minnesota Press, 2011.

———. *Towards a Philosophy of Photography*. London: Reaktion, 2000.

Foer, Jonathan Safran. *Everything Is Illuminated*. Boston: Houghton
Mifflin, 2002.

Gass, William. *Willie Masters' Lonesome Wife*. Normal, Ill.: Dalkey
Archive Press, 1989.

Ginsberg, Allen. *Planet News, 1961–1967*. San Francisco: City Lights
Books, 1968.

Ginsberg, Allen, and Donald Merriam Allen. *Composed on the
Tongue*. Bolinas, Calif.: Grey Fox Press, 1980.

Ginsberg, Allen, and Bill Morgan. *Deliberate Prose: Selected Essays
1952–1995*. New York: HarperCollins Publishers, 2000.

Grosz, Elizabeth. "The Creative Urge." Interviewed by Julie Copeland.
Sunday Morning. ABC Radio (Australia), June 5, 2005. http://
www.abc.net.au/rn/arts/sunmorn/stories/s1381964.htm.

Harris, Mary Emma. *The Arts at Black Mountain College*. Cambridge,
Mass.: MIT Press, 1987.

Higgins, Dick. *A Dialectic of Centuries: Notes toward a Theory of the
New Arts*. New York: Printed Editions, 1978.

———. *Horizons: The Poetics and Theory of the Intermedia*.
Carbondale: Southern Illinois University Press, 1984.

Keroauc, Jack. "Essentials of Spontaneous Prose." In *The Portable
Beat Reader*, ed. Ann Charters. New York: Viking, 1992.

Kesey, Ken. *Kesey's Garage Sale*. New York: Viking, 1973.

Lautréamont, Comte de. *Maldoror and the Complete Works of Comte
de Lautréamont*. Cambridge, England: Exact Change, 1994.

Lee, Bruce, and John Little. *Bruce Lee: Artist of Life*. Boston: Tuttle
Publishing, 2001.

Martin, Steve. *Born Standing Up: A Comic's Life*. New York: Scribner,
2007.

McLuhan, Marshall. *Understanding Media: The Extensions of Man*.
New York: McGraw-Hill, 1964.

McLuhan, Marshall, and Norman Mailer. *The Way It Is*. Canadian
Broadcast Channel, November 26, 1967. http://www.youtube.
com/watch?v=23V9U_616aw.

Michaux, Henri, and David Ball. *Darkness Moves: An Henri Michaux
Anthology, 1927–1984*. Berkeley: University of California Press,
1994.

Miller, Geoffrey F. "Aesthetic Fitness: How Sexual Selection
Shaped Artistic Virtuosity as a Fitness Indicator and Aesthetic
Preferences as Mate Choice Criteria." http://www.unm.
edu/~psych/faculty/aesthetic_fitness.htm.

Nietzsche, Friedrich Wilhelm. *Twilight of the Idols and The Anti-Christ*. London and New York: Penguin, 1990.

Odin, Steve. *Process Metaphysics and Hua-yen Buddhism: A Critical Study of Cumulative Penetration vs. Interpenetration*. Albany: State University of New York Press, 1982.

Paik, Nam June. "Cybernated Art." In *The New Media Reader,* ed. Noah Wardrip-Fruin and Nick Montfort. Cambridge, Mass.: MIT Press, 2003.

———. Various handwritten notes shown at the Kunsthalle Bremen in conjunction with the *40jahrevideokunst.de* exhibition, March 25–May 21, 2006.

Perloff, Marjorie. *Radical Artifice: Writing Poetry in the Age of Media*. Chicago: University of Chicago Press, 1991.

Pound, Ezra. *ABC of Reading*. New York: J. Laughlin, 1960.

Purcell, Andrew. "Free Radical." *Guardian,* June 27, 2007. http://www.guardian.co.uk/music/2007/jun/29/jazz.urban.

Reinhardt, Ad. *Art-as-Art: The Selected Writings of Ad Reinhardt*. New York: Viking Press, 1975.

Rich, Frank. "Throw the Truthiness Bums Out." *New York Times,* November 5, 2006. http://select.nytimes.com/2006/11/05/opinion/05rich.html.

Rimbaud, Arthur. *A Season in Hell and The Drunken Boat*. New York: New Directions, 1961.

Rotman, Brian. "Becoming beside Oneself." http://www.stanford.edu/dept/HPS/WritingScience/etexts/Rotman/Becoming.html.

Scherer, Michael. "The Truthiness Hurts." http://www.salon.com/news/opinion/feature/2006/05/01/colbert.

Seckler, Dorothy. Oral history interview with Robert Rauschenberg, December 21, 1965. Archives of American Art, Smithsonian Institution. http://www.aaa.si.edu/collections/oralhistories/transcripts/rausch65.htm.

Seinfeld, Jerry. *SeinLanguage*. New York: Bantam Books, 1993.

Sukenick, Ronald. *Down and In: Life in the Underground*. New York: Beech Tree Books, 1987.

———. *The Endless Short Story*. New York: Fiction Collective, 1986.

———. "In My Own Recognizance." Electronic book review posted on the Web on September 16, 2003. http://www.electronicbookreview.com/thread/electropoetics/axiomatic.

———. *Last Fall*. Normal, Ill.: FC2, 2005.

———. "The New Tradition in Fiction." In *Surfiction: Fiction Now and Tomorrow*, ed. Raymond Federman. Chicago: Swallow Press, 1975.

———. *98.6*. New York: Fiction Collective, 1975.

———. *Out*. Chicago: Swallow Press, 1973.

Ulmer, Gregory L. "Emergent Ontologies." August 2000. http://www.egs.edu/faculty/gregory-ulmer/articles/emergent-ontologies/.

———. *Heuretics: The Logic of Invention*. Baltimore, Md.: Johns Hopkins University Press, 1994.

———. *Teletheory: Grammatology in the Age of Video*. New York: Routledge, 1989.

Vitiello, Stephen. "Now and Zen: Nam June Paik's Magnetic Mirror in the Face of Boredom." *Journal of the New Media Caucus* 2, no. 2 (Spring 2006). http://www.newmediacaucus.org/html/journal/issues/html_only/2006_spring_special/Sp06_vitiello.htm.

Von Kleist, Heinrich. *An Abyss Deep Enough*. New York: Dutton, 1982.

Vonnegut, Kurt. *Welcome to the Monkey House*. New York: Delacourt Press, 1968.

Warhol, Andy. *The Andy Warhol Diaries*. Ed. Pat Hackett. New York: Warner Books, 1989.

Whitehead, Alfred North. *Process and Reality*. New York: Free Press, 1979.

———. *Religion in the Making: Lowell Lectures 1926*. New York: New American Library, 1974.

Whitman, Walt. *Leaves of Grass*. Toronto and New York: Bantam Books, 1983.

Williams, William Carlos. *Paterson*. New York: New Directions, 1963.

Wolfram, Stephen. *A New Kind of Science*. Champaign, Ill.: Wolfram Media, 2002.

MARK AMERIKA is a cult novelist, media theorist, web publisher, and VJ artist. He is the author of many books, among them *The Kafka Chronicles, Sexual Blood,* and most recently a collection of artist writings, *META/DATA: A Digital Poetics.* His artwork has been exhibited in several national and international venues, including the Whitney Biennial, the Walker Art Center, and the Institute of Contemporary Arts in London. His literary writing and artwork have been featured in *Time Magazine,* the *New York Times,* the *Wall Street Journal,* the *Guardian,* and *Village Voice.* He is professor of art and art history at the University of Colorado at Boulder and principal research fellow of media studies at La Trobe University. More information can be found at his website, http://www.markamerika.com.